IRIS TILLMAN HILL, EDITOR │ A LYNDHURST BOOK │ PUBLISHED BY THE UNIVERSITY OF NORTH CAROLINA PRESS
IN ASSOCIATION WITH THE CENTER FOR DOCUMENTARY STUDIES │ CHAPEL HILL │ LONDON

SODOM LAUREL ALBUM

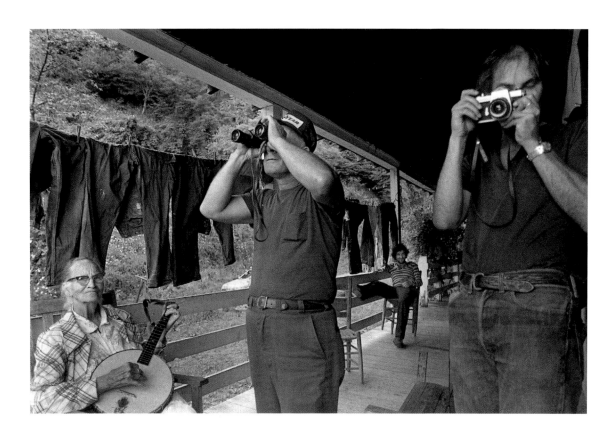

Rob Amberg

Published on the occasion of the exhibition **Sodom Laurel Album** *organized by the Asheville Art Museum and the Center for Documentary Studies*

The exhibition *Sodom Laurel Album* is made possible with the support of the Asheville Savings Bank and the Mary Duke Biddle Foundation, with additional funds provided by the Madison County Arts Council and by the following organizations: Rural Advancement Foundation International *www.rafiusa.org,* Mountain Partners in Agriculture *www.asapconnections.org,* and Farmers Legal Action Group *www.flaginc.org.*

The audio collection for Sodom Laurel Album *is a project of Lyndhurst Books in association with the Southern Folklife Collection of the Wilson Library at the University of North Carolina–Chapel Hill and the University of North Carolina Press.*

Produced and compiled by Iris Tillman Hill
Mastered by Jeff Carroll in the studio of the Southern Folklife Collection

Lyndhurst Books, published by the Center for Documentary Studies, are works of creative exploration by writers and photographers who convey new ways of seeing and understanding human experience in all its diversity—books that tell stories, challenge our assumptions, awaken our social conscience, and connect life, learning, and art. These publications have been made possible by the generous support of the Lyndhurst Foundation.

Center for Documentary Studies at Duke University
http://cds.aas.duke.edu

Designed by Bonnie Campbell
Set in Adobe Garamond by Copperline Book Services, Inc.
Map on page xxiv by Jacky Woolsey
Manufactured in China
Cover photograph: On Dellie's Porch, Sodom Laurel, 1978

The words of Dellie Norton and Tilda Norton Payne are used with the permission of Tilda Payne, of Simon Peter Norton Jr. with the permission of Simon Peter Norton Jr. and Williard E. Norton, and of Mary Norton with the permission of AB Norton.

We gratefully acknowledge the following permissions and express our thanks to Tilda Payne for Dellie Norton's songs and oral history; to Bertha McDevitt for songs by Cas Wallin, Doug Wallin, and Berzilla Wallin; to Edison Dewey Ramsey for "Black is the Color" by Evelyn Ramsey and for his and Evelyn's song with Cas Wallin; and finally to Sheila Kay Adams for "Pretty Fair Miss," recorded during her performance at the 1976 North Carolina Bicentennial Folklife Festival.

Library of Congress Cataloging-in-Publication Data
Amberg, Rob.
Sodom Laurel album / Rob Amberg.
 p. cm.
Includes bibliographical references and index.
ISBN 0-8078-2742-8
1. Documentary photography—North Carolina—Madison County. 2. Amberg, Rob. 3. Tobacco farmers—North Carolina—Madison County—Social life and customs—Pictorial works. I. Title.
TR820.5 .A468 2002
779'.99756'875 091734—dc21

2002002858

06 05 04 03 02 5 4 3 2 1

For my parents, Robert Warren Amberg
and Catherine Galeano Amberg

"It is only with the heart that one can see rightly;
what is essential is invisible to the eye."
— ANTOINE DE SAINT-EXUPÉRY,
 The Little Prince

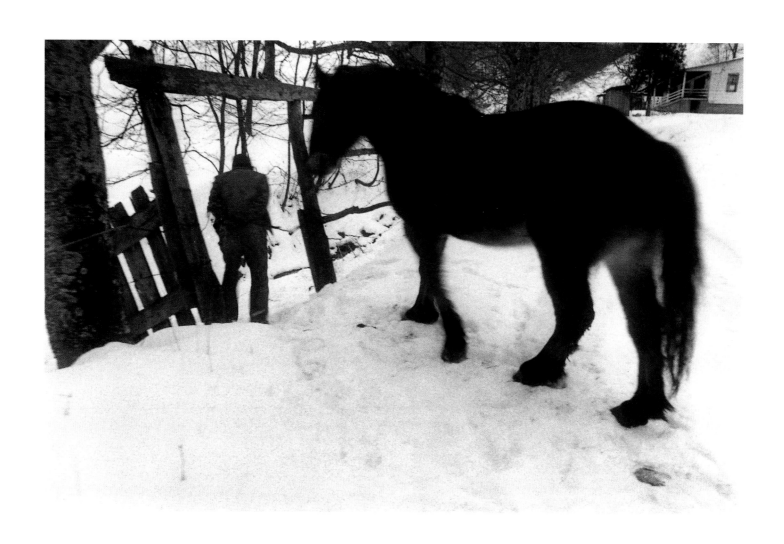

CONTENTS

PREFACE

I HAD NO IDEA WHERE I WAS. I was in my car following Sheila Rice, and she was driving very fast, her car throwing up a cloud of dust that coated my windshield. A while back we had turned off the main road through Marshall, North Carolina, and gone down through a long wide valley with scattered houses and tobacco fields on either side. We went up a tall mountain with a great view at the top and passed a trailer, its front yard covered with gamecock cages. The road turned to dirt and fell in steep drop-offs without a guardrail in sight. We were heading for Sodom Laurel, the small community where Sheila grew up. She was going to introduce me to her great-aunt Dellie Norton.

I remember passing a small store with people standing around, drinks and cigarettes in hand, all of them staring at me as I hurried to keep up with Sheila's car. She finally stopped next to a row of overflowing dumpsters and got out of her car. Across the road stood a lopsided basketball hoop with a typewriter hanging from the rim. "Well this is Sodom, where I'm from. Dellie lives up this road."

The dirt road ran along a creek, passing houses, tobacco fields, and gardens and eventually came to a mailbox with the name "Dellie Norton" on it. We forded the creek, and the driveway was soon too steep and rocky for my car. A barn appeared to slide into the road just ahead; it was surrounded by a small tobacco patch. Sheila drove past a long row of cherry trees with just the beginnings of cherries, red

and yellow, on the branches. Finally, we came to a white clapboard house with a porch running along two sides of it. Smoke rose from the chimney. An outhouse sat beside the creek. Beyond the porch I saw layers of mountains unfold in the distance.

Sheila and I went up the stairs and made our way inside. She introduced me to several people, most of them Dellie's relatives. I was relieved to see David Holt, a young musician I knew from Asheville. David had been hanging around with Dellie for a couple of years, learning old songs and finding paying performances for her. Sheila and I went into the kitchen where Dellie was cooking on a wood stove. She was as old as my grandmother, and sweating, her head wrapped in a handkerchief. She took my hand with a strong grip. "Why, your hands are so smooth. You ain't done any hard work," she announced to everyone. Then, she added, "He's pretty, I might just keep him for myself."

Back out on the porch, there was a man sketched into a corner by himself, watching everything that went on around him. "My name is Simon," he told me. Sheila said everyone called him "Junior." He was older than I was. He had a wad of tobacco in his mouth and as we shook hands I noticed his hand didn't close on mine and his arms wouldn't straighten. His speech was almost unintelligible, and I understood little of what he was saying. He

scared me. Sheila said he lived with Dellie. "What am I doing here?" I asked myself. I was only much later to learn the answer to that question.

Sheila Rice was a student at Mars Hill College in Madison County, North Carolina, where I had just started teaching and working in their new photography archives. She was young, energetic, pretty, an aspiring banjo player and singer, finishing her degree in education. She worked part-time in the library, and one day I mentioned my interest in doing a book on mountain life and how hard it had been to find a place where I could spend some time. Sheila immediately offered to take me to her home community of Sodom Laurel to meet her Granny Dell. Sheila thought Dellie would let me hang out and take pictures. Most mountain people were standoffish with strangers and would barely speak with them, Sheila explained, but Dellie was different. She was curious about new people, and it interested Dellie that young, educated people from cities would want to learn from her.

BY THE TIME I MET SHEILA, I had been living in the mountains of western North Carolina for almost two years. I had arrived in Madison County with ten dollars in my pocket and everything I owned in the back of my Ford Maverick. I knew little about the area and little more about myself, but the move felt right. Uncle Vinnie and Aunt Rosemary were living on fifty acres of mountain land near Marshall, the county seat. Vinnie was raising cows and a large garden, and working occasional jobs to supplement his pension. His new house, placed high on his land on Hays Run, looked out over the mountains.

Vinnie was the black sheep of my mother's Italian family. He had abandoned a life of responsibility for a life that seemed to me spontaneous and alive. He was the perfect uncle. When I was a boy, he took me fishing, taught me how to find crawdads hiding under rocks in a creek bed, and gave me a dog. Mostly, he showed me that life was more than it appeared to be on the surface. So years later, when he suggested I move to the mountains, the idea sounded empowering and appealing, and, in November 1973, I arrived at Vinnie and Ro's. I had little idea of what I was going to do; I was twenty-six years old.

Most of my life to that point had been spent figuring out where I didn't want to live and the sort of things I didn't want to do. Washington, D.C., where I was born. Dayton, Ohio, where I went to college. And Tucson, Arizona, where I took some photography classes and began to see photography as an extension of my interest in social issues.

THERE IS A GRAYING PHOTOGRAPH in my family album from a trip we made to the southern mountains when I was seven years old. The picture looks down on a deep river gorge with steep, tree-covered mountains on either side of the water. No houses, no roads, no shopping centers. Walt Dis-

ney's depiction of Davy Crockett was all the rage at the time, and it, too, left an indelible imprint on me. Driving into Madison County for the first time brought those images, and that time, to my mind. There was a wildness about the place, and I saw the farms romantically, as much a part of the landscape as the trees and rocks. I imagined walking for days and not seeing or hearing another person. What must it have been like in Davy Crockett's time? I was full of dreams, wanting to find something I felt I had lost. I was nostalgic for a past and a place I didn't have and was certain I had found them.

When I arrived in 1973, finding work in the county proved impossible. I had no manual skills, and the jobs I was qualified for were closed off to anyone not from the county and tied to the Democratic party. The vast majority of county residents had been born there, and the local people I met expressed amazement that someone from a city with a college degree would choose to live in Madison County. There were no movie theaters or restaurants. The first supermarket opened just two months before my arrival. The county was dry, so buying a beer meant an hour's drive to Asheville unless you knew the local bootlegger, which I didn't. But people were also beginning to move into the mountains — refugees from the 1960s, employees of the federal anti-poverty programs, people with money, retirees like Vinnie, and wanderers like me. Within a couple of years I found four other natives of Montgomery

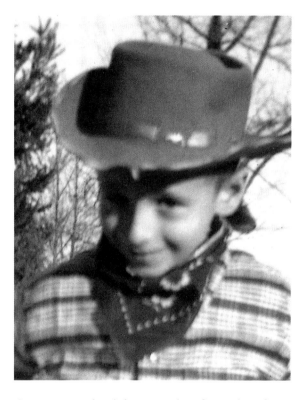

County, Maryland, living within five miles of me, all of us seeking some indefinable connection with a place we knew little about.

Construction work eventually gave way to a job with Head Start in Asheville, and then to work as a darkroom technician with a local portrait photographer. I had moved into town by then and was making photographs, but my pictures of musicians, folk and crafts festivals, and mountain landscapes were static, and, I knew, superficial. With

the demands of work and the long distances between places, it was hard to spend the necessary time finding people and places to photograph. My own preconceived notions also made it hard for me to see and understand these people and the place, once I really began to try.

One day in 1975 I stopped by Mars Hill College to show some photographs to the college librarian. Soon I had my part-time job teaching photography and working in the archives. I had the vague idea that I'd like to do a book about mountain culture but had no real plan. Sheila was working in the library, and soon she led me over mountain roads to Sodom Laurel, opening a way for me to begin this other journey.

IN SODOM LAUREL people were related by birth or marriage, and I was definitely an outsider. Like all newcomers, I was often greeted by the question, "You ain't from around here, are you?" People were right to ask, to question my motivation. Why was I here? I asked myself. What right did I have to assume that I could represent a culture I knew little about? Was I furthering stereotypes or simply picturing the superficialities of a deeply intricate society? I was sometimes embarrassed that my photographs offered no tangible benefits in a community that seemed to value things that aided survival: firewood, bean seeds, a cut of cloth. While I was often torn between my competing needs to

observe and participate, I was certain of the inherent value of photographs and saw pictures as memories of times and places, full of history and personal detail. Photographs can teach us to look at the very texture and feeling of life around us. I saw, too, that photographs played an important role in Sodom Laurel. Most everyone possessed a family album or a framed hand-painted photograph of a long-dead relative. Many people had old postcard prints made by a man named Jim Long who had lived in Sodom Laurel and made photographs on glass plates. When I walked into Bonnie Chandler's home and saw my photographs of her family reunion framed on the wall, I knew that what I was doing had meaning for the community.

Helping neighbors with their tobacco, and raising it myself for a couple of years, also let me enter more closely into the lives of the people I was photographing. Work was common ground for all of us, and it relaxed everyone when I took pictures. The hard, physical labor, stretching over months of time also slowed me down, and I began to see the beauty and the rhythm of the growing process. I mostly enjoyed the long days in the field, cutting plant after plant, handing them back to my partner who would spud plants on a stick and gouge them in the ground. Hanging sticks in the barn for curing, spreading out the leaves so they wouldn't mold, and then, months later, pulling down the sticks, stripping off and tying up the leaves, meant hours in our lives that we shared in communal work.

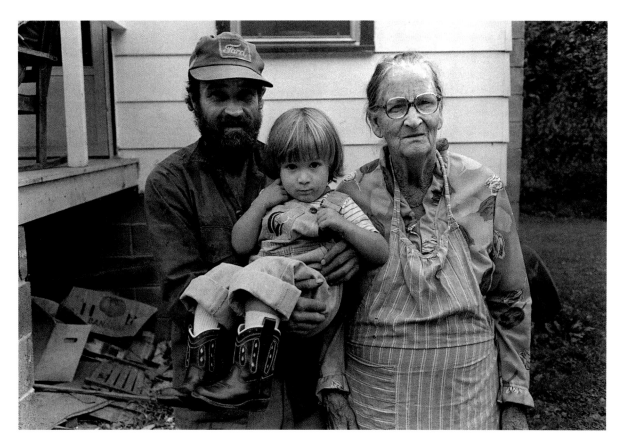

While I was photographing Sodom, I was also hearing stories rich in history. I loved the nuances of Dellie's language and her emotion when she recounted stories about people and places. Along the way I did a series of interviews with her and, later, with her daughters, Mary and Tildie, which added another dimension to my seeing.

"THIS HERE'S ROB HAMBURGER," was how Dellie would introduce me to friends and relatives. "Me and him is doing a book about the moun-

tains." Dellie was faithful to the idea long after I had given up on it as my own life changed during the nineteen years I knew her. I still wanted to live in the mountains, and was greatly drawn to the way Dellie lived, but I hadn't figured out how to do it. I didn't know how to farm, didn't have the right mindset to farm, and really didn't want to farm. What I wanted was to make photographs, and I slowly began getting freelance location work for editorial and commercial clients. I left for a couple of years to work as a photographer with the

Rural Advancement Fund in Pittsboro, North Carolina, but moving back, picking up my freelance work again, I knew Madison County was the right place for me.

More years passed and, after Dellie's death in 1993, I revisited the idea of our book. Initially, all I could see were the problems. I saw myself as someone wedded to dates, facts, and objectivity, and there were major gaps in Dellie's life history in my record. My photographs didn't tell a complete story; while the nineteen years I knew her was a unifying thread, there were also long periods of time when I didn't see her. But, my thinking changed as I worked on our book. I came to believe that our life stories are rarely consistent, always subjective, and never complete. Insignificant incidents take on new meaning with passing years. Dates grow blurred and less important. Perhaps, our life stories more closely resemble novels than histories. I also started to see my own life as part of the picture I had been piecing together. What began as a documentary study has become a narrative. The photographs and voices are not organized chronologically. The majority of the photographs were made between 1975 and 1979 when I spent my most concentrated period of time with Dellie. The closing images were made in the late 1980s and early 1990s, Dellie's last years, after my return to the county. Some of the tobacco photographs were also made later in other Madison County communities. The oral histories were collected in the 1980s and 1990s and have been edited for readability; my personal entries were fashioned from my notes and recollections. All this being said, this book represents what my time with Dellie, Junior, and the Sodom Laurel community *felt* like.

Insight often comes from the most unexpected of sources. Dellie would have been 104 years old this year (she was born in 1898), and it saddens me that she can't see this book. I believe she would have wanted it to tell others about people like her, their lives, and the place they lived. I hope this book would please her. Some time ago, I realized that my experiences with Dellie and Junior were part of a process of self-discovery, my own personal evolution. Dellie opened windows in my life that could not have been opened by anyone else. What a wonderful gift she gave me. I hope *Sodom Laurel Album* will open windows for others.

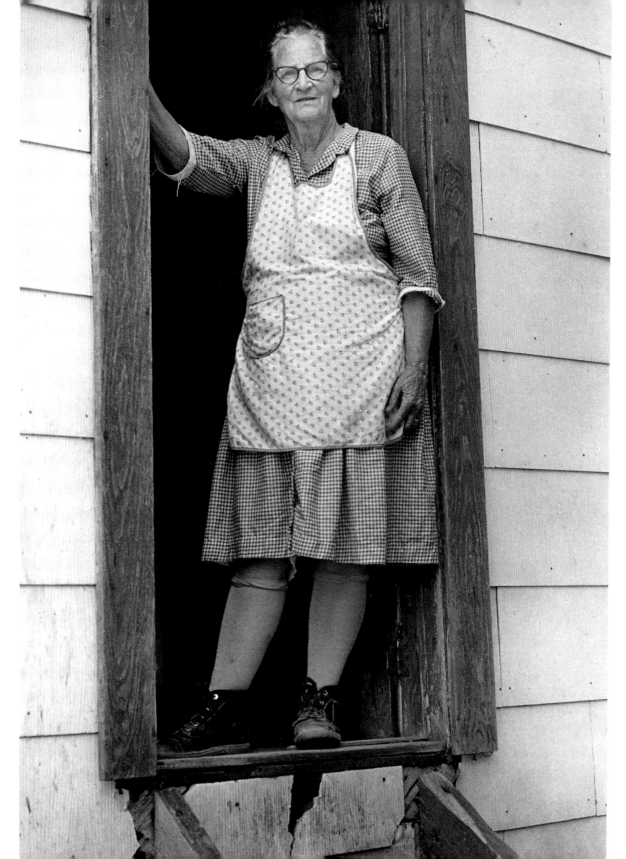

INTRODUCTION

WHEN I FIRST MET DELLIE NORTON and her adopted son, Junior, Dellie was seventy-six years old and had been widowed for about ten years. Junior was in his early thirties and had lived with Dellie since he was six. When Junior's father, who was Dellie's first cousin, died, and Junior's mother couldn't care for all seven children, Dellie took him in. Informal adoption was common in tight-knit mountain hamlets. In addition to her own five children, Dellie raised her husband's three daughters from a previous marriage, and had numerous other children stay with her for varying amounts of time. Children provided her with company, as well as with an extra pair of hands for the never-ending work around the farm. Junior also received a monthly disability check which was an important part of the family's cash income. So taking in Junior, while clearly an act of kindness, was also a very practical decision.

Electricity and telephones didn't come to Madison County until the 1950s, and there was little money in the community before the federal programs of the 1960s. Throughout her life Dellie worked to fill her family's most basic needs, raising food and canning, maintaining the farmstead, cutting firewood, caring for animals, and planting tobacco to earn money. She knew her land intimately: which field produced the best beans, where to find a stand of locust trees that could be split into fence posts, how to store food through the long winters without electricity, what time of the year to collect specific herbs that were used as medicines, where the springs were. She seemed proud of this hard-earned knowledge, and her life. As far as I could tell, she harbored no secret wish to live elsewhere or differently. I believe that Dellie knew the land itself was her most valuable asset. Her ability to survive and do well on her land provided her with real security; it was her home place and promised the continuation of her family line.

Burley tobacco was the mainstay of the area, and for most of the twentieth century Madison County was the leading producer of burley in North Carolina. County residents kept cattle and sheep, cultivated gardens and large fields of corn, and grew commercial tomatoes and ornamentals, but tobacco paid the bills. Up until the mid-1980s, most families with a tobacco allotment raised the crop themselves, often trading work with their neighbors on the labor-intensive crop. Tobacco has many problems: it's hard on the soil, susceptible to disease, and the end product is bad for people. Yet cultivating tobacco also promoted a sense of community and a pride in making a living from the land; it provided mountain people with the means to stay on their land and assured the continuation of a rural, agrarian way of life.

While tobacco was the money crop, most families

also found other ways to earn income. Some left for factory jobs elsewhere, as Dellie describes in her stories, but many also found ways to come home and resume their farm life, sometimes with new resources. Dellie and the other old-timers in Madison County had maintained an almost self-sufficient way of life. Dellie was not only self-reliant, she also was very strong from her years of farming and maintaining a household. She didn't get her first electric washing machine until the late 1950s, and it was there on the porch, with its old-fashioned wringer still in working order, when I arrived on the scene.

By the 1970s, Dellie, like most of her neighbors in the small community of Sodom Laurel, had become more firmly connected to the world of modern conveniences, and committed to living in it. She still raised a big garden, milked a cow, grew tobacco, and hunted for ginseng, but she also loved her telephone and TV and the polyester pantsuits she wore whenever she left home, which she did with some frequency. She had oil heat and shelves of prescription medicine in her bathroom. She paid bills, had insurance, and shopped for groceries at the store. She also received disability and social security checks and supplemental food and medical care. While Dellie remembered a time when she had been more self-sufficient, she seemed to like the changes in her life.

DELLIE ALSO SANG BALLADS. Music was one of the few available and affordable forms of entertainment, and most everyone in Sodom Laurel, even the children, sang or played instruments. The community had produced professional musicians with dreams of stardom, but the majority of residents viewed music as part of their daily routine. They sang in church. Dellie sang to pass the day, to keep from feeling lonely. Singing made the hard work in the fields more tolerable and front porch visits with neighbors and relatives more enjoyable. Singing was something people just did. Dellie once told me she never would have believed that she would become famous for her singing. I don't think it occurred to Dellie that she would leave any kind of legacy to the wider world.

The wider world has been aware of the music of the southern mountains for almost a century. The noted British ethnomusicologist Cecil Sharp and his assistant, Maud Karpeles, collected more songs in Madison County in 1916 than in any other single place for their classic volume, *English Folk Songs from the Southern Appalachians.* One of their singers was Dellie's aunt Zipporah Rice, and although Dellie herself never sang for him, she had a clear memory from her teenage years of the man from "across the water" who collected ballads in the community. Sharp recognized the southern mountains, and Madison County in particular, as being the storehouse of the British-American mu-

sic tradition. The ballads he collected had made their way across the ocean to America, endured over many generations, through untold hardships and relocations, and ended up in Sodom Laurel, North Carolina, where they were being sung the same way they had been in the British Isles in the sixteenth and seventeenth centuries. As Sharp said, "I discovered that I could get what I wanted from pretty nearly everyone I met, young and old. In fact I found myself for the first time in my life in a community in which singing was as common and almost as universal as speaking."

In the mid-1960s, there was a national revival of folk music. Main stream musicians like the Kingston Trio and Peter, Paul, and Mary were doing popular renditions of songs that had been in the Sodom Laurel community for centuries. There was also a growing curiosity about the sources of this music. Soon Dellie, her sister Berzilla, Dillard Chandler, Cas Wallin, Doug Wallin, and a number of others were "discovered" by folk music scholars and collectors. By the time I arrived, this group of mostly elderly community members was traveling regularly to folk festivals. There was also a steady stream of students, musicians, photographers, collectors, and culture tourists flowing in and out of the community.

This attention provided the singers with an opportunity to meet new people and see places they had only heard about or seen on TV. Being among the first in their community to fly in a jet, or see Washington, D.C., or receive awards from the state, added to their celebrity in the community, which they relished. The money singers received was often needed and always appreciated, and that educated people would record their songs and pay them to talk about their lives assured them a place in the world that went far beyond their histories in Sodom Laurel. The old-timers were not fixed in a remote and isolated place, were not living in the past. They were busily making the connections that some of us young people found so hard to see.

Yet there were downsides to the attention as well. There were misunderstandings about money —the expectation of royalty checks that never arrived, the hope of contracts that didn't materialize. Twenty-five years after Alan Lomax recorded her, Dellie continued to complain about him never sending her any money. Doug Wallin even took a swing at the filmmaker John Cohen, claiming that Cohen "had kept all the money" though, as Cohen told him, the record he'd made had sold very few copies. The promise of paying jobs also produced a competitiveness among the singers for those jobs, and there was jealousy if one person was included in a festival or album and the others weren't. A subtle, but friendly, rivalry over whose was the correct version of a particular ballad had always existed, but with money and an audience involved, that rivalry

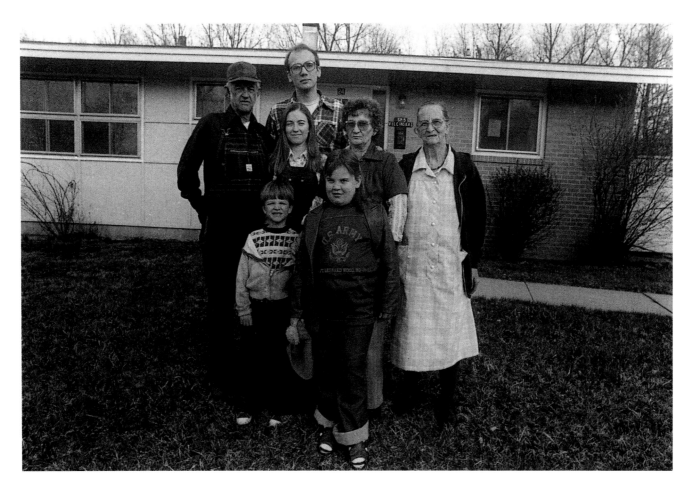

became more spiteful. Whatever preconceptions I came with about romantic mountaineers were beginning to crumble, faced with real people and places.

Other incidents began to alter my understanding. Life in Sodom was uncertain. The local way of speaking was so different that I feared unknowingly offending someone with a wrong phrase or offhand remark. There was also a lot of drinking which often led to fights, shootings, thefts, and other acts of violence and mayhem. Most everyone, Dellie included, carried a gun. Her life seemed punctuated by troubling incidents when someone settled an old grudge or took the law into his own hands. Did it make sense? Here in Sodom, twenty-two miles from Marshall and the sheriff's office, people solved

their own problems and were quick to defend themselves and their land. And while everyone was proud of their generational links to the land, and their love of it, there was also, what seemed to me, much abuse of that land. Many home places were littered with trash piles and junked cars, and had outhouses built over creeks.

There were also countless acts of kindness and moments of serenity. Dellie and her friends telling stories and singing on the porch. Impromptu meals at someone's house. Visits to friends in the hospital, vigils by a kin's sickbed. Gifts of chicken and eggs. Coins and dollar bills given freely to a neighbor's kids. People would invite me to spend the night and mean it, not taking no for an answer, and I sensed that people not only watched out for me but accepted me into the community.

Dellie loved to "run about" and my ability to find my way around "them foreign places," as she referred to Asheville and other cities, was a skill she definitely valued. Dellie often told me about her earlier life, about bad roads and little money, when it wasn't possible to see new places and meet new people. She wanted to make up for it now. For a few years I was her chauffeur of choice. For me, our trips were fun, a way to feel useful; it was also a valuable introduction to her family and friends. Short trips to the bypass for groceries, to the doctor in Greenville, Tennessee, over to a relative's house for a visit, or to someone else's place to get apples were numerous

and routine. Longer trips to festivals, where she and Berzilla performed with other ballad singers, or out to Fort Leonard Wood, Missouri, to visit her granddaughter Sue, were true adventures. Missouri was the farthest any of them had been from home, and for much of the seventeen-hour drive, Dellie regularly moaned, "We're surely lost now. We'll never find Sue and Vince. We'll never see Sodom again." When we finally pulled up in front of Sue and Vince's, Dellie's face beamed with surprise and relief.

WHEN I MOVED to Madison County, the population was three-tiered: the old-timers, rooted in traditional ways; their children and grandchildren born into the mountain culture, but many moving away, finding new kinds of work; and the newcomers, often yearning for a traditional way of life and an escape from the modern American suburb. Today, as the population born outside Madison County approaches 50 percent, that earlier world is gone. The old-timers have mostly died, taking their way of life with them. I see fewer gardens and no milk cows. People rarely visit in person, choosing instead to telephone or send e-mail. Better roads have provided easy access to town, and most everyone works away from their farms. Tobacco is no longer the secure income or proud crop it used to be. The younger generation of locals, descendants of Scotch-Irish settlers, see their land, cul-

ture, and heritage being slowly consumed by the mainstream, and often don't fight the trend. The latest wave of newcomers no longer have people like Dellie to share her stories of a more integrated and hardscrabble life close to the land. Many newcomers homeschool their children and seem more interested in insulating themselves from the local culture. The land is more a hobby, or a financial asset, than the sustainer of families it once was. The grocery store that opened just prior to my arrival has expanded to a superstore, and the county now has its first fast-food restaurant and chain motel.

Dellie belonged to an oral tradition. She rarely wrote down songs or stories, repeating them the way she had heard them. At her core, Dellie was a teacher, and she understood the importance of passing on those ballads, family histories, and knowledge of the land to new generations. Family, friends, and audiences were drawn to her, and would heed her words. While Dellie's life gave expression to a particular time and place, her inner strength and understanding of the complexity of life were qualities that crossed all boundaries. Her ability to live mostly off her land was a reminder of a more self-sufficient and connected way of life most of us can only read about or imagine. Organic food, herbal medicines, simplified needs, and neighborhood workdays are notions that resonate clearly with many of us, but they were part of her daily routine. For Dellie, hers was not an "alternative" lifestyle; she was a pragmatist and a survivor. She used her surroundings to provide a life for her family in a place where you could easily get lost or die if you didn't know how to work and do.

The totality of Dellie's life experience was not one I, or her grandchildren I suspect, would choose to repeat. The thought of living off the land, without a car, computer, chainsaw, health care, and the other "necessities" of life, is a scary and sobering thought. But everyone who knew Dellie, or someone like her, has kept something of her and her way of life. A story or a song. A love of gardening. A quilt she made. A certain way of doing a task. An understanding and acceptance of the strength and resilience it takes to live. A memory that makes you laugh, or cry. In those ways, Dellie's legacy is of a culture that has not so much vanished as continued to evolve in new and unexpected ways.

Sodom Laurel Album

3

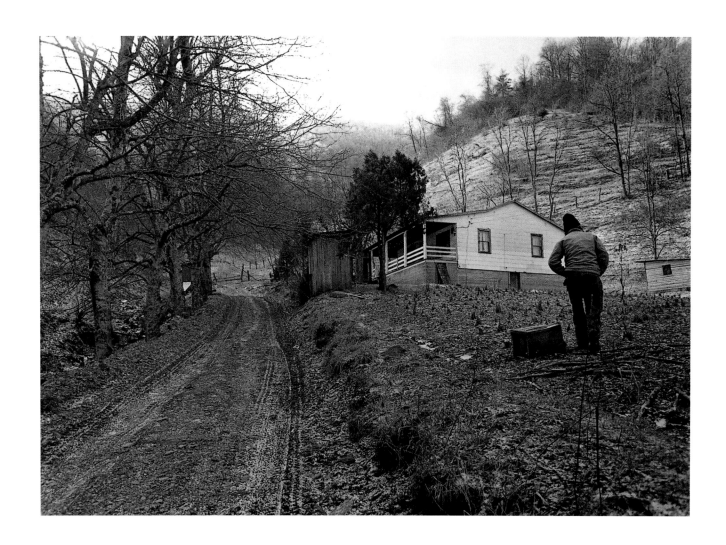

ROB AMBERG That first night the house was full of visitors, people going to the music festival in Sodom and needing a place to spend the night. I shared the sofa bed with a left-handed guitar player named Grover. During the night, Grover rolled over against me, rubbed my back, and sleepily murmured, "Oh, baby." I heard the door to Dellie's room open long before daylight. I lay there quietly as she made her way to the chair next to my bed. She put on her glasses, fiddled with her hair, and gathered herself for the day. Soon, she lifted the box of Bruton's snuff from the windowsill above her head and put a spoonful in her mouth.

Everyone left later in the day, and that night the place felt deserted. No music or long conversations. I talked with Dellie and Junior, but I didn't know what questions to ask or thoughts to pursue. I didn't yet understand the significance of their stories or their lives. We watched TV with terrible reception, even with the trio of antennas perched on the hill behind the house, each pointing in a different direction. We ate cookies, drank a glass of milk, and went to bed early.

I was given my own room with a double bed covered by a homemade quilt, a nightstand, and a reading lamp. An open window provided air, and a look out to an old shed and a tree-covered mountain. It was calming, but I was anxious and didn't sleep well. Branches scraped the tin roof of the house. Dogs barked throughout the night. A car revved its engine close by. It was still dark when I heard Dellie yell, "Junior, bring me some stove wood."

He did, grumbling. Biscuits and gravy were his reward. After breakfast, I helped Dellie wash the dishes in two tin pans placed on the kitchen table. One for washing, the other for rinsing. Then, Junior and I did chores. Split and hauled in stove wood. Fed the animals. Hoed the tobacco. Later, he showed me the place: the spring, garden, and barn. We took a short walk to an adjoining cove that Junior called the Teat Holler. There were the remains of an old house where Dellie's son lived before he was killed.

Dellie talked on the phone, watched the soap operas on TV. It was a slow, monotonous day. I was bored, restless. I shot film, but the pictures felt staged and static. And Dellie and her farm didn't fit my image of mountain life. She wasn't romantic or historic in her look, but somewhat rough and coarse. The place was going downhill. Fences needed mending. It was being overtaken with weeds. Junior bothered me in some indefinable way. He was loud, with an opinion about everything. But he was also fearful and insecure. When it was time to leave, I said I would come back, but did I mean it? Dellie looked me directly in the eye and said, "You'll be welcome as the flowers in May."

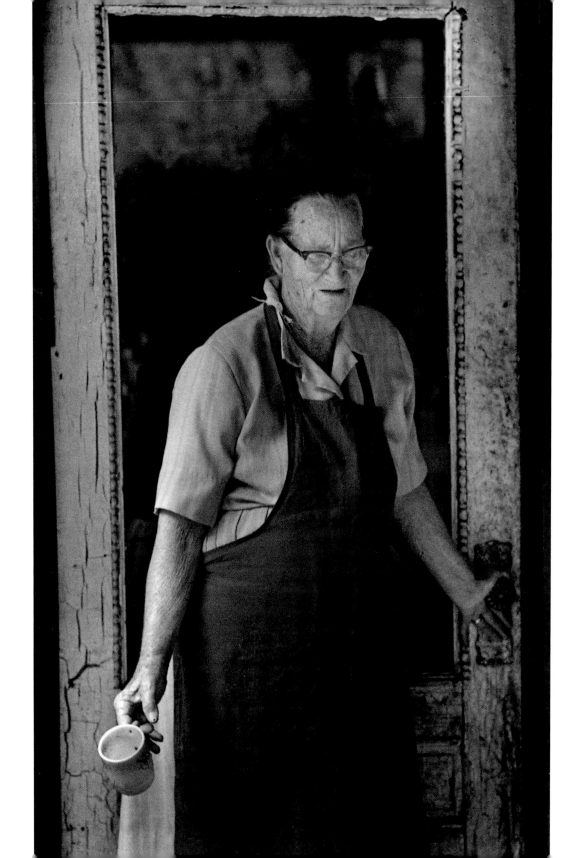

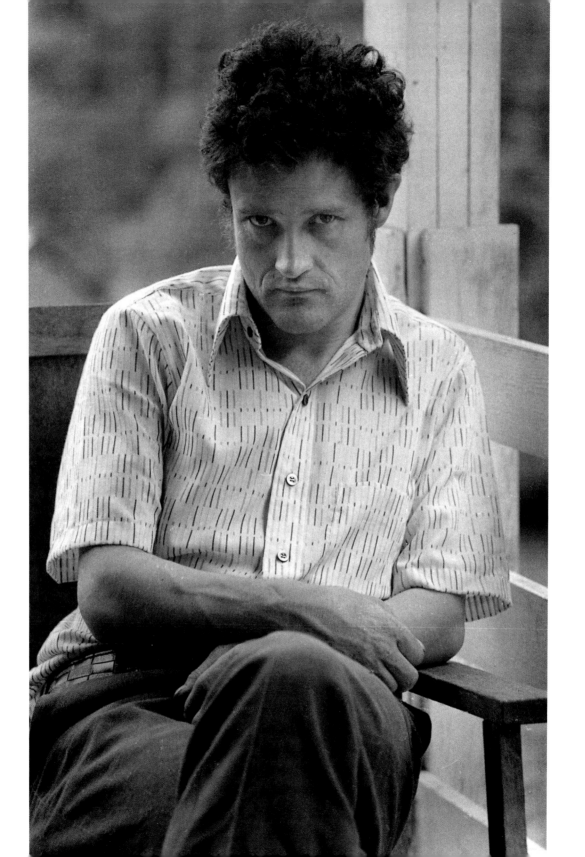

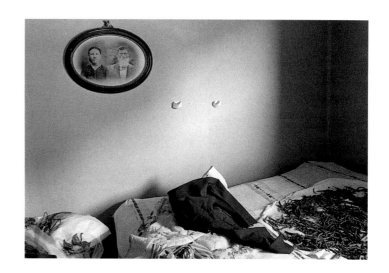

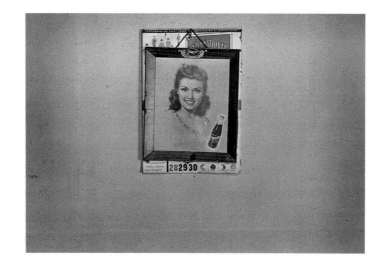

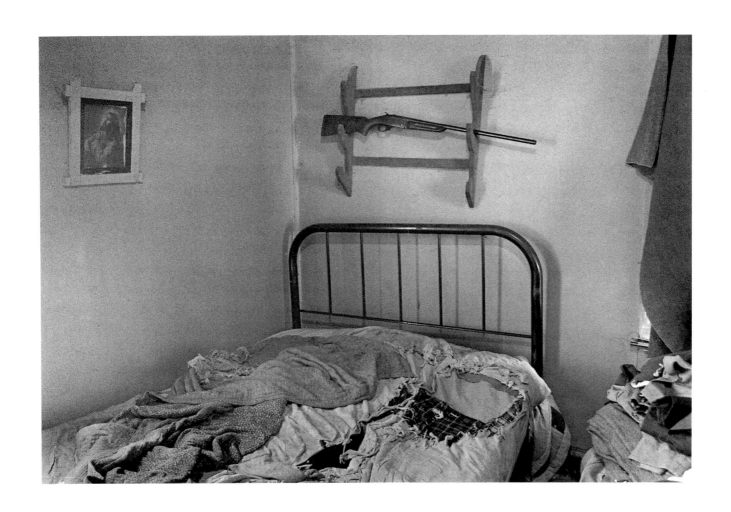

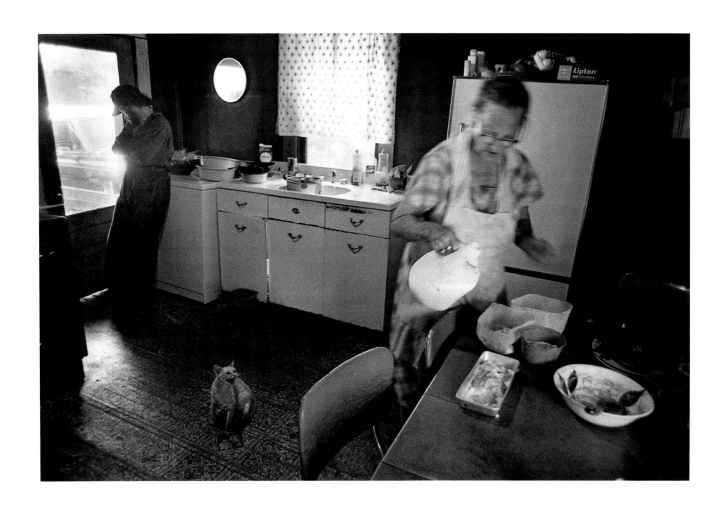

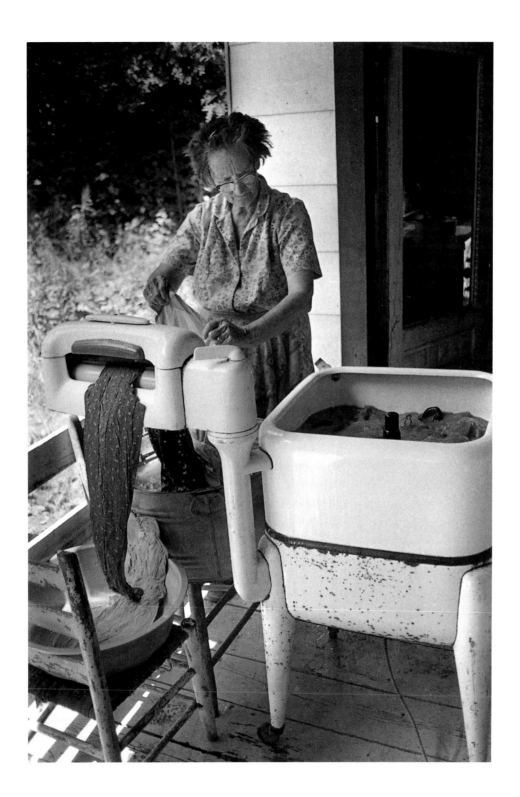

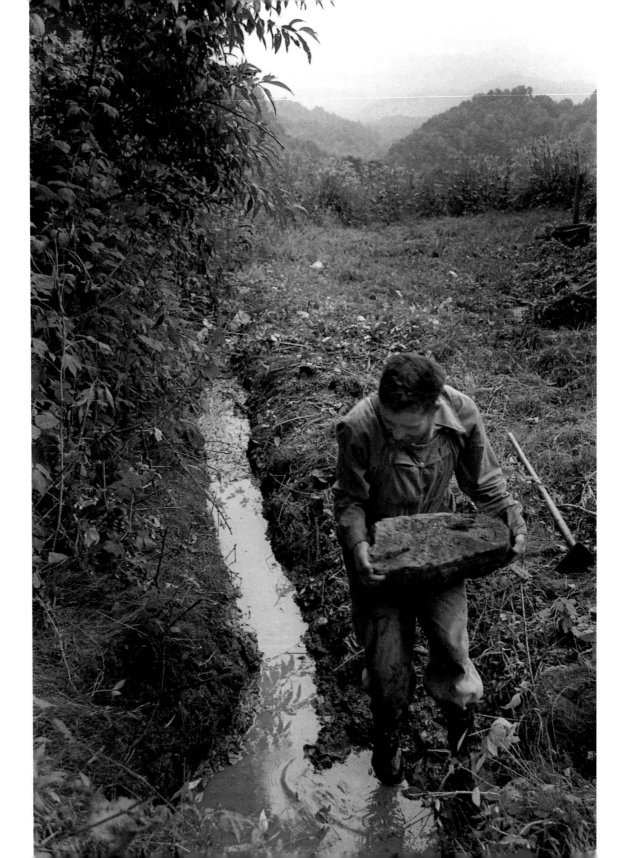

12

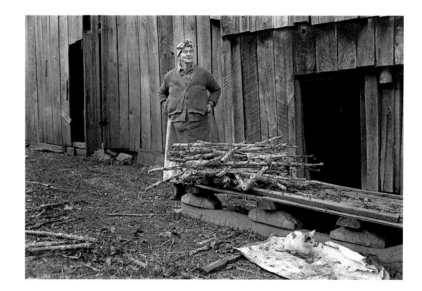

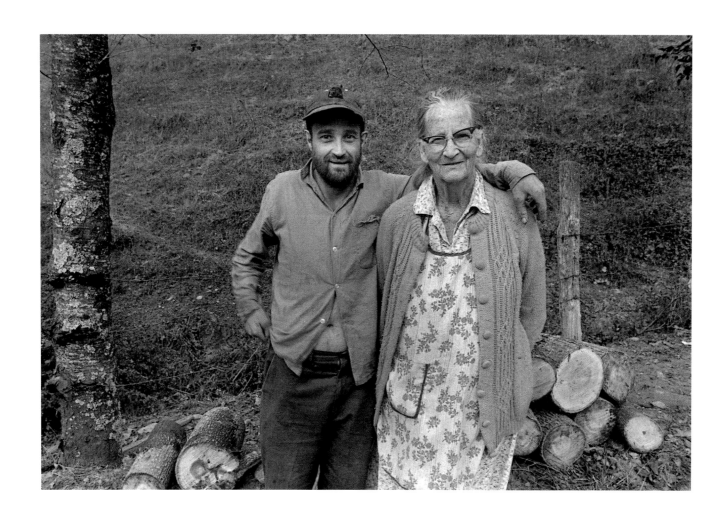

14

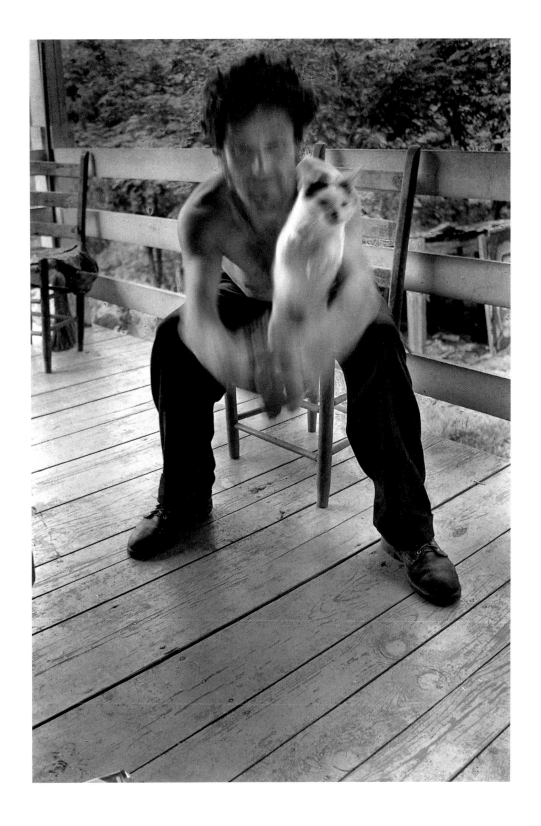

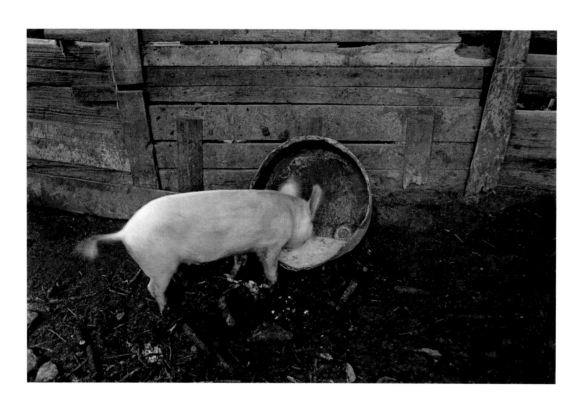

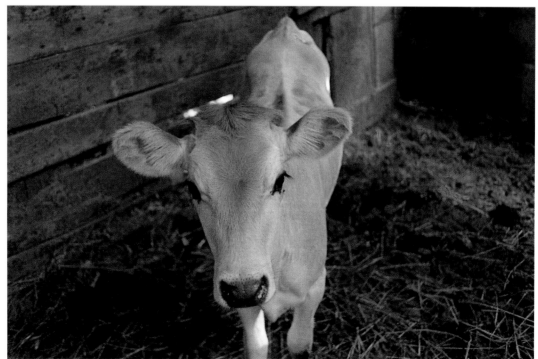

16

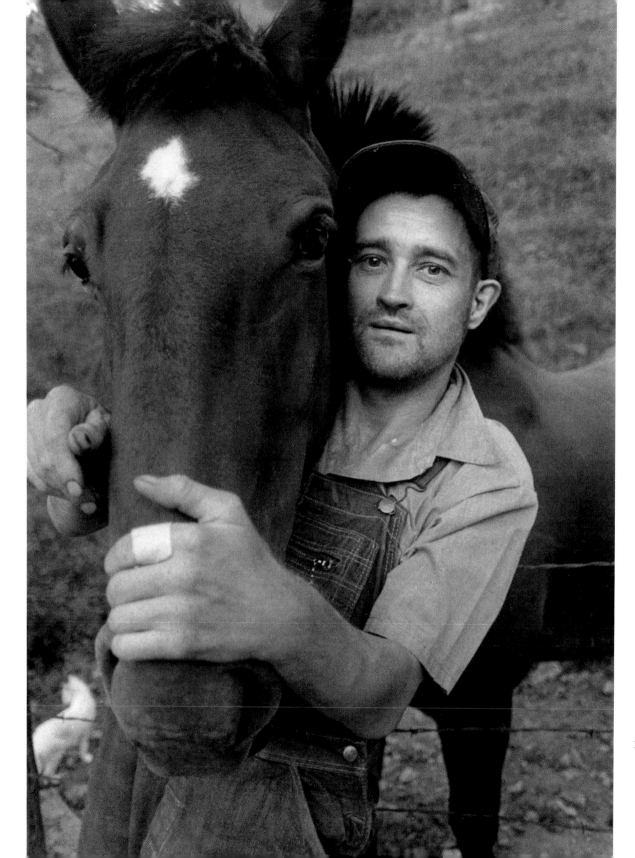

17

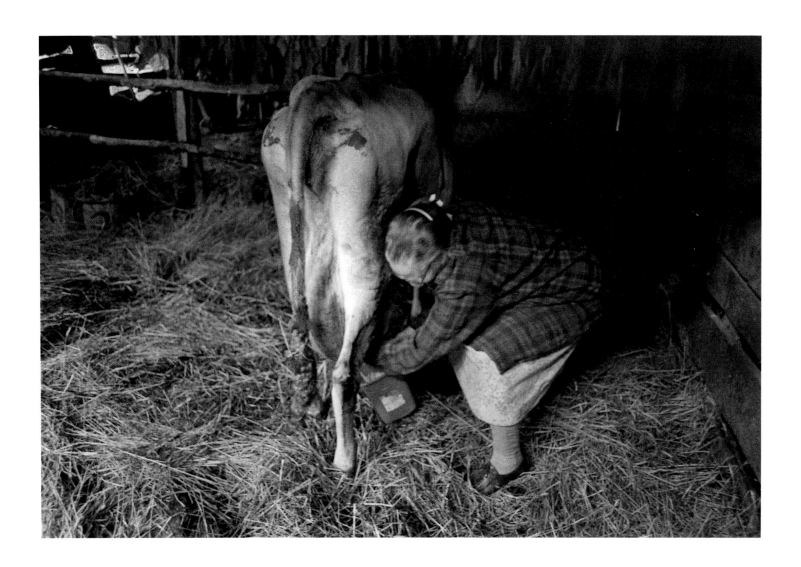

18

DELLIE NORTON My grandparents moved here in a covered wagon. I think now that old John Chandler and Andy Chandler — they was my great-grandparents — they come from close to the ocean. They come in a covered wagon when they first moved in here. I've heared old people talk about it.

Now my mother was married before she married my daddy. She had three boys and a girl. I got one half-sister and three half-brothers. They died when they was very little.

My grandmother had fifty acres of land and she give my mammy's brother Baliff twenty-five acres and she give my mammy twenty-five acres. We lived up there in the Ben Cove when I was little bitty. I was born up there. I was delivered by a midwife. I was trying to think of her name. Can't do it though. Sometimes they paid them with different things. If they had any money they paid them with money, but if they didn't, they'd take any kind of food. Dried apples. Dried peaches. Or brush beans. Or anything like that. And meat.

One year we had it real tough. Daddy couldn't get no work around close and he had to go to his sister's in Pennsylvania. He went and stayed two years that I never seed him. He worked at making these bathtubs. That's what he made. I was just little and I didn't even know him when he got back. I'd never seed him with a suit of clothes and a tie on before. Me and Branscum was just little bitty things. I guess Branscum wouldn't have been two years old. There ain't but two years between us. We was out up there playing, and this man come down and come to us. He knowed us. But we didn't know him. We was afeared of him.

My mammy knew he'd be back. He sent money back, but he saved a lot he brought in. We had plenty to eat and things like that. My mother made the awfulest crop that year you ever seed. She worked just like a man. She'd plow. Plowed the ground, laid it off, and planted it. The other children was bigger than me — three of them — and they'd help. I wouldn't be much hand to work because I was just very little. They finally got to logging on Spillcorn, and they'd walk and go to that job. But that was maybe fifteen years after he come back from Pennsylvania. There didn't used to be no work around here to do.

We had two log houses when I was growing up, but they didn't set together. There was a big yard between them. The kitchen was in one house, and the living room and the bedrooms was all together in one log house. We didn't have no flooring in the kitchen, where we did the cooking. We had a dirt floor. The living room and bedrooms was all together and it was big. It was big enough to hold four beds and plenty of room with a big fireplace. It was warm, but if it was snowy you had to wade the snow to get down to the kitchen to eat and to cook.

We cooked with one of these old kind of step stoves. Back then you couldn't get one of these big, good stoves like you get now. It had four eyes on top and a little apron out in front. And just a place where you put your bread in. And really, it was very small, but you could cook good on them. There was a door there at the little apron where you put your wood in. You don't ever see none of them no more.

My mother's brother lived right on down below us in a log house and he had five younguns. I'd go down there a lot and play with them, and they'd come to play with me. And then there was another house on down, and sometimes we'd go down there. And they had twelve children. There was bunches of children and they all lived pretty close. Younguns couldn't get toys back in them days like they do now. They generally made them a rag doll. When I was little I had rag dolls to play with that my older sisters would make.

I had two dresses when I begin to go to school. Two checked cotton dresses. I wore one to school and one of a Sunday. When I wore that one a week to school, I'd put my Sunday dress on for my mother to wash my school dress.

My mother was a good sewer. She could make any kind of dresses, pants. She could weave and card. She'd make us yarn jackets to wear. Knit gloves and stockings. I had shoes. I mighta not of had none when I was very small, but when I went to go to school I had shoes. But they was different to what shoes is now. They called them button shoes, high-topped button shoes. You had to have a hook to button them up with.

You didn't get out unless you walked or went in a wagon or rode a horse back in them days. You had money if you wanted to get out and go to these foreign stores and places. If you hadn't had the money you couldn't get out and get nothing.

You had to ride a horse though if you went to Marshall, or walk. That's twenty-two miles from here. You generally didn't go too often. I guess I'd sometimes go to Marshall once a week. Maybe out to Walnut. I'd trade out at Walnut—at the old station they called it. John Ramsey had a big store there. I'd go over there every Easter to get my Easter outfit. Every Easter. I'd walk out there and walk back the same day. I'd walk through the mountains, and it ain't so far—maybe eight or ten miles. I loved to walk back then. I could walk. Sometimes there were people out there that I knew and I'd stop in and see them.

You couldn't get a car back in here. Not in them days. You could take a wagon, but people just didn't have no cars. I guess they could've come so far, but they couldn't have come on up I don't guess. That road used to go right on up through the branch. Right up the branch.

I rode a mule to the top of the mountain with a sack of fertilize. Right in front of me. I had a saddle on the mule. You couldn't put it behind you. It would've went off. You had to put it in front of you. They made two-hundred-pound sacks back then. That was the reason they would clear them big new grounds on top of the mountain. You could raise all kinds of stuff. Taters. Did raise some baccer up there once I think. The land was better. It would make better stuff. The land was richer.

Back in them days we'd have workings. Everybody around nearly would come and help. They

didn't charge you nothing. In a day or two they'd clear an acre, all but ready to burn it off. Have it all piled high, big brush piles—a sight. They didn't have no power saws. They'd saw those trees down with a crosscut saw. You didn't have to dig those roots from the trees unless you wanted to. You just let the stumps stand and rot out and plant around them. You had to grub the little things. Most of the time you'd lay it off and plant your stuff. You didn't have to plow it up unless you wanted to. You'd come back later and hoe it. We had two acres on this big steep hill and we never did plow it. Hoed it without plowing it.

You'd take you a hoe and make you a hole and drop your stuff in it where it was steep that way. Sometimes, back then in some places, you didn't use fertilize. The ground was rich and would make good stuff unless it was baccer. Now the baccer, when they first got to raising it, they'd put just a teaspoon of fertilize with each hill. They didn't plant it like they do now. Make a little hill around that fertilize, cover it over, and stick your baccer in there.

Things don't grow enough to make stuff as good as they used to. Lord, I've seen one cabbage cut up fill a dishpan full. And big ears of corn. I don't think it grows as well now. You can't grow nothing now unless you've got the fertilize. But used to, you didn't have to have it.

You'd save your seed. You'd plant a cabbage and it would make seeds. Plant a beet, and it would make seeds. You'd save your seeds, and my mother was a person that would sure save them. Plenty of seeds of every kind. I do that yet. I save my mater seeds and cucumber seeds and watermelon seeds. Bean seeds. You'd save enough of it. It wouldn't take too much. A bushel of seed would plant two or three acres.

We'd save our corn seed right on the cob. I've seed mammy sack it up and hang it on a tier pole in the barn to keep the rats or anything from bothering it. We'd shell it to feed to the hogs. When we first moved up in here hogs, and cows too, just ran wild in the mountains. They'd eat chestnuts. There used to be the awfulest sight of chestnuts. Hogs would get fat on them. When we first moved, before Daddy bought that place up there, we had the awfulest bunch of hogs ever was. There was a fence above the house and my mammy had a dog trained. It knowed our hogs from our neighbors' and wouldn't let those other hogs in the slop at all. It ran them off.

I reckon it did save money—if you had to pay for seeds then like you do now. I don't think back then there was no place to go to get no seeds. You had to save them or do without. If I didn't have them, I'd buy them, or beg them from somebody else. Somebody always had them some. But I always tried to save me some. I didn't have to beg.

TWO Planting Tobacco

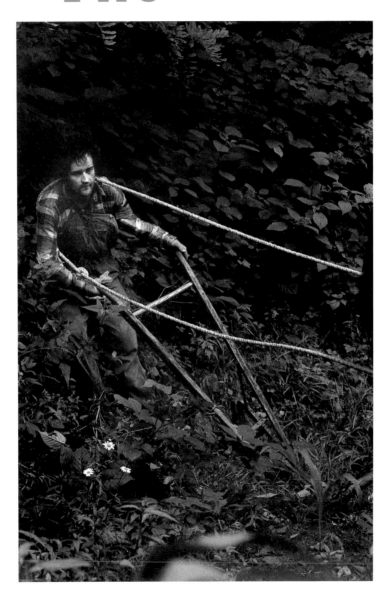

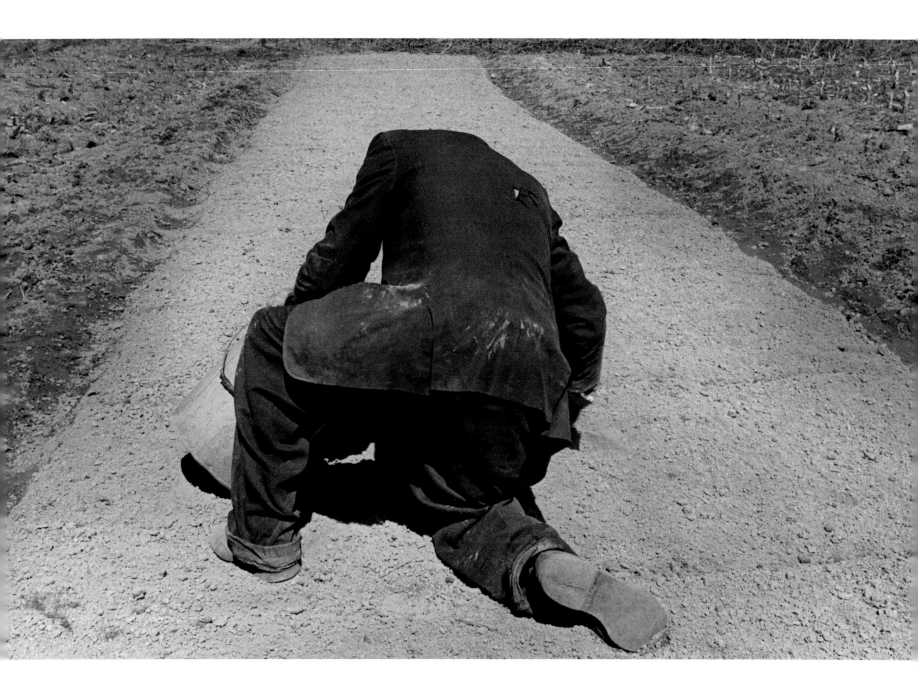

ROB AMBERG Dellie and Junior raised tobacco that first year I met them. Her grandson was supposed to do most of the work, but he quit after the first plowing and left it for them to finish. Dellie said she needed the money and didn't want to lose her allotment by not growing it. Junior dreaded the work, knowing he would be doing most of the plowing, hoeing, and heavy lifting still to come. But the plants were in the ground and growing. The tedious work of preparing and sowing the seed bed, and then transplanting the seedlings to the field, was over. The next big task was topping and suckering the plants, but that was weeks away.

One day, Dellie, her older sister, Berzilla, and I went to visit their cousin Tilman. It was something the three of us did a lot—we drove around and visited. Tilman lived by himself, high on a mountain in the Ben Cove in a one-room cabin. It was midday, and we were greeted by a pack of snarling dogs that cornered us in the truck. We blew the horn over and over, and finally Tilman came out on the porch, clearly not awake, waving a shotgun in our direction until he realized it was Dellie. He showed us his tobacco, which was knee-high and beginning to make flowers. He let me take a picture of his tobacco and barn, but not of him. Later that year, they found him dead in the cabin, his body eaten by rats. People said his hat brim was stuffed with money.

Years later, when I lived in the Big Pine community, I helped my neighbors set out their tobacco. It was the only paying work close by and a good way to get to know people. We waited for rain, a "good season," to set the plants by hand. Early one morning, after a night of light rain, my neighbor McKinley called, asking if I wanted to work. When I got to the field, it was laid off in precise rows. The ground was soft, with plenty of water in it to keep the plants moist. My boots were soon caked with mud and heavy. It was a day of constant bending, stooping, and sweating: punching a hole in the muddy ground with a stick, inserting a plant in the hole, and then pulling dirt around the plant. My back throbbed, and I was filthy. The stick had given me blisters. But it was also a good day, working, talking, and joking with a group of new people, ranging in age from twelve to seventy-five. McKinley's wife fixed us all lunch. We set two acres that day.

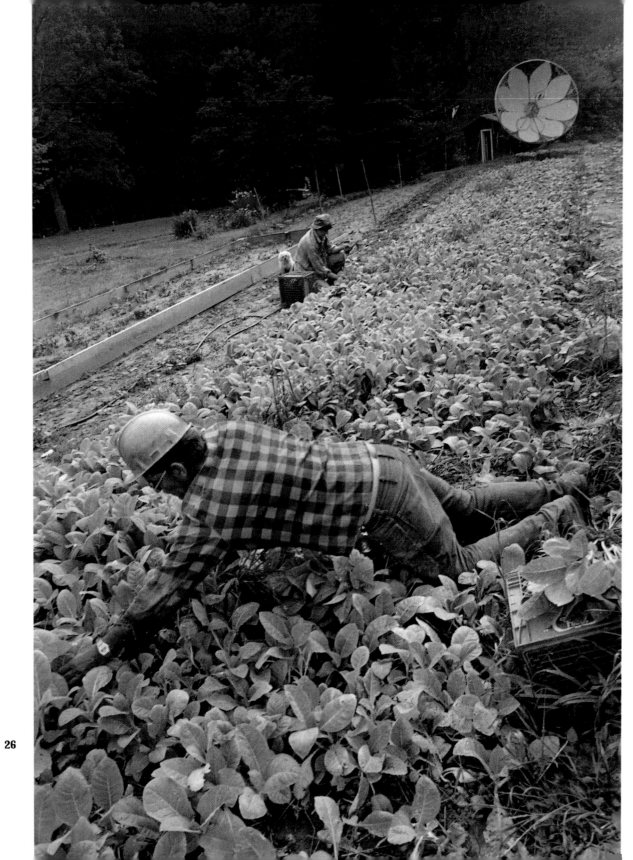

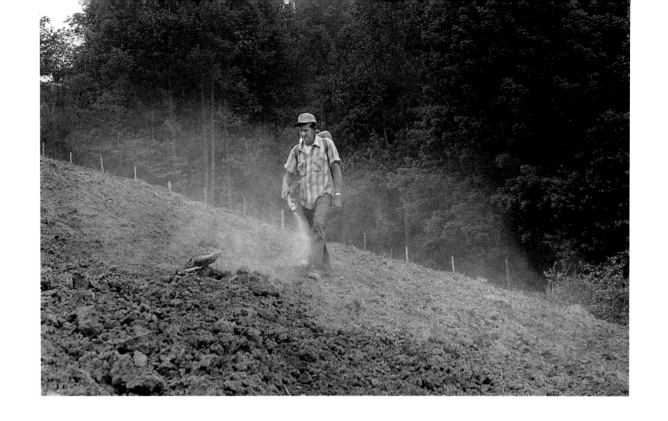

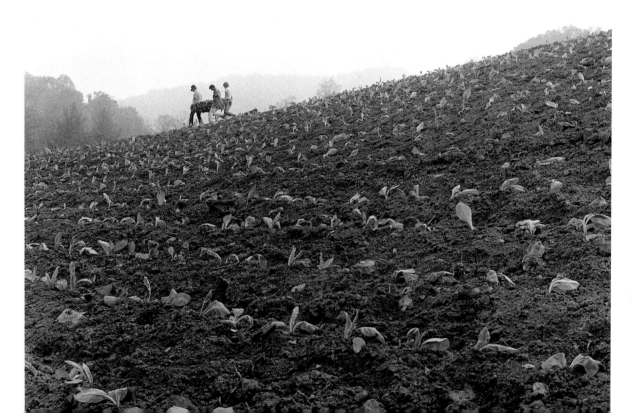

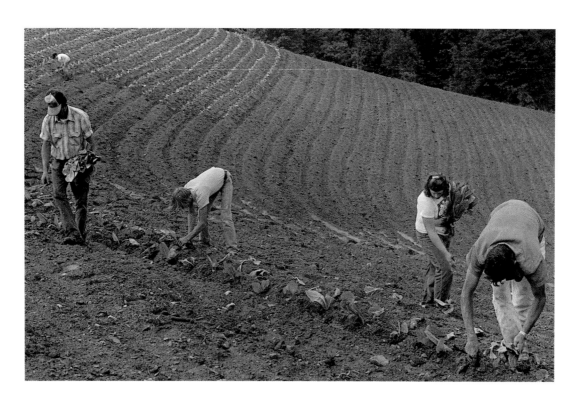

28

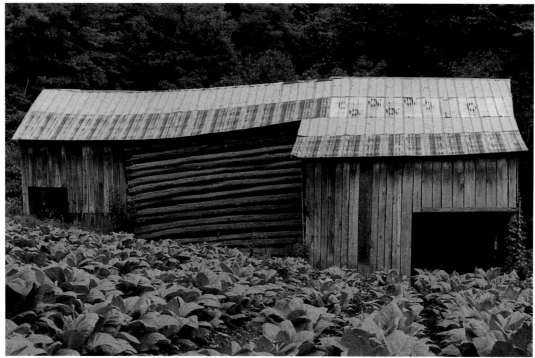

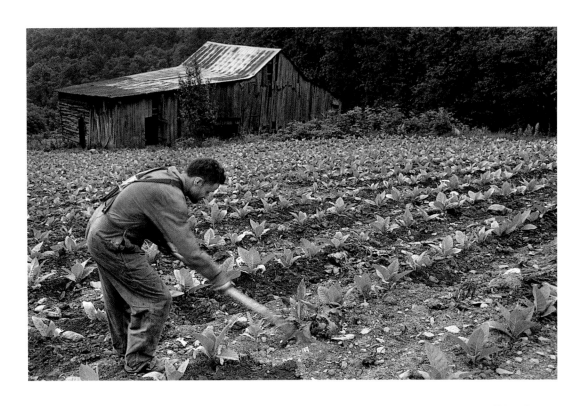

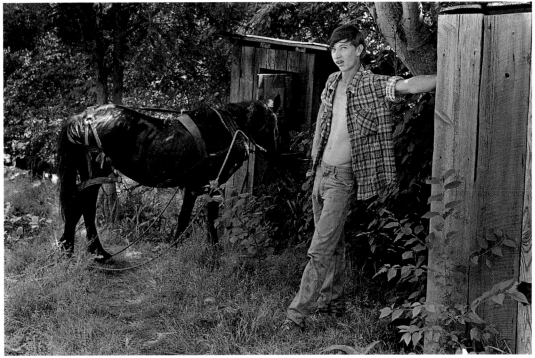

29

DELLIE NORTON I remember the first crop of tobacco we ever made. My daddy made it on Bob Norton's place. I would've been seventeen year old.

I guess my daddy raised two or three acres. They didn't have to have no allotment when they first raised it. They could raise every bit of it they wanted. Then, later years, they measured the land and didn't let you raise but so much according to what land you had. If you had a whole lot of land they'd give you more acreage to raise, and if you had less, they give you less. The government give you so much at the beginning to tend. I think they started us out with an acre. And then they got to giving us a few more tenths at a time till we had pretty good acreage. And then they cut the acreages out and went to giving you pounds. You have to raise so many pounds. That's the way it is now. I think I had sixteen hundred and something pounds this year.

I think a person should raise as much as they want to raise. That's the way I think it ought to be. I don't think it's fair, because they allow some people to raise so much more—they give them so much more than poor people. I don't think it's fair. I think it'd be a lot better if you could raise all you wanted to raise than to give some a little and some a whole lot.

There weren't so many people raising it when it first come out, but I know my daddy raised it. And Bob Norton. And a few more people. I guess they just didn't want to be bothered with it at the first beginning—didn't know how it would go about selling. They found out the next year how people got so much out of it, and then bunches of them went to raising it.

You'd get ready to sow the bed in February or March. You got wood and burnt the ground to keep it from getting weeds in it. They didn't put this plastic cover over it like they do now and gas it. They put a top cover on it and kept it weeded till the plants got big enough. They'd take their ashes out of the stove— they'd burn hickory wood—or out of the chimney—which either one they had. They'd keep the ashes spread over the plants to keep the bugs from eating the plants. After the plants got big enough, you had to have your ground ready. They'd haul manure before they plowed and put it on the ground. Daddy used to have steers to plow with. Plow the land up and then lay it off in rows. Then drop your fertilize, just a little bit about a foot apart. And then make a little hill and wait till it come a good rain and go back and set it out.

Sometimes you'd have plenty of help setting it out, and sometimes you wouldn't have so many. The first year that Daddy raised baccer we had all our ground ready and there come a good season and we set

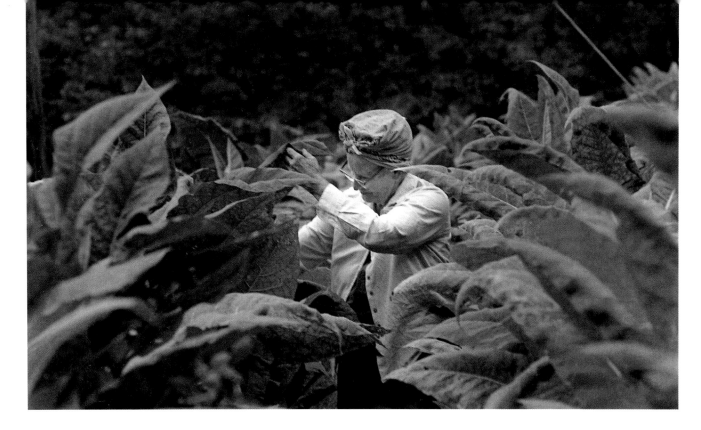

tobacco all night by lanterns. We'd light them lanterns and set them around in the rows as you went and go set the baccer out. We set out three acres that year. Setting baccer is not too hard a job if you're well and young. I could set two rows while some of them were setting one. You'd have someone go in front and drop the plants, and then you'd go right after them. Some of them used a peg or a stick to make a hole, but I never did. I generally just used my hand. After about a week you'd plow it and hoe it. Then you'd let it lay about a week and a half and then plow it and hoe it again. Let it lay that long again if it didn't rain. If it rained and got the ground wet some-times you couldn't get back in it as quick. You'd just have to wait.

The next work you had to do with the baccer after it got big was break the top out of it where it blooms up there. After you broke the top out of it, there would come about three suckers at the top between the leaves and the stalk. It comes a sucker at every leaf, and you had to keep them broke out or they'd prise the leaves off after they got so big. You had to sucker it about three times. The last time you broke them out, you broke them from the top to the bottom at every leaf. Then it would be about time for it to get ripe and ready for cutting.

THREE Generations

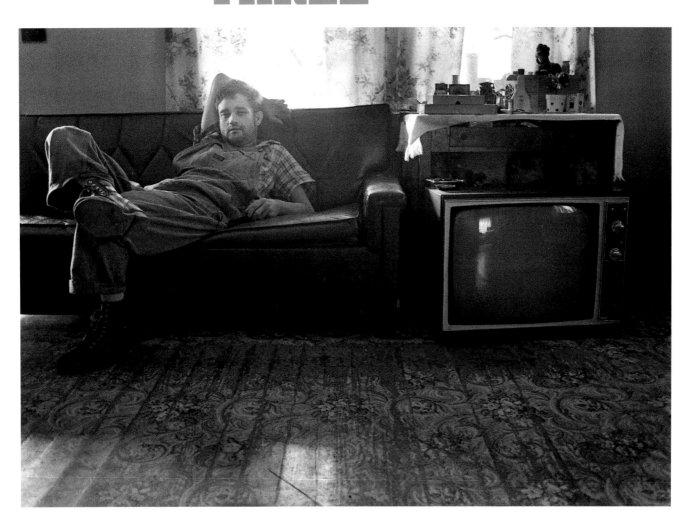

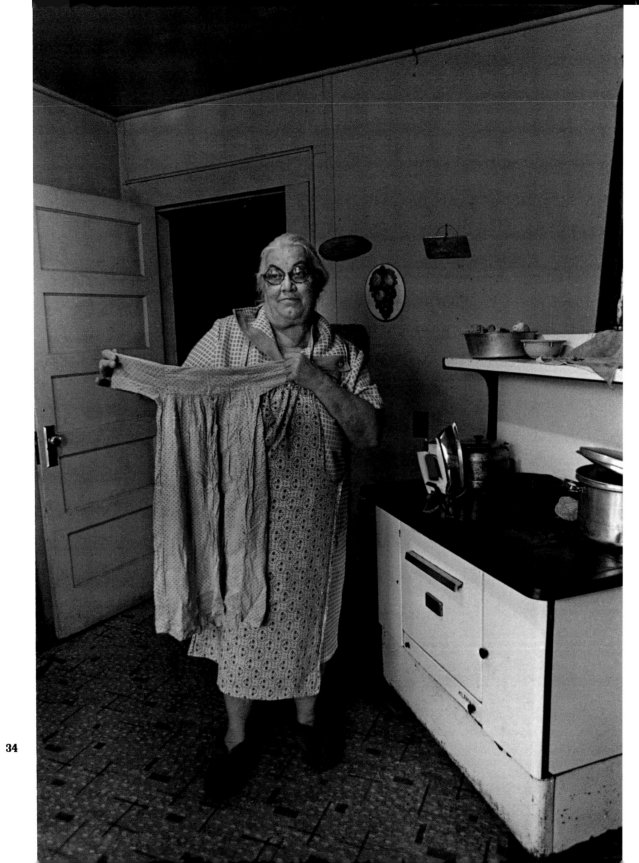

34

ROB AMBERG My friend John Rountree suggested I take more pictures of the kids, the future mountaineers. He said I was "missing so much." I resisted, focused as I was on the past. The wizened, heroic faces. Romantic old ways. The young people wanted the mainstream, access, TV, money, jobs. They wanted what people in the rest of the country already had. They wanted what I had left. Most of them thought a trailer like Marthie and Joe's was a step up. Modern, clean, tight.

Some evenings when I was in Sodom I walked down to the store. Dellie didn't like it when I did. She had said she wanted me for herself, and meant it. Most people at the store were standoffish. They didn't know me and wondered why I would want to take their pictures. Some asked me hard questions about religion and politics. Questions I was reluctant to answer, not wanting to disappoint or offend. The kids would talk about their lives, boredom, a desire to leave Sodom. They rode the bus a long way to school, and the closest entertainment was in Asheville. They asked me if there were jobs up North, and if it was nice. "It's nice here," I answered. "No traffic, no noise, the mountains." Why would anyone want to leave?

The meanness of the place was hard to ignore. Shootings at the store. Blood shed at the festival. Grandsons who stole from Dellie, or woke her in the night, drunk, demanding food and money. And the gossip, the rumors, the ill will, the jealousy. Even Dellie, drowning those kittens in the branch because she couldn't afford to keep them or neuter the mother cat. Had it always been hard and harsh like that?

I told Dellie about going to the Klan meeting, not knowing what she would think. "That's them damn Rebels, ain't it?" she asked. She told me about her granny and her uncles—her granny shot at, the uncles shot dead. "It was them damn Rebels that done it. Shot them like dogs," she said. A troop of Southern calvary had killed them for being Unionists. Dellie's family, like many of their neighbors, had no stake in the Southern cause. "One of them Rebels claimed he shot at Granny Franklin's head five times, like you would a squirrel's head, and missed her every time," Dellie said. "He was talking about it later on in Mars Hill, and another uncle heard him, and killed him over it. Granny Franklin rode a mule over to Burnsville, testified, and kept him from hanging."

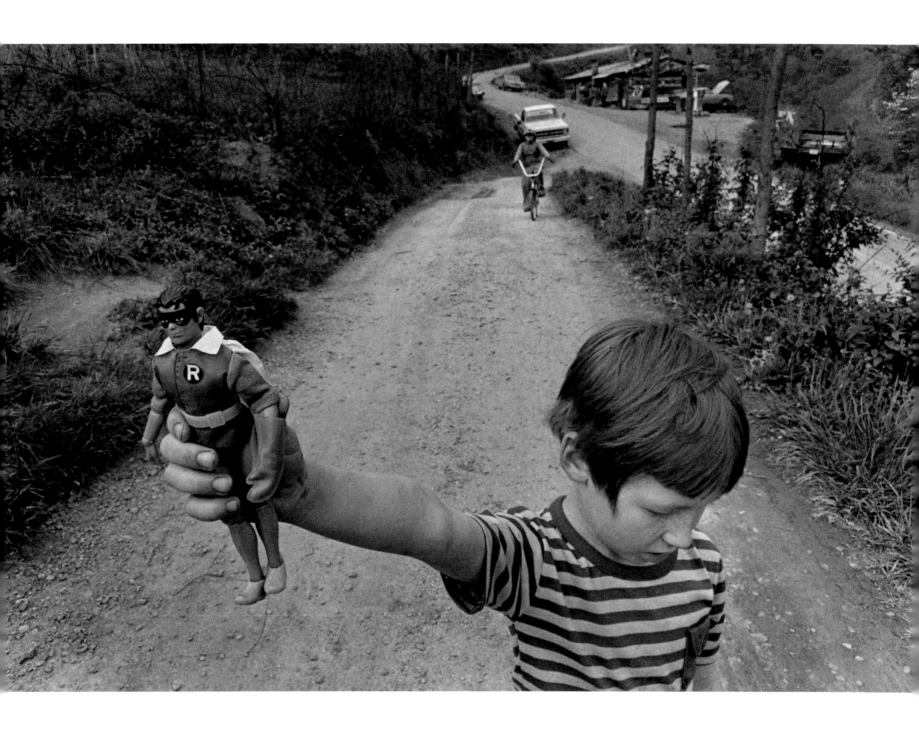

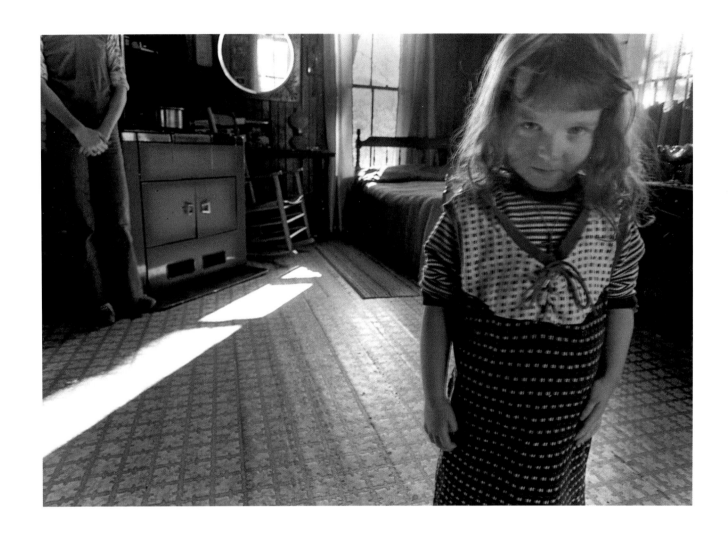

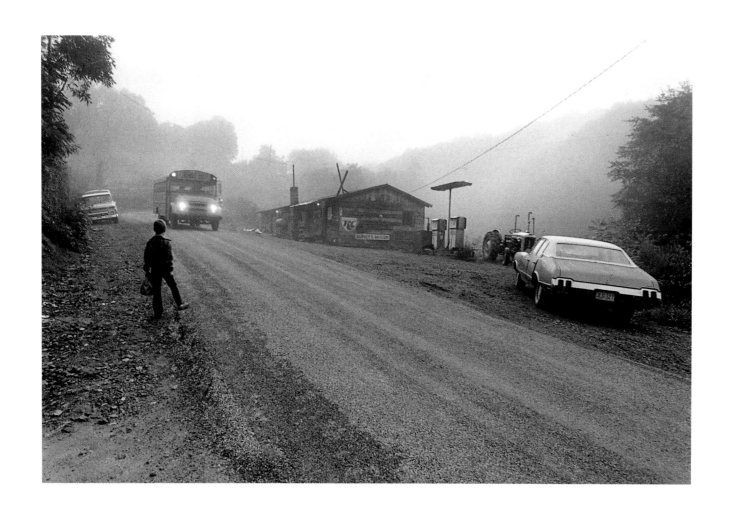

38

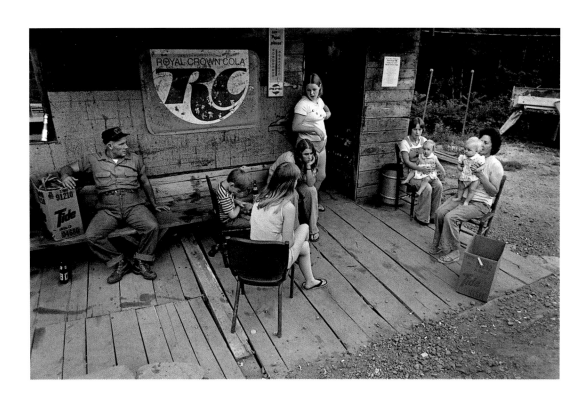

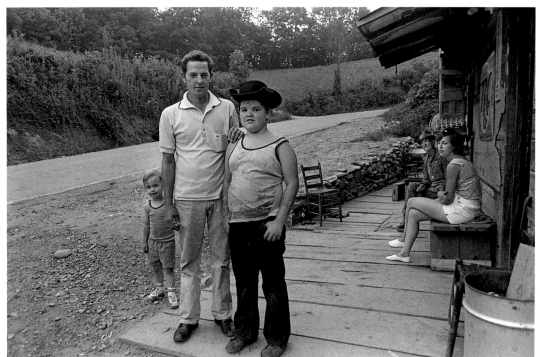

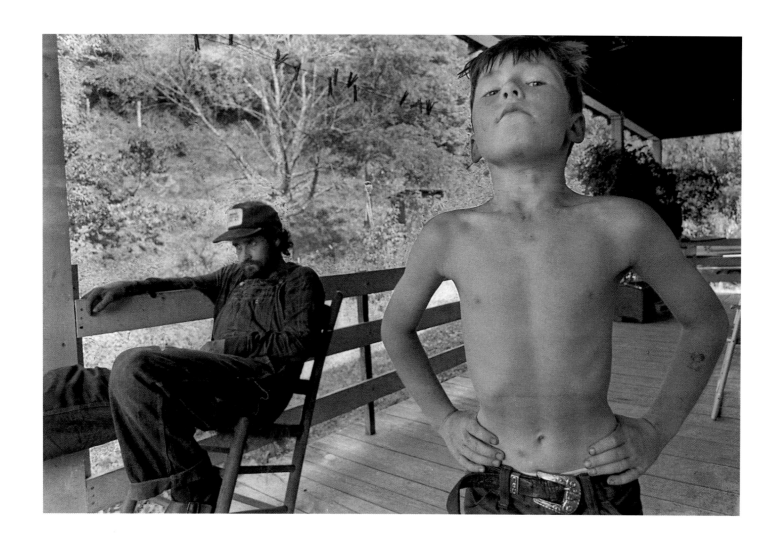

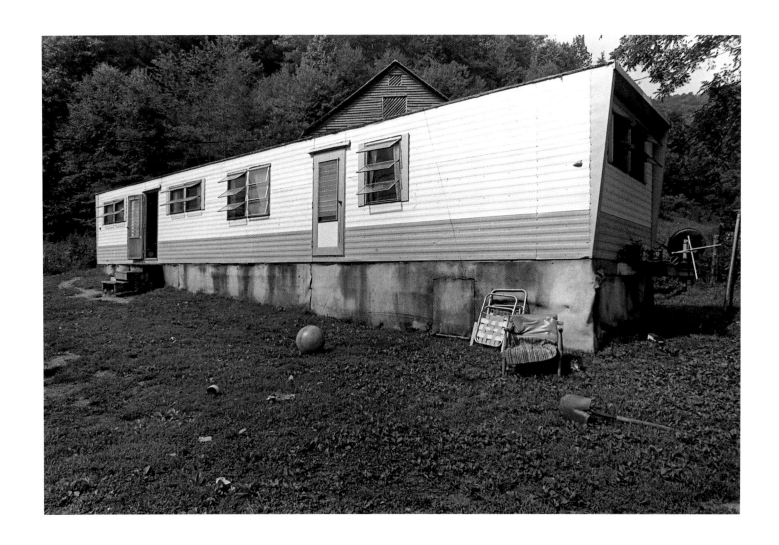

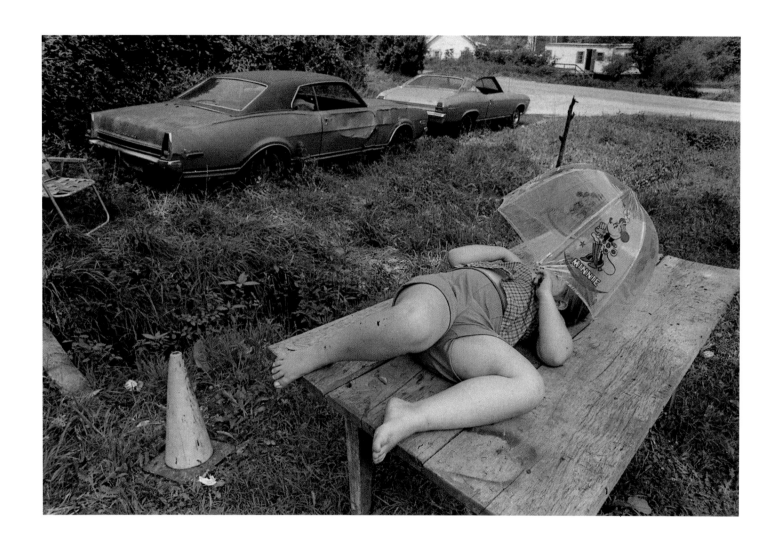

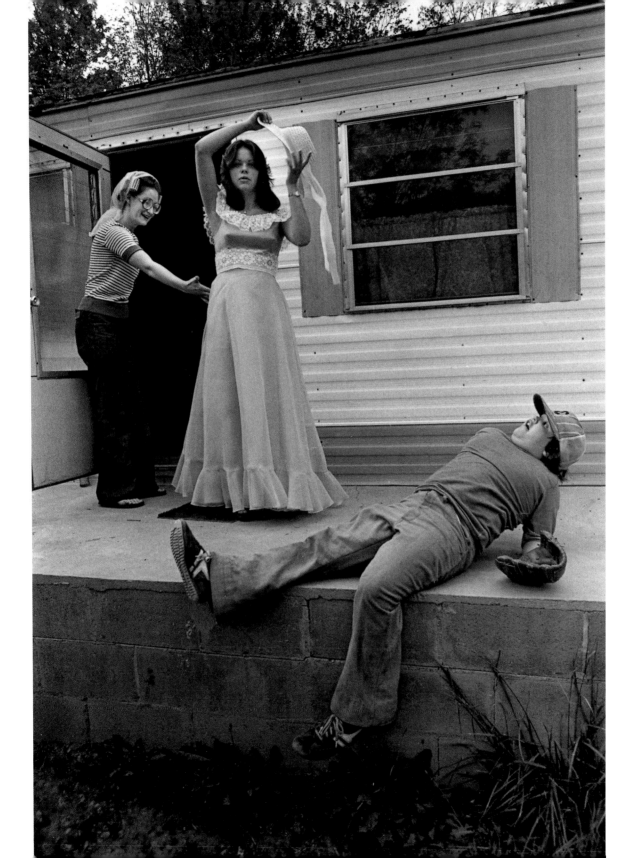

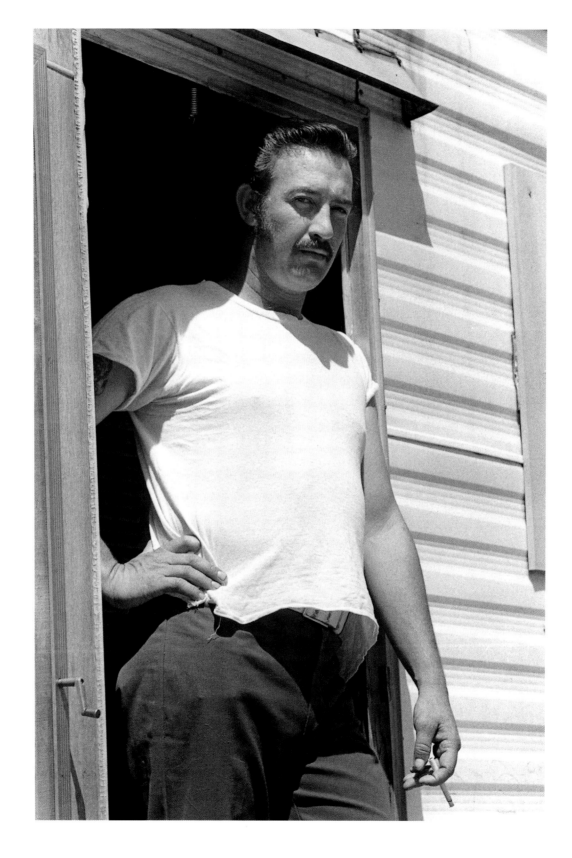

44

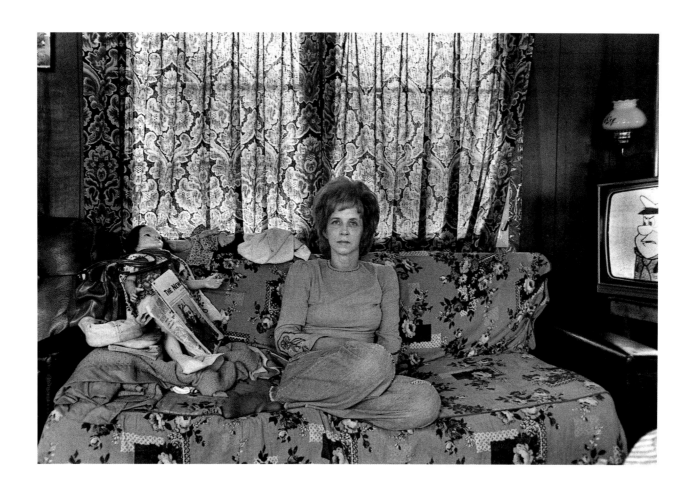

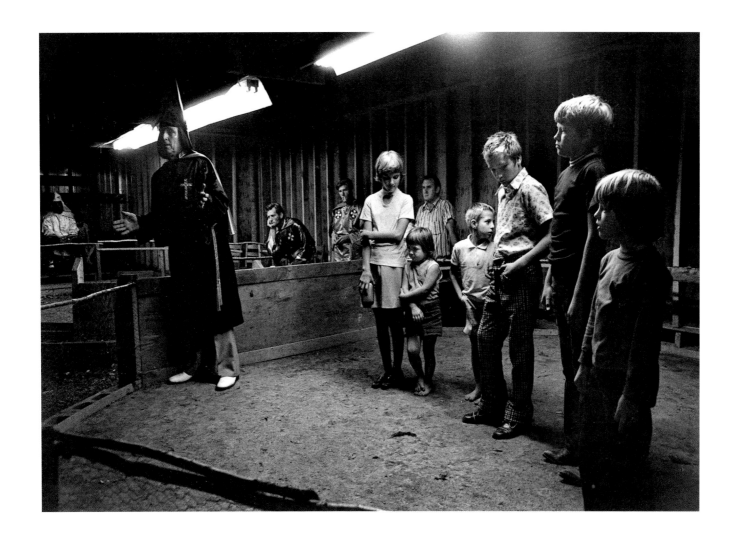

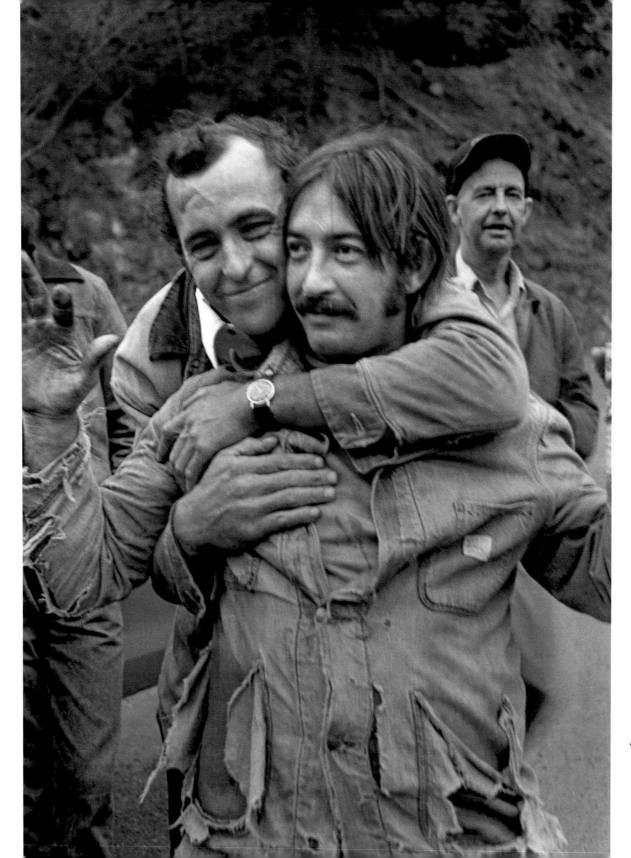

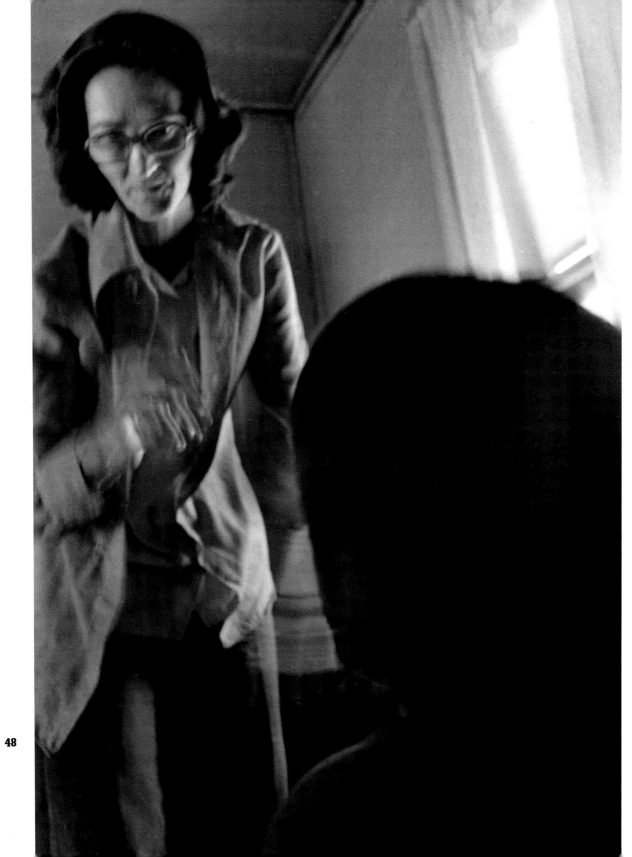

48

TILDIE PAYNE, DELLIE'S MIDDLE DAUGHTER

My daddy logged. We went down to South Carolina when I was nine years old, and he logged down there. We stayed over a year and then we come back over there and we never did move no more. He got pulpwood out. And we raised tobacco down at Murphy Rice's. We raised that whole bottom full of baccer down, you know, where Nori's house is at. We'd rent corn ground from Derb, up in the garden holler. You know where Mary's house is at. Garden holler is to the right. There's big fields in there. I'd stay out of school the first day, first two days of school, and pull fodder every year. Teacher would ask, "Why didn't you get in here the first days of school?" You know they didn't care back then whether they went to school or not. The younguns would hoe the baccer. And if there was weeds, like when I was just little, they'd put me out in front pulling weeds from between the baccer.

He worked hard, Daddy did. He got that pulpwood out. He'd have ricks of that from as far as from Charles's down here. Up in them fields above the house. John Gosnell would haul it down to Barnard, and he sold it down there at Roy Robert's. And when he'd go down there, like they'd go of a morning down there and sell a load, he'd get our groceries and bring them back. Meal, flour. He kept that pulpwood cut all the time. Him and Teat cut that with a crosscut saw. Now, Bill Chandler stayed with us for years too, and he helped Daddy. Daddy'd get people to come in like that and give them so much. Mommy, she used to wash for Nori. Nori give her that talking machine for doing the washing cause Mary wanted it. And Mom would go down there and do the washing. She'd pick beans, dig roots. Daddy did too. They'd go out and dig sassafras bark. He'd take all of us, and Grandpap would go too. You could sell it to the peddler. Or you could take it to Asheville. Mommy would swap the peddler for groceries. She sold butter. She'd take chickens down there too and she'd get groceries with that money. Flour, meal, coffee, lard. Stuff like that that she had to have. We growed a hog a year till the last few years. We had plenty of taters, beans, stuff like that. That's right. No money. Most of the people didn't have no money. They might've had five or six dollars, two or three dollars, something like that, that people lived on. But most nobody didn't have much money. See, money, they didn't even start making money till—what was that old president that was in there? Johnson. I seed on television where they was making money at. Right there was when the money all started coming in here. They put out the Opportunity thing [Opportunity Corporation]. You know, the tobacco was all some people had. And a milk cow. I don't know if I ever seed any hay anywhere. They had to go to Tennessee somewheres to buy it. But now, they got hay fields. Not over there though, not in the Burton Cove.

Back when we was little, Daddy was a hellcat. He came in drunk, and gosh, Mommy had to leave. He'd shoot the house up. He'd come in and grab the shotgun and shoot. He shot in the house. He shot the sewing machine. He didn't shoot at people. He was just, I don't know what it was, he shot through the sewing machine that stood there. Daddy was mean when he was drunk, but Daddy hadn't drunk none in seventeen years before he died. That's right. Mommy would just get up and leave. That's the only thing she could do without getting . . . I don't know what he'd done. I don't believe he'd kill nobody, but he might have and him drunk. She'd go stay with Aunt Mary. She'd take Marthie, the biggest ones, and me and Teat and Mary'd stay at the house. Daddy'd go in a day or two and get her to come back. She done that three or four times, I guess. Most of the time they'd get along pretty well together. That drinking, that's what caused the trouble. He was quiet, Daddy was. Mom, she'd just talk all the time. Dad didn't. She'd just raise quarrels with him sometimes. And Dad was a real good person, you know. After he quit drinking and everything, he was a much different man than when he was drinking. I can barely remember when they raised moonshine. I've seed Nori and Mom, the law'd be coming, and all of them be grabbing them jars and jugs and running out in the baccer patches and up in the woods, setting it around, afraid they was gonna get it. I don't think he was ever catched. I was real little then. I can barely remember when Daddy made moonshine.

My mom, she used to do a lot of cooking. I seed her just stand there and cook all day. Green beans. Chicken and dumplings. Yeah, eating time. That was the best times when I think about it. We'd all be at the table. We had something to eat all the time. Never was out of something to eat. We got down low sometimes. Used to, we'd not have no flour, and Mom would make us some cornbread for breakfast. But not often did we get out of flour. Flour was harder to get or something or another. She'd just make us some cornbread gravy and some cornbread. We'd eat that for breakfast. I thought it was real good myself. Some of them complained. Daddy wouldn't let us get in a fuss or a quarrel or nothing. There was no quarreling or fussing at our table. Everybody went to table and they set down and they eat. I seed Uncle Branscum's younguns get in a fight at the table. Throwing bread and everything at one another. Now we couldn't have done that.

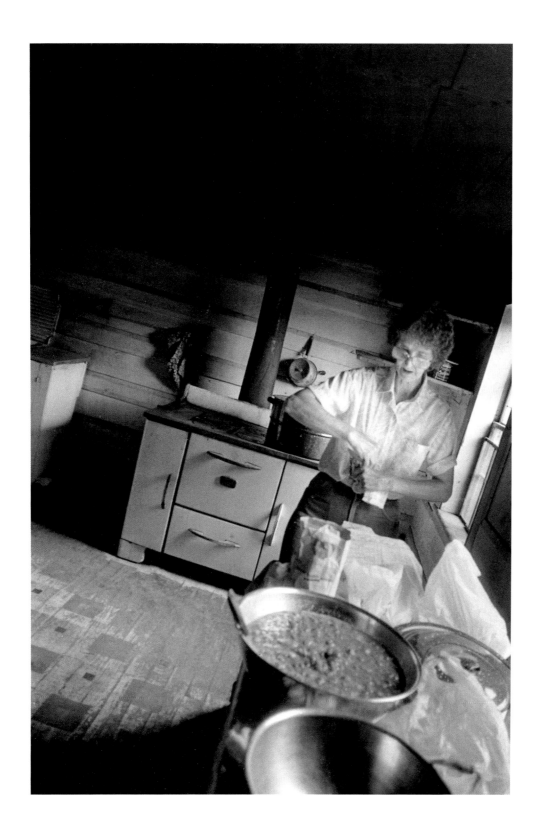

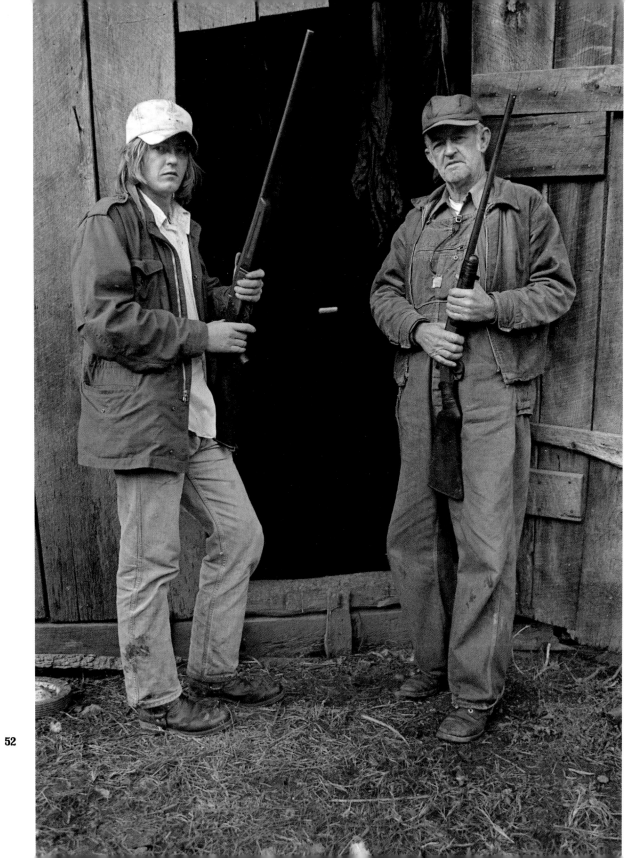

52

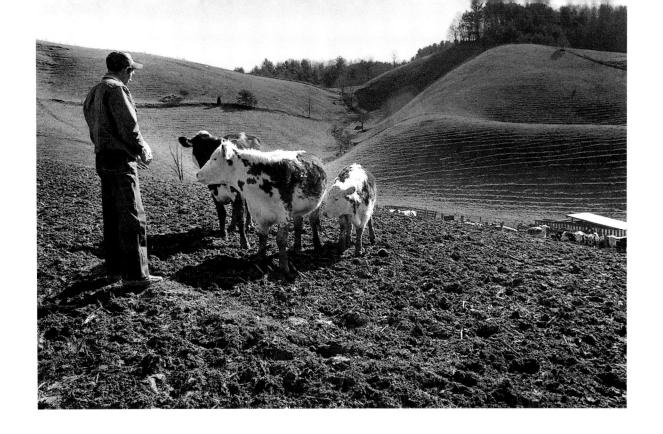

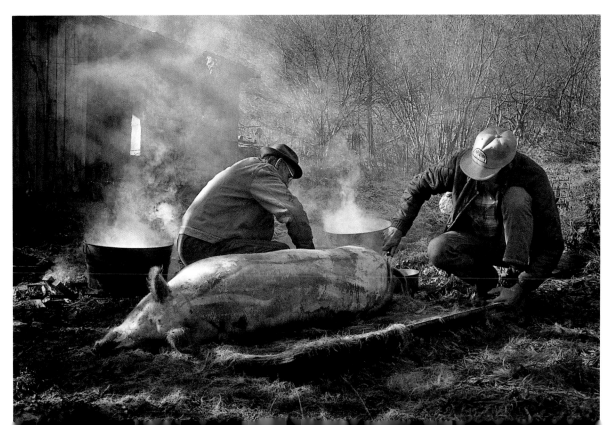

53

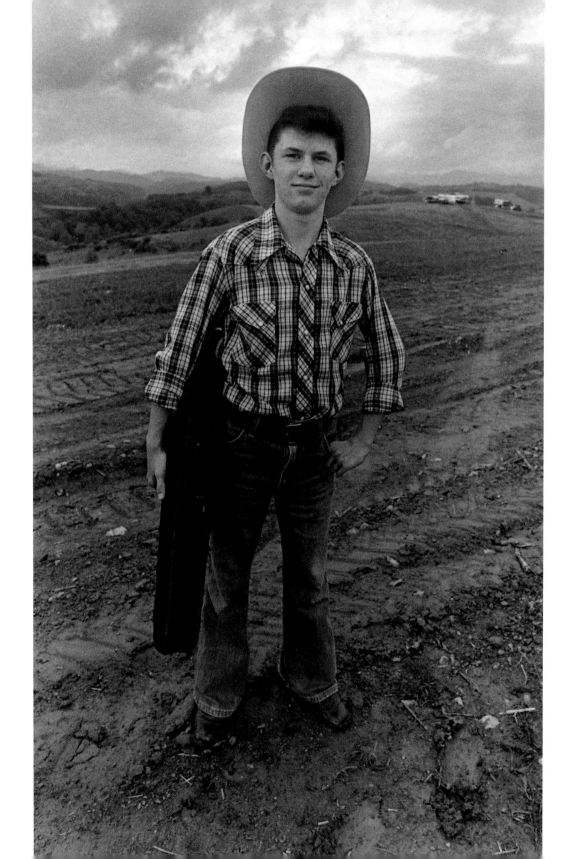

54

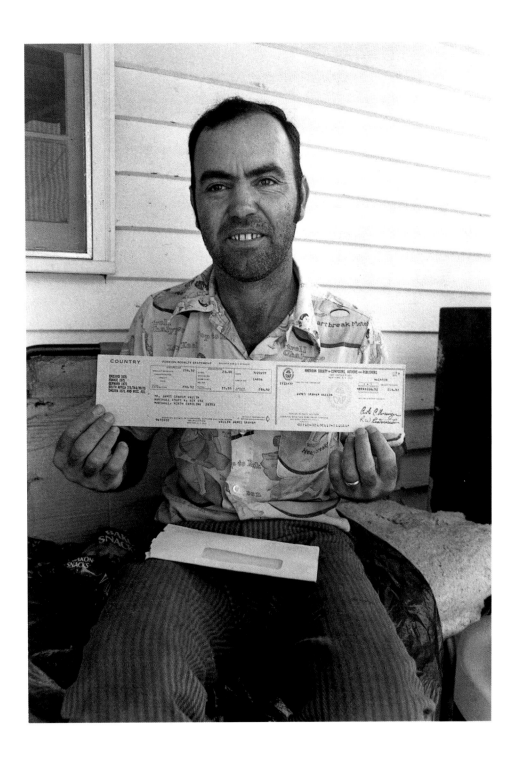

TILDIE PAYNE, CONT'D.

Especially after supper, we'd all get out on the porch, and she'd sing. We'd join in with her every once in awhile. She'd sing "Camp a Little While in the Wilderness" or something like that. Mary'd sing with her. Daddy picked a banjo. He'd get up of a morning a picking that banjo. That's what waked me up of a morning. He'd play that "Francis Edna Joe," and he'd play it slow. Just like he was a talking it. And I know that he didn't know no chords on the banjer. He just picked it his own way, I guess. It'd be four-thirty, five o'clock of a morning. I'd hear Mom get up and scraping that pan. Making biscuits.

We didn't live in the house you seed up there. We lived in a log house and it had two rooms. There was one bed, like right over here, and the table was right over here. The cook stove was right there. And there was a cabinet right there with the dishes in it. And there was a mealbox. Daddy and Mom slept in that bed. And then we had three more beds in another room. There was a wall between them two rooms and a door where you went back through. And then my grandpap, he slept over here. Teat slept back here. And me and Mary slept over there. And then there was another bed, a big bed, if anybody come, they slept there. There was a fireplace and chimney in the big room. And the cook stove was in there too. The heat all went back through there. Daddy'd get up and keep the

fire going. The house was made of chestnut logs, chinked with mud. Red mud as they could get. A rock chimney and a board roof. It was warm. Mom kept it wallpapered. And there was an upstairs in it. It went upstairs. There was some beds up there.

The log house was right below the new house. In the bottom. Earl Ray and his brother, they built it, was up there warming their hands on the chimney when they was building the new house. Warming their hands on the smoke coming out. They tore the old house down, and they built it back to that barn down there. You can see the logs. Daddy built it back beside of it. Everybody else was a building new houses. That's about the time that Ethel and Pearlie built that one down there. We never did have no room, no way for nothing. So, I guess they just thought they'd build a house that had some rooms in it. I'd say it was about '58, '57. I never did live in that house. Maybe it was '56, I guess. Fifty-six or '57 because my dad got his first social security check. You know, he had to pay I don't know how much to social security to get his social security check, and he paid them every month. He took the full amount. And when they sent his check out, it was for two or three thousand dollars, and I guess that was a lot of money. He was going to build a house out of that. And they had cattle too, over there. Back then. I think they had fifteen or sixteen head when he died. They'd get calves and raise them up, and then they'd sell them, steers or whatever.

Me and Daddy was closer . . . he was closer to me than he was any of them. He said I minded better than the rest of them did. See, I was smart. Daddy would whoop them. I seed Daddy whoop Teat and Marthie. You know, they'd just yap-yap-yap, right back at him. Even Mary would. I seed him whoop Mary a little bit. And you know, if he said, "Go get the water in," I'd go and get the water in. If he said, "Carry the wood in," I went and carried the wood in. I'd just mind every word he said, and he never did lay a lick on me. Never did whoop me. He told everybody I was the only youngun he had that minded. He told several people I minded him better . . . if he said to go and hoe corn all day I'd just go ahead and do it. No quarreling back. But Marthie, Lord have mercy, I looked for Daddy to kill her sometimes. She'd slip off. She was just mean, Marthie was. She was gonna do it, whether or not, anything that she took a notion to do. And she'd go stay all night, and Daddy out looking for her all night with other younguns. Slip off. So, he really got rough on her. And Teat would fool around and he'd forget to turn the horse out or go put the horse up or something or another, and Daddy whooped him over that a time or two. But, you know, if Daddy said he was gonna whoop you, he'd whoop you. It might be sometimes a day or two and he'd catch them and give them a lick or two. I'd seen him do that. So I knowed he'd whoop me if I done any-

thing, and I didn't want a whooping. He'd pet Mary. She was sickly, Mary was. She'd always vomit, like Mom.

Me and Robena Adams would go all over them mountains. Robena said lately, "Boy, I wouldn't let my younguns get out like that for anything in the world. Like me and you went through them mountains. I'd be afraid a copperhead would bite them." She said she'd be scared to death if she knowed her younguns was out like me and her was when we was little. We'd go a strawberry picking. We'd go on the Sims Mountain. We seed plenty of snakes, but I'd just run off and leave them. And then if we took a notion, we'd go to the watershed. There was old log houses down in there then. We'd go down there and get to talking about them people that lived in those houses, about the officials running the people out of there, you know. Throwing their stuff out. We'd heared tell of that. They wouldn't want to move, and they'd go in there and throw their furniture out of the house and everything. That's what I've heard my grandpa tell, and Aunt Zip. They'd tell me about it. It's pitiful, I think. We'd go down in them hollers there, and we'd find them old log houses still down in there with the floors rotting out. Sometimes they still had the boards on them. Had the floors in them sometimes. That's why I don't like it here in this trailer. I told Rubin, I said, "I feel like I've got

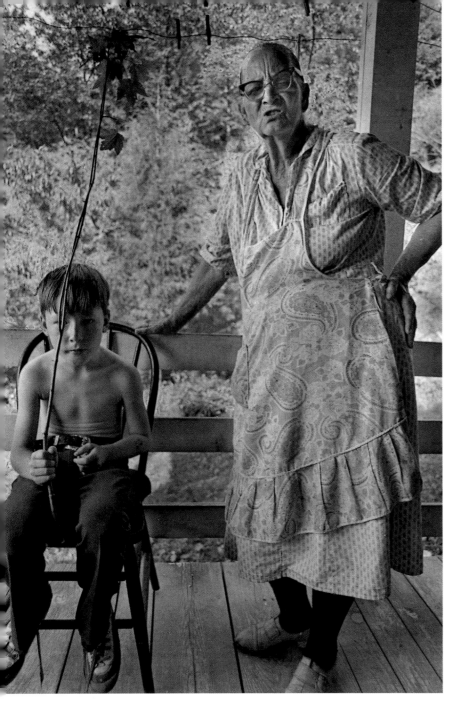

no privacy here. I'd rather be back over yonder or back over there one." But he likes it here. See, he can just get out and hit that road any time. But if you go down in that garden, there's somebody that can tell you about seeing you. Go out in the yard, and you got them hollering and blowing.

The only thing that I worked to do was go to school and learn everything I could learn while I was going to school. And you know that helped a lot. I lost all my friends when I moved out here on the highway. But it was easier. You could catch a bus and go to Asheville or go to Marshall. There was a Queen City run and a Greyhound run. And they'd run like two or three or four times a day. They come from Knoxville, and then they'd go that way. You could catch a bus at nine o'clock through there, or twelve o'clock. Or else you could come back by four o'clock if you wanted to go to Asheville. And you know, you'd see them driving cars and everything, and I thinks, "You can't get nowhere unless you have a car." So I started learning to drive a car. That's when I knowed I could really do anything I wanted to then. The first car I ever had was a '51 Ford.

I always went back home. Not to live. I went back and stayed a little while at a time, but just not to live. I never stayed out of work long, you know, at a time. Maybe like there'd come a lay off or something or another. Most of the time, I just go out and hunt me a job. Sometimes, if I was tired

and wanted to lay around for two or three months, I'd come over and stay with Mom and take two or three months off and then I'd go hunt me a job again. I never had a problem finding jobs.

Troy would want to play fiddle all night. I can show you that too. I got it on tape. You know, he'd sleep all day and that night he'd be ready to go to Hot Springs. You know, that got aggravating after a while. They was making so much noise out there, I couldn't sleep even though we owned an acre of land over there. They didn't care. He wanted a divorce, so I bought a place up there in Rollins after me and Troy split up, and I sold it and bought this place here. I had some younguns with Troy, but they all died. I had RH negative blood and antibodies in my blood that would kill a baby in the ninth month. That's why Glenna is a eighth-month baby. And you know, I'd been to the doctor and been to the doctor, and they never told me that till I was in Asheville before she was born. 1972. Right then, that's when I started. When I went back to work, every nickel that I had left over I'd put it in the bank, and forget about it. Yeah, I knew that if I didn't try then, I wouldn't. I wanted education for Glenna, most of all. Glenna turned out just the way I wanted her to be. She done just like I brought her up to do. Quiet, and easy, and not never say nothing about nobody. Or never do nothing wrong. That's the way she seems to be to me. I always teached her that. She loves her job. I bought her a new car when she was sixteen. She had her driver's license. No, I got her the car before she got the driver's license.

We just grow half the garden we used to grow, just half of it. I bought a new freezer back when I first moved here, and I just keep the freezer full of vegetables. Corn and stuff. But now, just about half of what we used to. And we don't need it all that much. Course Glenna comes about, she takes stuff out of the freezer. She gets taters from the basement. She gets canned stuff. I doubt if Glenna could grow a garden. She might see me plant a few beans, stuff like that. It'd have to be an awful little one if she was to plant it. I used to make her go down and help me hoe and stuff like that. She didn't like that either. She likes to eat though. But Glenna, she has seed us plant taters. Since she's moved out, I tried to get her to plant her some tomatoes over there, and she says, "Aw, you'll have plenty of tomatoes. I ain't going to fool with them." This year we didn't have none. The blight hit them. Mine just had come in and that blight hit them, and they all just fell off on the ground. Just like you had poured hot water on them.

FOUR Harvesting Tobacco

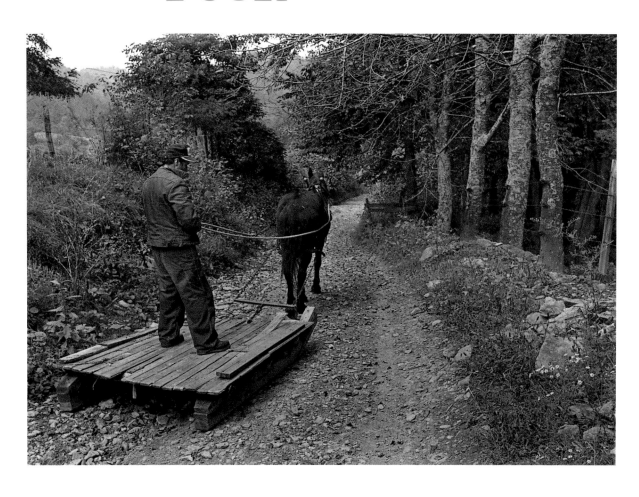

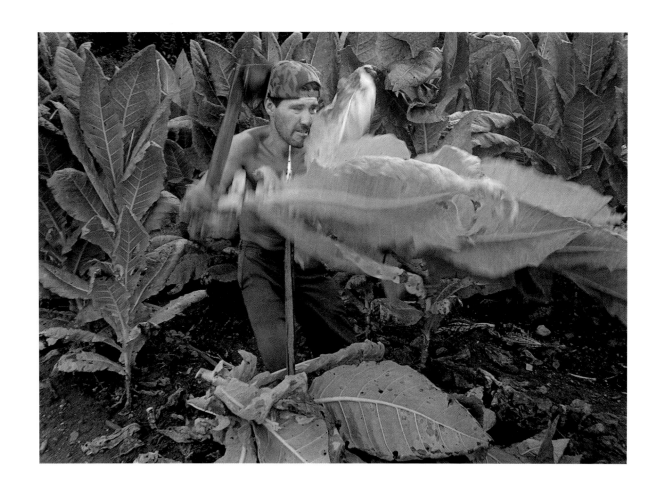

ROB AMBERG A small group of Dellie's relatives and friends got together one Saturday to help her and Junior hang their tobacco. It was a group effort, and the time went fast. Dellie fixed dinner (her word for lunch) for everyone and was relieved to get the tobacco in the barn. It had threatened rain all day, which would have muddied the leaves, made them harder to move, and lowered the price.

Junior and I went to work tobacco with their neighbors, Rube and Dustin. The field was still wet with dew when we got there, but it was soon hot. We spent all day in the sun. Backs bowed. Our hands black and sticky from the tar. Lunch was beanie-weenies, crackers, and cold drinks from Rube's store. The afternoon was harder and hotter still. Always another plant, another row. We stopped for supper, and then we hauled tobacco to the barn by moonlight. We hung the tobacco in the tier poles by the light of a hundred-watt bulb. Fourteen hours. Two dollars an hour. Twenty-eight dollars. It was midnight when we got home. Dellie was furious. The next day when they came to pick us up, we asked them for more money. They said, "No, two dollars is what we pay." So we stayed at the house.

Part of my reasoning for doing this hard, dirty, low-paying work was to learn about the culture and the people, and part of it was wanting to be of help. If I was asking people to open their lives to me, the least I could do was try to help out. But there were other, less well-defined reasons. My fantasy to live in the mountains and be a farmer. My need to prove to myself I could do it. There was a recognition that my life had been easy. I wanted to do something hard and different than what was expected of me. I didn't want to imitate Dellie's life, but I thought I could learn and even adopt some of her attitudes and ways of living.

Coming back from Hot Springs one day, I saw a family hanging tobacco in a barn up on a hill. A husband and wife, three or four children, a couple of neighbor men. I stopped and asked if I could take pictures while they worked. They said it would be OK, but when I pulled out my camera they stopped working and posed. It didn't seem to be going anywhere, so I put the camera down and helped them hang a truck load of tobacco. We talked while we worked, found out we knew some of the same people, and the work seemed to bind us. When the next load arrived, I picked the camera up again; they ignored me and kept working.

Now, all that hard work is done by Hispanics. The local people won't do it, and the farmers prefer to hire the Mexicans. They are fast and good and they work hard. I went to photograph a crew of migrants cutting tobacco up in the Spillcorn community. Drove up a deep holler, past the junk cars, trash piles, and old men, who seemed to stare out at nothing. I opened my car door to mariachi music, a dark woman making tortillas over an open fire, and men speaking Spanish.

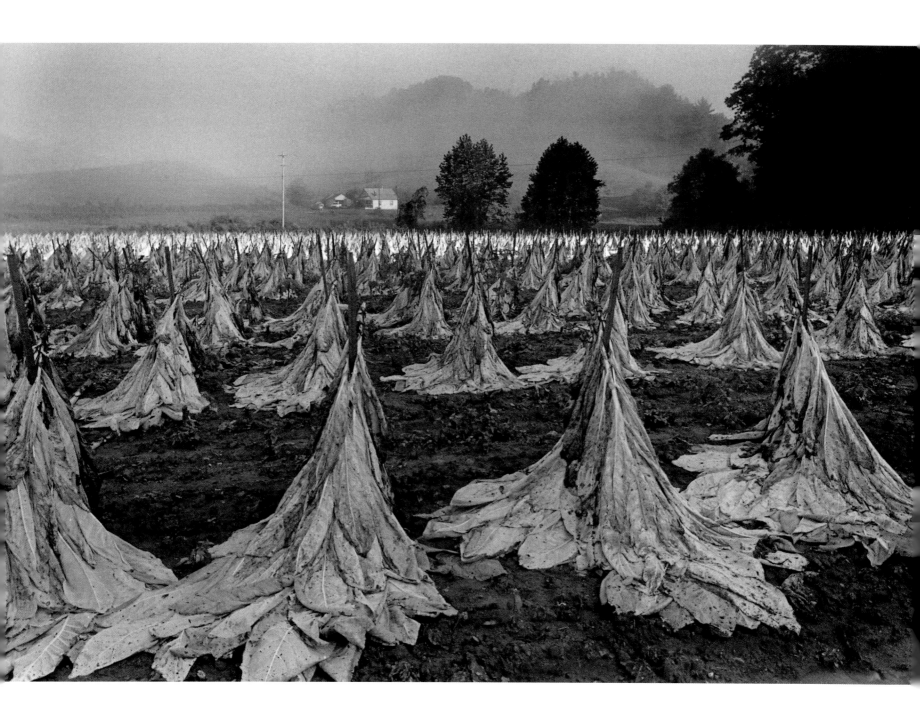

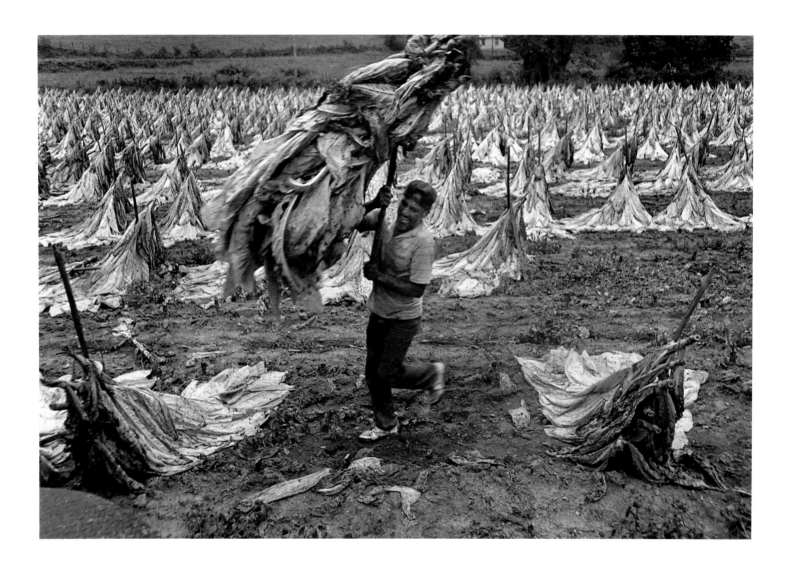

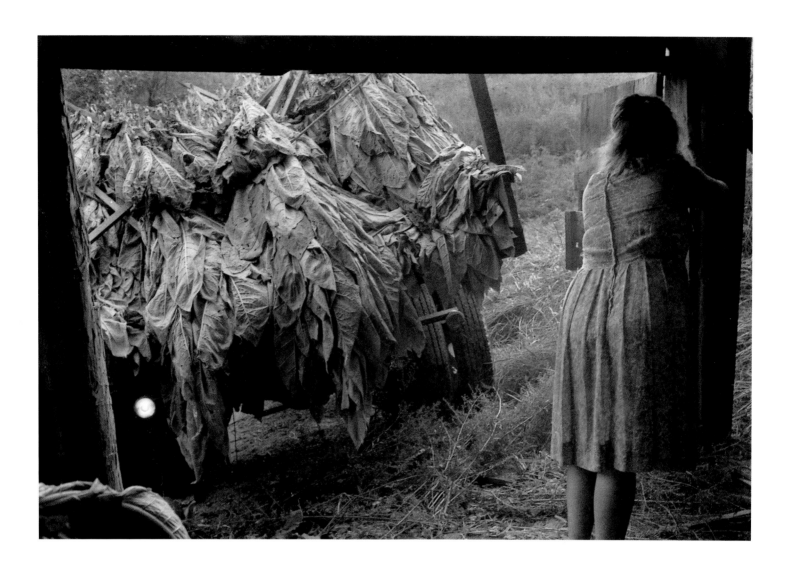

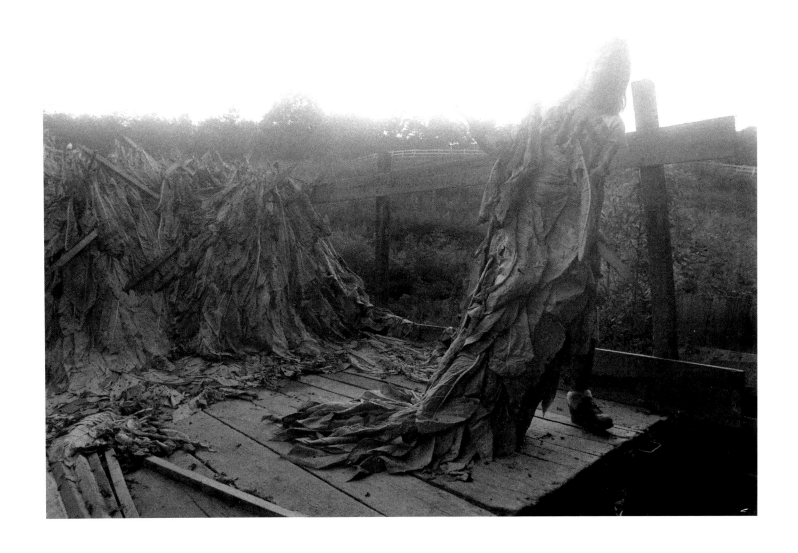

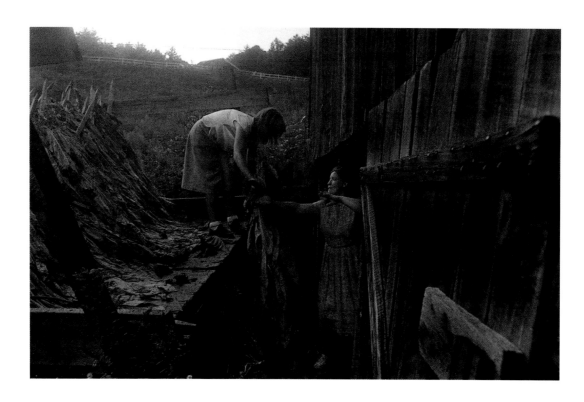

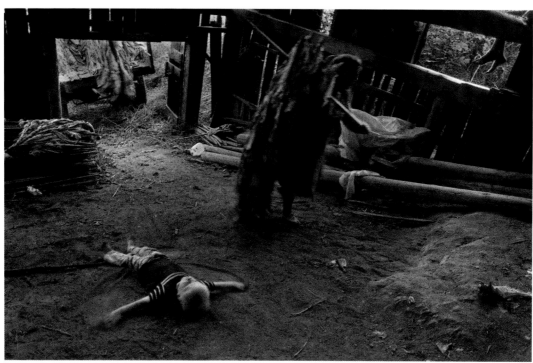

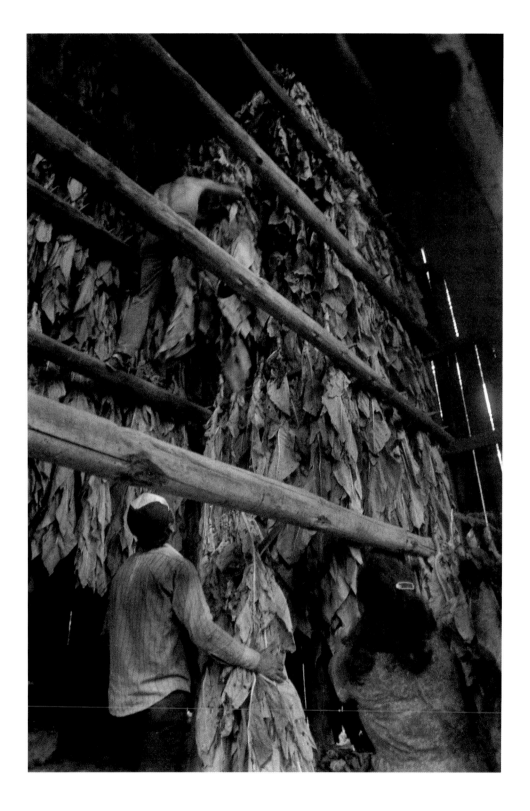

69

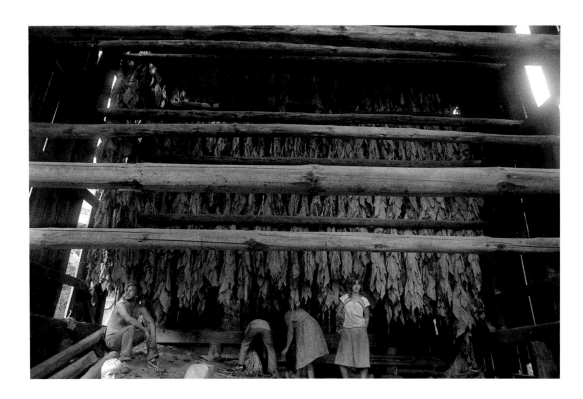

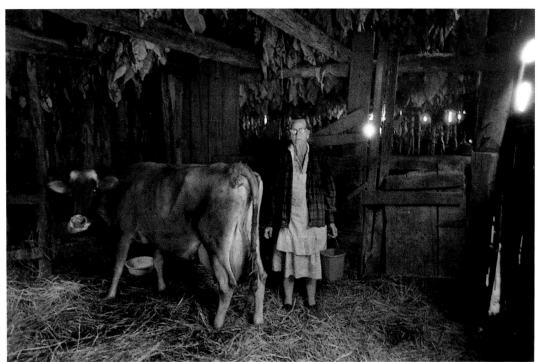

70

DELLIE NORTON You'd split it right down through the middle of the stalk with a little bac-cer knife. They had knives made specially for that. Then you'd string it on a baccer stick and haul it in. Six, seven, eight plants on a stick if they weren't too awful big. If they were too awful big, we'd put about five, so it would cure good. If you scrouged it, it would scald and wouldn't cure out good. Too many plants on a stick.

If you didn't have barn room, you had to go in the mountains and get you big poles and make scaffolds, and most of the people done that to make the baccer that much prettier. It'd cure out on those scaffolds so bright. If a rain come, you had to put that baccer in the barn and fill the scaffolds back again with baccer.

We had to work at it, but the people up here liked to do the work. They was getting some pay out of it where they couldn't get no pay out of anything else back in them days. It was really good that they could find something to make money from. You had a hard time getting money. There weren't many jobs to make no money at, and if you had to work for somebody, you just got a dollar a day. That's all a man got back when I was growing up, a dollar a day if they could get that. They worked from about seven in the morn-ing till six at night.

I guess I was about eighteen years old and I rented an acre from a man—we lived on his place—I tended it by myself. Right up here in Sodom. All by myself. Daddy plowed the ground, but I cut the baccer and hoed it and set it out. I cut it and hauled it in with a horse and hung it myself. I think I got a hundred and something dollars. It didn't bring too much, my part of it. I think I got maybe a hundred and fifty dollars. It was really good baccer. I went and bought me some nice dresses, first one thing and then another to wear. I weren't used to having no money myself to get nothing with. And I had the money then, when I made the baccer, and I could go and get anything I wanted to with the money till I spent it all.

FIVE On the Porch

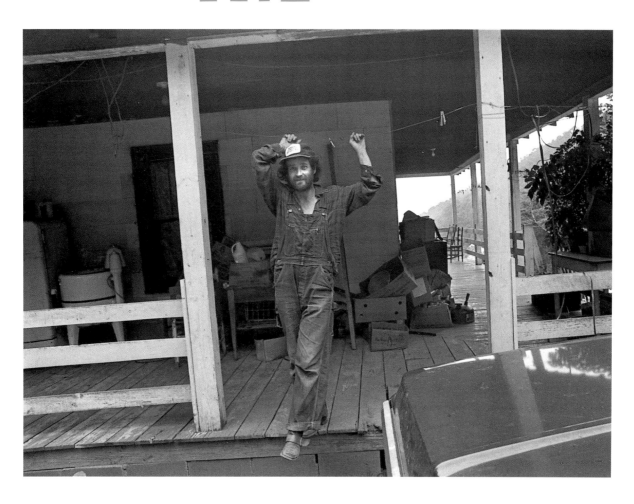

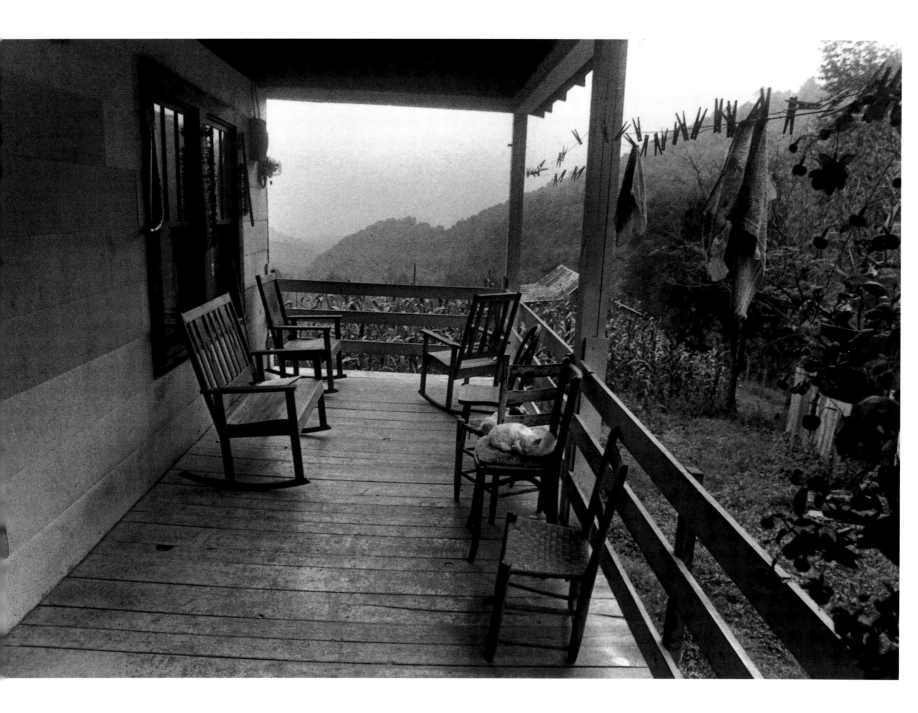

74

ROB AMBERG On most evenings we sat on the porch. It was always quiet. A breeze blew cool after hot days. On moonless nights the sky was the darkest I'd ever seen. We could see a single artificial light, far away. Dellie said it was Earl Rice's store. Sometimes we would string beans or cap berries. Dellie would sing and tell stories of growing up in the mountains. I would tell her about growing up in the suburbs. Mary and AB, or Marthie and Joe, came up often and we would play setback, taking turns sitting out so everyone would have a chance to play.

On many Sunday mornings we would wake up to find Willie sitting on Dellie's porch. Dellie said he was her boyfriend although he was at least twenty years younger than she was. He wasn't happy that I was there. Dellie said he was jealous. Dellie would fix him biscuits and gravy for breakfast, and they might drive around for the day and visit people. She said he wanted to marry her, but she was adamant that she would never be bossed by another man.

That first summer I was there, a man named Allen Miller came to Sodom from New York to film part of a movie on American music. He negotiated with Dellie and the other singers for days, eventually paying people equal amounts so no one would get jealous. He made sure everyone was included who wanted to be. He arrived at Dellie's with a crew of five and two rental trucks full of equipment that barely made it up her driveway. Dellie sang "Young Emily" while sitting in her favorite chair with a backdrop of mountains. Miller had her do ten or twelve takes of it until she finally said she wouldn't sing it again. Sheila sang "Black Is the Color," walking barefoot through Dellie's snaky, rocky pasture, wearing a long flowing dress. We told him it was unrealistic, that no one would walk around barefoot like that, but reality wasn't his concern and he shot the scene his way.

Other people would often come to visit on weekends. Peter and Polly Gott and their children, Susie and Timmy, would come to play music and pick cherries. Dellie's stepdaughter Bonnie and her husband, Doc, would come from Tennessee. They would bring food and visit, play cards, and reminisce. Sometimes, strangers would come. They would camp in the yard for a couple of days and ask Dellie to teach them music and tell them stories. Children and grandchildren were always around, helping Dellie with work, a part of the routine.

Dellie was related to most people in Sodom, often on both sides of her family. She knew everyone in the community and their ancestry. She was born a Chandler and married Ross Norton. Her daughter Mary married AB Norton and remained a Norton. Two of Mary's children married Chandlers, another a Norton. Dellie's daughter Marthie married Joe Chandler, and one of their daughters married a Norton. Most of Dellie's grandchildren married within the community. It was hard not to. These were the people you saw every day. The people you grew up with. The people who knew you best. The community held you and made it hard to leave.

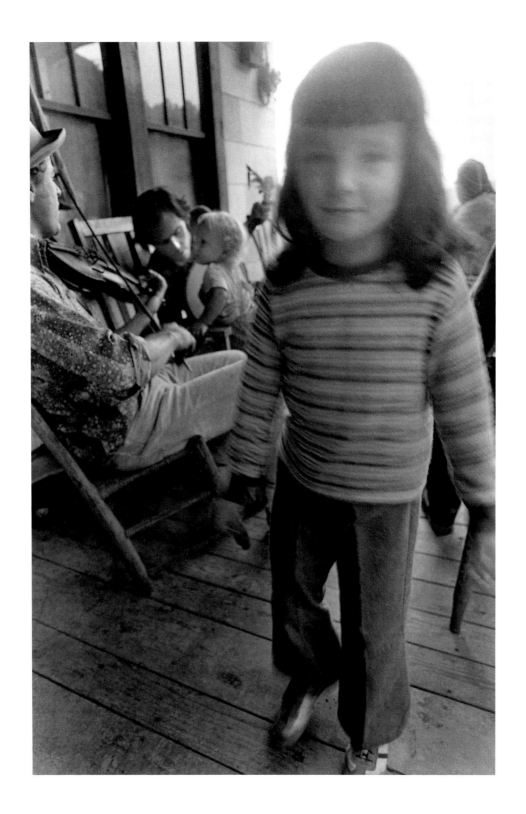

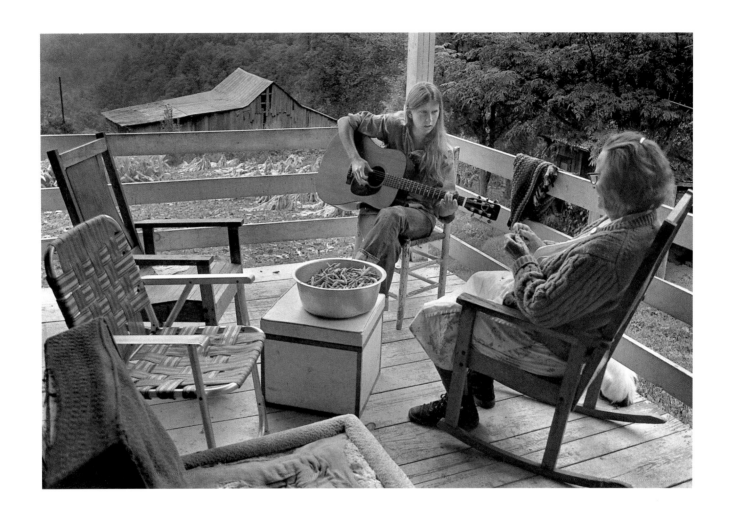

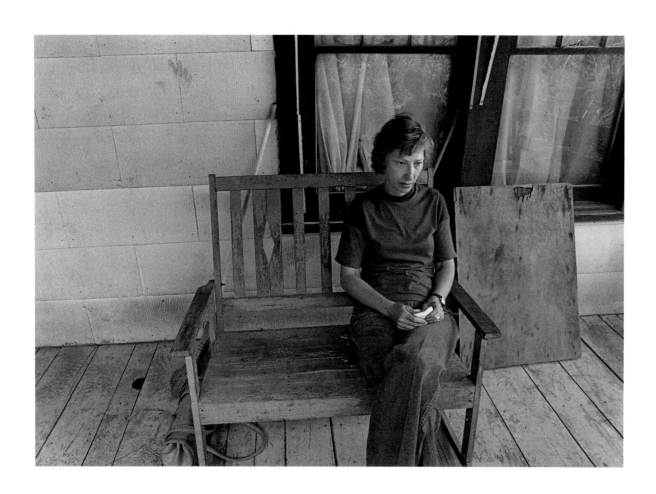

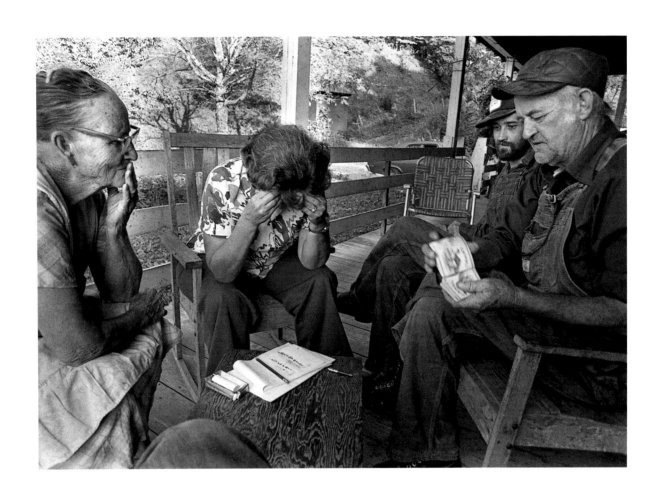

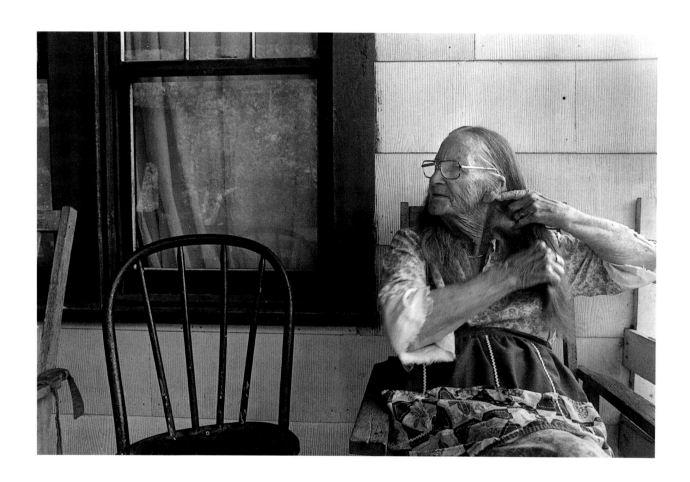

DELLIE NORTON

After I got so old, I wanted to get out and go places. Get out from here. So I did. I was about eighteen, I guess, when we moved to South Carolina, and I got a job in a factory, spinning. It was a big place in Whitney, South Carolina. There was all kind of different jobs in that factory to do, but I was just spinning. You got paid for what you done. Sometimes I'd get more than other times.

They wouldn't let you work unless you was so old. I think you had to be over thirteen. They wouldn't let you come in at twelve years old. There was plenty of boys and men. They had to handle that heavy work. Doffing, I think they called it. Roll in them things that they put on the spinners. They'd put them spools along your frames. We went down there on a train. First train I ever rode. I liked it. It was pretty well full. And it was pretty well full as we come back. They was lots of people that went out to get jobs. There wasn't no work here to do. Dave Norton's family was down there. I remember Joe Sams and his family, they was there too. They lived at Marshall, and they went to South Carolina at the same time. They stayed on.

There was no work much you could do around here unless you hired out in the fields to make a dollar. Some people would hire you, but they'd just give you fifty cents a day or seventy-five. I never did get over a dollar a working in the fields. Women had to leave out if they got any work to do, unless they got plenty of learning and they could teach or something like that. And the girls around here that made teachers, they had to go way off to make teachers. They'd pay their way, partly a working to pay their way to get to make teachers. Bob's girl, Nepal, she went back in towards Asheville in there. I think the Presbyterians probably got her in. And Berzilla's girl too, Jessie. Jessie went to Dorland Bell in Hot Springs.

Well, I liked it in South Carolina awful good at the first beginning. I learned quick, and I could just go on with it. That boss man said I was the best hand he had in there. But it didn't agree with none of us there. The water weren't no count, and Daddy left us there. He didn't like it at all. He worked a little while there, and then him and my oldest brother, they left. They left me and my mother and Lizzie Thomas and my sister, Berzilla. And them people at the mill tried to get us to stay on. They said we could stay on as long as we'd work. They was three of us working in there, me and Berzilla and Lizzie Thomas. Berzilla was married, but her and Lee had parted at that time. Monny, her oldest child, weren't born then. They stayed parted I don't know how long.

It didn't agree with none of us. It was just like summer there, and we come back here, back to these mountains, and the snow at the foot of these mountains was knee deep. And the flowers was blooming there when we left. I think we moved back in February, and the snow, Lord, it was one more sight. And they had,

they called them hacks back then. We hired a hack in Marshall, and they couldn't come only to the foot of the mountain over there, and then we had to walk on in. We shipped our stuff so we didn't have nothing, only what we had on. Lord, I thought it was bad. That snow was one more sight. Liked to froze to death before we got somewhere where we could warm.

I believe we moved right into that house on Bob's. And we didn't stay too long in there. I think we made one crop, and then we went to New River, Tennessee, to get work there. My daddy and brothers worked at the logging jobs. Me and my mother cooked for a contractor.

My whole family lived up there. My daddy didn't stay with us. He worked in the other holler. They called it Camp 20 over there, and that was the main job. There was two or three places, but the main one was at Camp 20. There was men that cooked over there where my daddy and two brothers worked. Me and my mother cooked over in the next holler for King and Shay. They was from Knoxville. You hardly ever seed them, only on Saturday. They'd come back there to boss. They took a contract to get the timber out on the other side where we had to stay.

The work was hard on the men. It weren't too hard on us. I'd plan ahead and make my pies and cakes, keep my taters and beans fixed, you know, so I'd just have them handy. Cook them up. They'd bring our groceries up on the log train. They'd take a load of logs back, and all we had to do was make a note of anything we wanted, and as they come back, they'd bring it. We didn't have to pay a thing for nothing we eat, and we could get anything we wanted that they had from the commissary. They had a big commissary on down about a mile. All you had to do was to hand your paper out and write it down for anything you wanted to eat, and they'd send it up to you on a train. They furnished everything you'd cook, and we didn't have to pay for no board or nothing. That's the way the job went. We were cooking for twenty-five or thirty men.

It wasn't too bad. They didn't drink too much. Now they might've over at Camp 20. There's where all so many men were at. This was just a contract job where me and my mother cooked at. There weren't so many men there, you see. At Camp 20, they had a real bunch of men there. I never heard Daddy say that they had any rough times or anything. They'd joke and tell stories and play cards and such like that.

I fell in love with one. Jack Edwards. He come back home with me when we come back, but me and him got into it and he left. I didn't care. He had come back here and stayed about a year, but me and him got into it and I don't know where he went. Never heared from him. He was in the army before we was at New River. Somehow or another

he got out and worked on a job. He helped me every day to cook. He drove a team, and he'd be in by four o'clock, and he'd help me fix beans, peel taters, anything. He was a good cook, like you.

Jack Edwards. I haven't heared from him in many of a day. He was working on the logging job on Spillcorn, and he told me that Sunday, he said, "Dellie, I ain't a gonna be back on Sunday. I'll have me another girl." So, he had bought him a new pair of these cutter shoes, and sure enough, they ruined his feet, and he didn't come back. The following Sunday I had me a new boyfriend when he did come back. He destroyed everything he ever give me. He had bought me a guitar, and he busted that all to pieces. Me and him was engaged to be married, and he had bought me a wedding ring. He took it and give it to another girl. He said he was just joking me about the other girl, but I didn't believe it at the time. We had a lot of pictures, and he took every one of them.

There was all kind of families moved in there to get work. Champ Ray and Lili, they lived there, and Lili and John Ramsey, I knowed them, and Cleophus and Laurie. They lived right against our house. They moved the houses on the log train when you had to move. When one place had been logged, you'd move on to another.

There was trees in that mountain, that was one more sight. They had the biggest trees in there you ever seed in your life. It had never been cut. Poplar, locust, most every kind of tree that growed. I never seed no trees around here grow as big as them. Me and my mother would go in the mountains sometimes hunting for ginseng. There was wild hogs in there. We seed a big bunch of them one time out in the mountain. They was scared of us and run the other way. But I was scared of them.

When we moved over to Camp 20 I come back home. I didn't like it over there. I just stayed one night at Camp 20. It didn't look to suit me. I left Daddy and Lloyd and Branscum and my mammy there, and I catched a train. I had two sisters that lived here. I stayed some with Mary and some with Berzilla. Tildie, Mary's girl, she was born, and I stayed some with her until she got stout enough to work. And then Jessie, Berzilla's girl, she was born, and I stayed with her until she got stout enough to do her work. I never went back to New River. Lord, they said it came a flood and said they was ditches in there, right where we lived, that was deeper than houses. Washed that whole place out right where we lived. Said it just swept that place out in there. I told them I'd like to went back just to see it, but I never went back.

Daddy, when he come back from New River, he bought him a mule, and he bought that old rock cliff mountain up there. He never went back to New River after he come home. He did work over in Spillcorn. I don't know how many miles that is

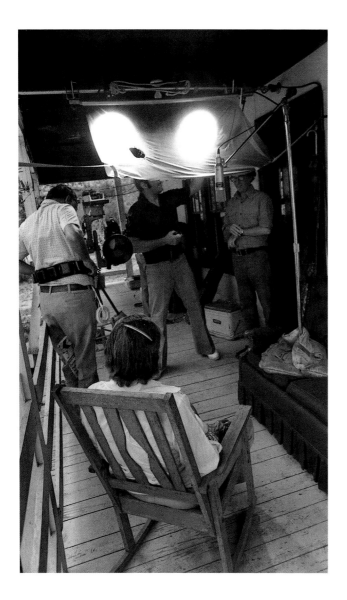

from here. It'd be a long way to walk, but they had to walk back then. I guess they'd start in of a Sunday and get in against suppertime. Branscum and Jack and Daddy all worked there.

Guy Roberts owned these mountains, just about. There's where Daddy bought his old place up there. There was a sawmill, and they logged this place out in here. They sawed the lumber and hauled it out on wagons. They had these teams of horses. Ray Cantrell had two big sets, teams. He had a pair of mares, and then he had a big pair of mules that he logged with all over them mountains. There weren't no chainsaws then. They sawed them down with crosscuts. Two men, one on each end of the saw. There were some big trees, big poplars and big oaks and all kinds. Guy Roberts sold the land to them. I don't know where those people was from that had the sawmill. I know one stayed with me. Joe was his name. I boarded people then. I was married. I don't know where he was from. Bonnie and Betty was young. I didn't have no children of my own then.

That was about the time people started raising tobacco. I'll tell you why I remember. They got a fire out at the sawmill and burnt up a barn of tobacco. That was Daddy's baccer. Killed one of his hogs. Burnt the saddle up in the barn. We had raised some tobacco before that down at Bob's, but by the time they had that sawmill in here, Daddy had bought that land and he raised baccer on his own.

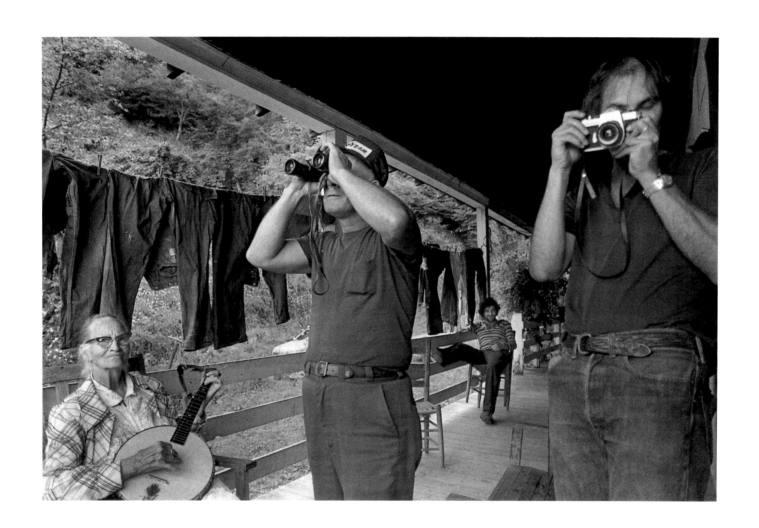

SIX With Junior

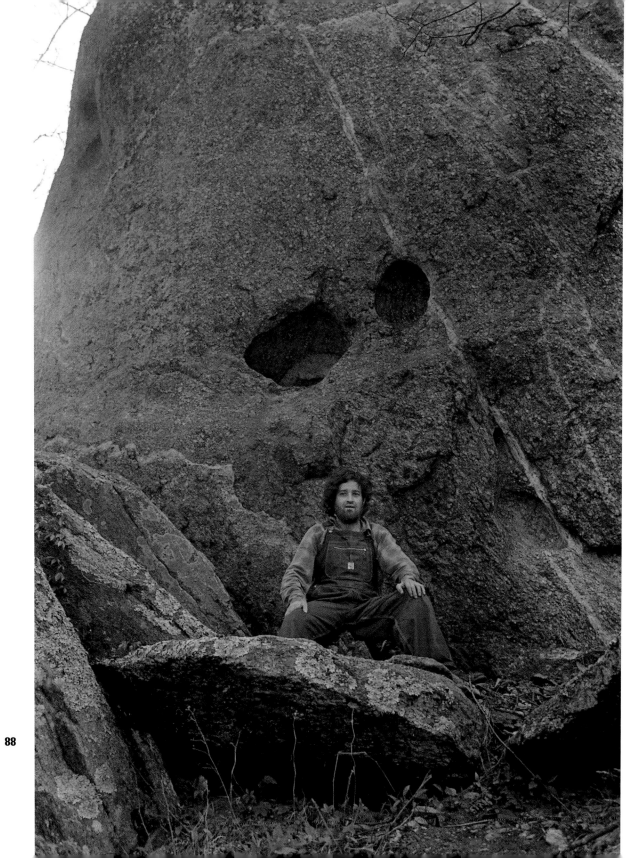

ROB AMBERG I was attracted to Junior in many ways, and enjoyed his company. I admired his ability to take everything one day at a time. Desired even his lack of goals and ambitions. Longed for his sense of place, his knowing where he belonged, and that he'd be in the same place five, ten, fifteen years from now. He fascinated me; like a chameleon, he was intuitive, changing his look and temperament to fit each situation, always with an eye toward survival.

Junior also repelled me. His slovenliness. The state of his room. His refusal to bathe or brush his few remaining teeth, pieces of which occasionally just broke off in his mouth. His love of TV wrestling. He believed Dellie saved his life and was loyal to her. But he was also argumentative with Dellie or her daughters when they asked him to work. He complained about Dellie to me, and I didn't know how to respond. I was scared to disagree. Dellie rarely let him go anywhere unless it included an offer of paying work. "She works me like a dog," he said. His basic needs were provided—food, clothing, shelter, a ration of chewing tobacco, and all the dopes (as Dellie referred to soft drinks) he could drink.

Junior and I got into a heated argument once. It started over a card game, but was more complicated than that. It involved some things I had said I would do that I didn't follow through on. He had trusted me, counted me as someone who treated him differently, and I had dismissed him, just like everyone else.

Junior had wanted to fly ever since Dellie came back from her trip to Washington, talking about the clouds looking like big feather beds. John Rountree and I hired Ralph to take Junior on an airplane ride for his birthday. We rented a little four-seater Cessna and followed the French Broad River into the county. Our plan was to fly over the High Rock and then over Dellie's house. But it was hazy, and when we got to Marshall it was difficult telling the haze from the mountains and none of us wanted to risk it. Junior barely spoke while we were in the plane, which was unusual for him, but I knew he was pleased with the day.

I will always feel a connection with Junior. I had known Dellie about four months when, after an extended visit, I was back home, showering, and noticed I had a small knot on one of my testicles. I went to see the doctor a couple of days later when the knot didn't go away. He had me in the hospital two hours later and operated the next day. The tumor was malignant, but the doctor was confident he got all of the cancer. Over a hundred stitches down my chest and abdomen kept me in bed for weeks. Dellie, Berzilla, and Marthie came to visit a few times. Their concern touched me, given the short time I'd known them and the lengths they had to go to get to the hospital. The experience shook and sobered me: Life is more intense, time more precious. Work had new meaning. I managed to get back up to Dellie's a few weeks later for her seventy-seventh birthday party. It was raucous. Loud music, lots of liquor, many people. At one point, Starlin Chandler pulled out a pistol and fired at the ceiling. His brother, known as Sweet William, grabbed Marthie's butt and breasts, and she punched him in the face. Junior stayed by my side the whole night, fending off drunks, protecting me. He carved a path out to the porch so we could get some air, bellowing, "Git out the way. Here comes Rob Hamburger. He's got a cancer."

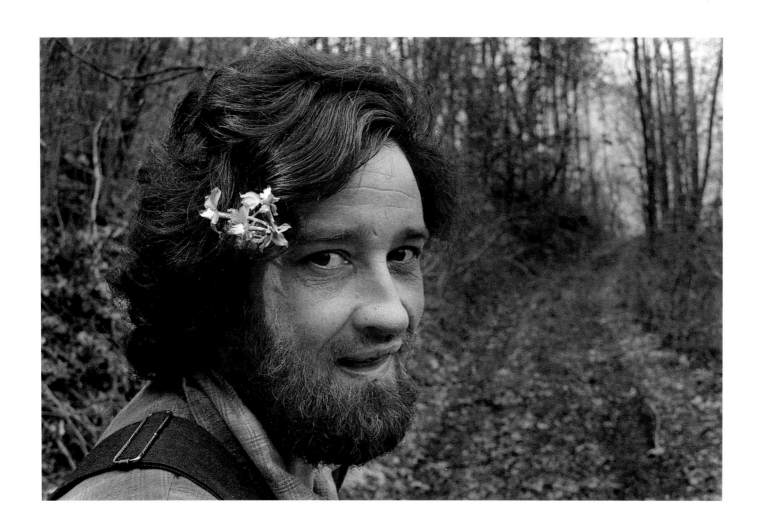

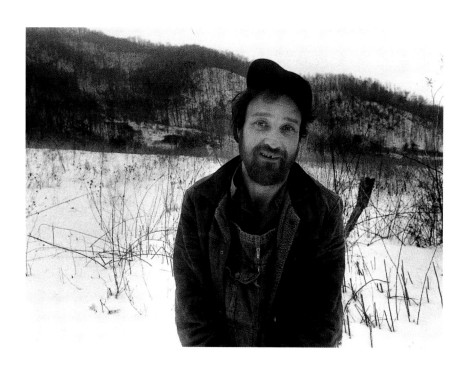

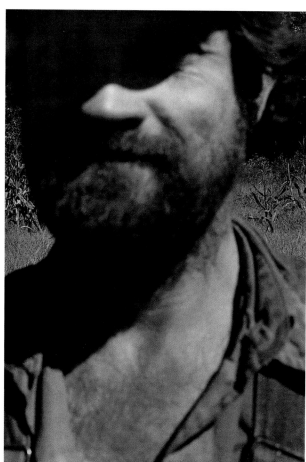

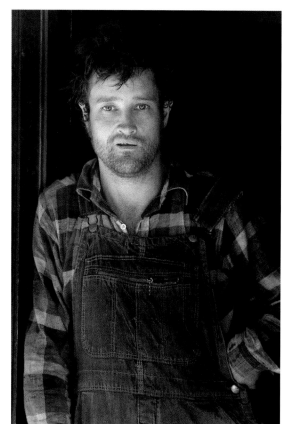

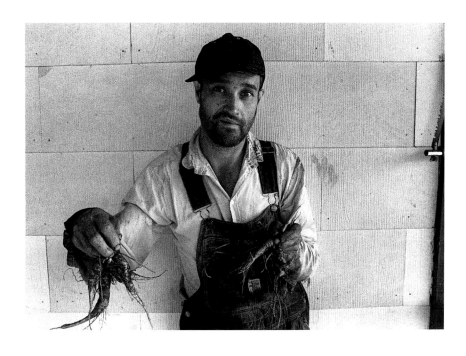

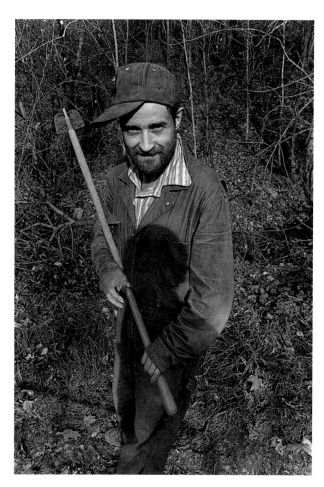

93

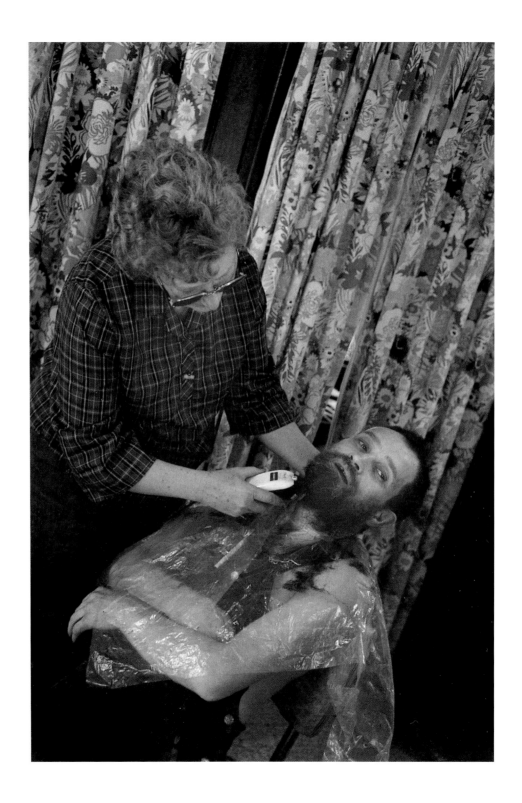

94

MARY NORTON, DELLIE'S YOUNGEST DAUGHTER Junior come to stay right before me and AB got married, or right after we got married. I remember him coming. They went and got him, and the poor little thing was scared to death. We didn't even know his name, and he couldn't tell us. They just pushed him out when they went to get him, and they never told us his name or nothing. Granny thought she was getting the one they called Enoch and come to find out that wasn't the one she got. It was Junior. I remember asking him his name the next morning, and he tried to follow Teat off. Teat petted him and everything, and when Teat left that morning in a car he come way down the road, down to the mail-boxes, trying to follow Teat off. And he come back to the house, and we finally understood him to say Junior. He was Junior. Everybody now calls him Simon, but I still call him June. Nan and all of them calls him Simon. Dr. Jones does too.

We got him when he was six years old. I've got it wrote down in the Bible somewhere here at Mommy's and down at my house too when we got him. I can't remember what year it was, but I think it must of been 1949, right before me and AB married. We married in '50.

I knew his mommy and daddy. I knew Simon, his daddy. I'd seen him. His daddy was a preacher. I can remember seeing him when I was little. I'd seed him in church and seed her. Junior's mother was like Junior. Her arms was crooked, and she couldn't walk good. Junior's got arms and hands just like her. But she must've had seven or eight kids, and when he died she didn't know to take care of them. It was real piti-ful. I don't know if Junior wasn't used to eating or hadn't had enough to eat or what, but he took diarrhea. I think he got foundered. They said they'd just give them some crackers or open a can of beans, and they'd eat them on the floor.

He had stone bruises on the bottom of his feet, and I carried him around for two weeks on my back. He couldn't walk. He had big stone bruises on his feet. It was pitiful. Stone bruises, where the youngun had gone barefooted and stepped on rocks and things. It's like you step on something—I've done my feet like that going barefooted—and it'll be like a blood blister or something, only its sore. We always called them stone bruises. He had them all over the bottom of his feet. The poor little thing. And he was rusty. I re-member giving him a bath, that's the reason he didn't want to take a bath now, because I scared him to death back then. See, I didn't know the youngun had never had a bath. We heated water and put it in a tub, a zinc tub, that's the way we took a bath. So I heated me some water and filled up the tub, and I just put him over in it, and it just like to scared him to death. He screamed and cried, and his little elbows and hands and his little feet, back there on his heels, was so rusty I had to grease them with Vaseline. And keep greasing

them and keep washing them to get it off. He must not have ever had a bath because it scared him to death. He held on to me and screamed, and I just had to get him out. I just washed him with a rag. He'd never seed a tub of water. I don't know what he's doing up there, but the next time I see Larry I'm going to tell him to put his butt to washing. I make him take a bath when I'm here. Keep his clothes clean, but he gets away till where nobody won't quarrel on him.

There was an old man—Jim Wallin's grandfather, Gwendolyn's grandfather—they called him Tommy, and he'd come and Mommy'd give him milk. He wouldn't take the milk if he didn't pay for it, and he'd give her fifty cents, and she'd tell him, I don't want that money Tommy, and he wouldn't have the milk if he didn't pay her. Anybody who needed milk and butter, she give it. I guess she give away more milk and butter than we used.

She'd buy hogs and raise hogs. She'd buy a sow, and it'd have pigs, and she'd sell off the pigs. And she'd raise calves and sell them. That's the way we had clothes and shoes. Sell a calf and get some cloth to make clothes or buy us a pair of shoes. We didn't get but like one pair a year. When I was little, maybe Daddy'd sell tobacco, and he'd get cloth, and she'd make us some shirts. And we'd have a pair of overalls that she'd buy, and we'd have to wear them to school. And we'd wear just old clothes around the house with patches on them. We didn't have clothes like now—I told Delline she had a pair of shoes for every day of the week and more besides. Back when I was growing up we just had, I called them, brogans. Boy's shoes. And we wore them. See, we had to walk from the upper place where Junior stays down to Rube's Store. The schoolhouse was down there in that big bottom where Rube raises tobacco.

As long as I can remember that's what they done —raise tobacco. I can remember them burning tobacco beds. Daddy would cut the wood and stand it up like this to burn the tobacco beds with. He got out in the mountains and got the wood to burn the tobacco beds with. He'd put the tobacco beds down at the lower side of the field and cut wood to burn them with. You didn't gas them back then to kill the weeds. He'd get wood and set it up —poles—he would get hay or straw. They called it firing the baccer beds. He'd put these poles so far apart in a fifty-foot bed and then light that. I can remember standing at the window and watching them flames. We called it a big fire. Then they'd rake it off and sow the bed, and that fire killed all the weeds. They didn't have anything like gas like they do now. People'll gas it and then put a cover over it. You've been over in that other holler where Teat lived. You know that bottom over there. They would tend it and that bottom below the house. And I can remember him a having a field above the

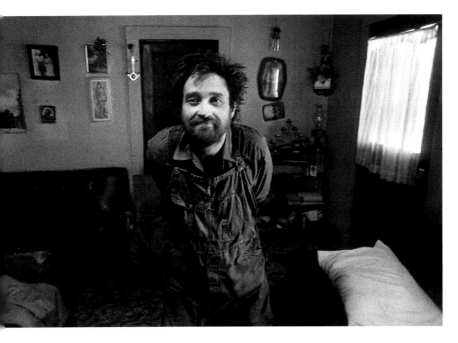

house he raised tobacco in. I think way back years ago you could raise as much as you wanted to, and in later years they started allowing you so much. And he graded his tobacco. He'd put it out in five piles. He would put out lugs, smokers, red, tips, and a bad grade. Now you just pull it all off and bale it.

Now, he'd make a corn patch, and he'd pull the fodder. Most of the people would just cut it down, but he'd take and pull all those leaves off of the corn and tie it up in bundles and then feed it to the cows. The ears would dry out, and he'd gather that and put in it a corn crib. They had to raise corn to feed the hogs and horse. I've had to pull hog weeds. Did you ever do that? We had to go out and pull hog weeds to keep the hog fed. Sometimes Mommy'd lets us have the knife to cut them, but I remember, well, I was a great big youngun, I was big enough to handle a knife. We'd get the butcher knife and get those big old weeds; I call them hog weeds yet, with leaves on them. We'd hack them down and put them into the hog and carry in stove wood. I had to do that, and carry in water. There was a lot of things back then that younguns had to do where my younguns didn't have to do nothing. They give me the job of carrying in the stove wood, and I never did like to wash the dishes. Tildie done that, and I'd carry up two buckets of water. We had a table on the porch and we called it night water. I'd carry two buckets and set it out on the porch. I can remember carrying water in a lard bucket as quick as I got big enough. I couldn't carry a big bucket—I was so little. But Mommy'd give me one of those lard buckets or a syrup bucket, and I'd carry water and pour it in the big bucket. We had our jobs we had to do.

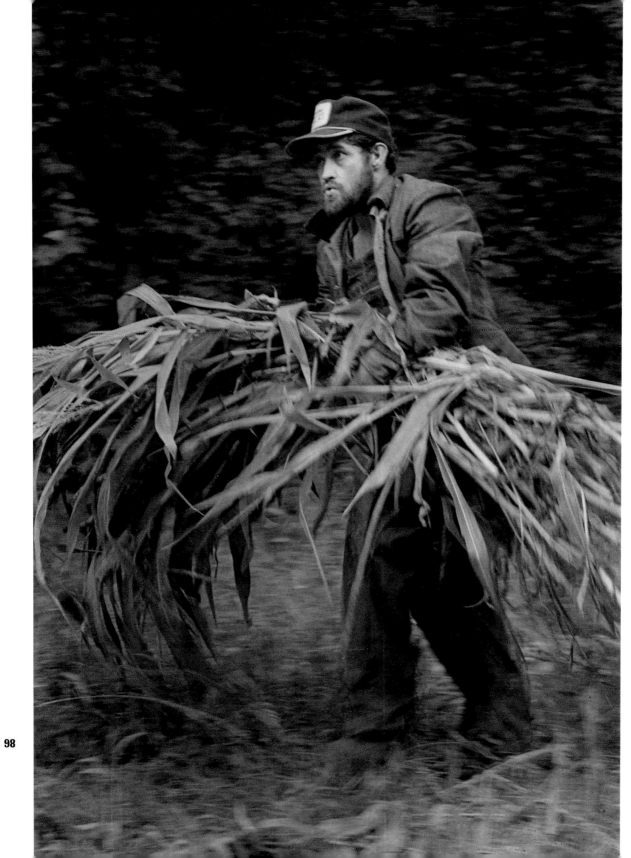

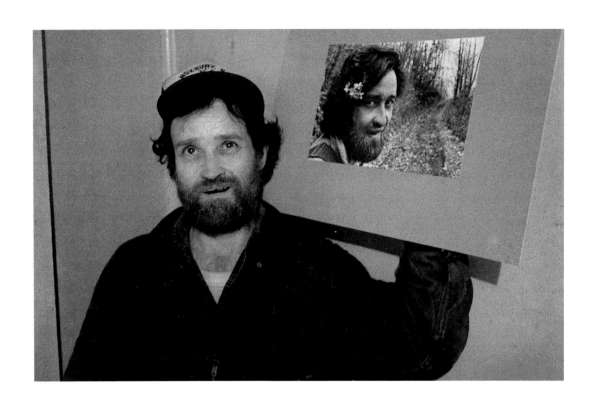

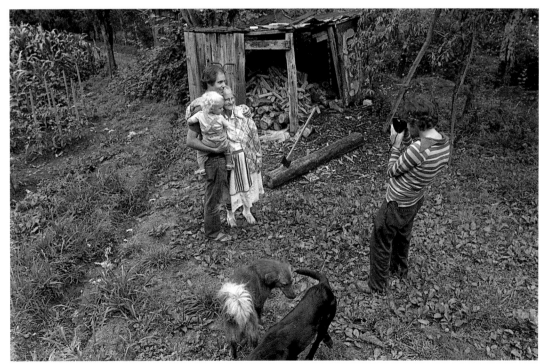

SEVEN To the Tobacco Market

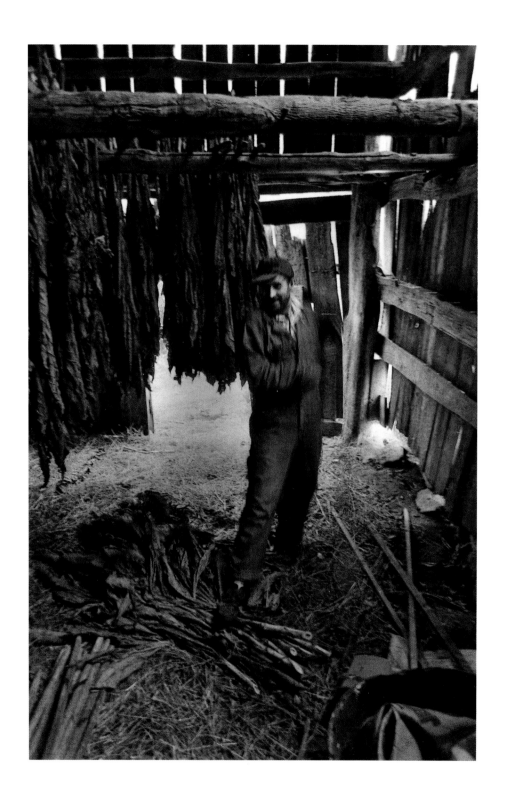

102

ROB AMBERG Dellie complained of stiffness in her joints, which wasn't helped by the damp, cold barn. It was a lonely time. Shorter days with less light, the end of another season. She would spend hours in the barn by herself or with Junior. Getting the tobacco ready for the market was the longest part of the process: taking down the sticks from the tier poles, pulling the leaves from the stalks, separating them into grades. Dellie said that grading brought a better price. The leaves were tied into bundles, called "hands." This was done in damp weather when the leaves were moist and pliable, so they wouldn't crumble in your hand. The hands would be packed on big baskets, in circular layers, sometimes four or five feet high. One day I was there helping with the leaves, and she sang "Early, Early in the Spring." She said then that she wouldn't raise tobacco again. "I ain't going to fool with it no more." She said she would lease her allotment to someone, and that's what she did the following year.

The year I raised tobacco with Tom over on Big Pine I remember being glad to be finished with it. The work had been hard and gone on forever, different phases of the process stretching over weeks and months. We were working that whole time without getting paid, in anticipation of a big check at the end. But it wasn't good tobacco. It had blue mold and didn't weigh much. We had Howard Allen haul it to the market for us; we rode in his two-ton flatbed, the floorboard littered with tools, chains, a pistol, and many items I couldn't identify. The warehouse was a blur of activity when we got there. Lines of farmers were unloading their crop, standing around watching the sale, and collecting checks. The buyers moved and gestured to the cadence of the singsong voice of the auctioneer. They were followed by people writing prices on tickets and identifying the purchaser. I saw a woman put a chocolate cake on her basket of tobacco, urging the buyers to taste her cake and buy her leaf. Tom and I got our check and paid the bills—hauling fee to Howard, leasing fee to John, fertilizer bill, pesticide bill, all the other expenses. Each of us made a few hundred dollars, and both of us quickly determined there were easier ways to make money.

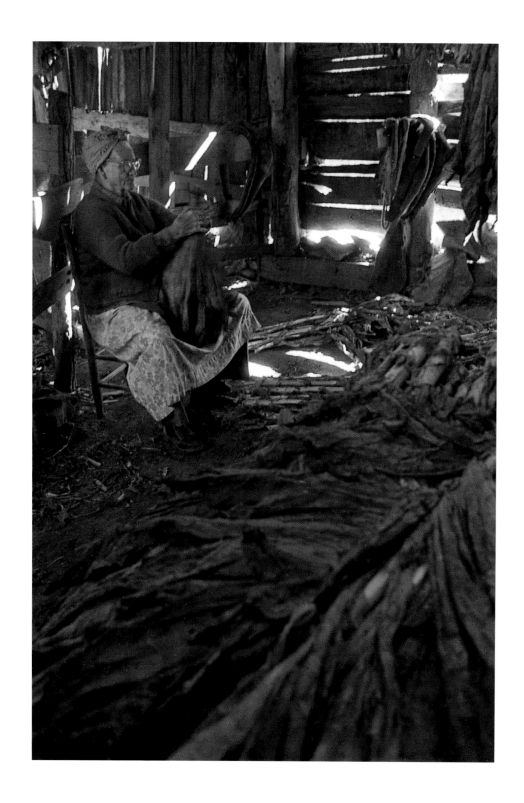

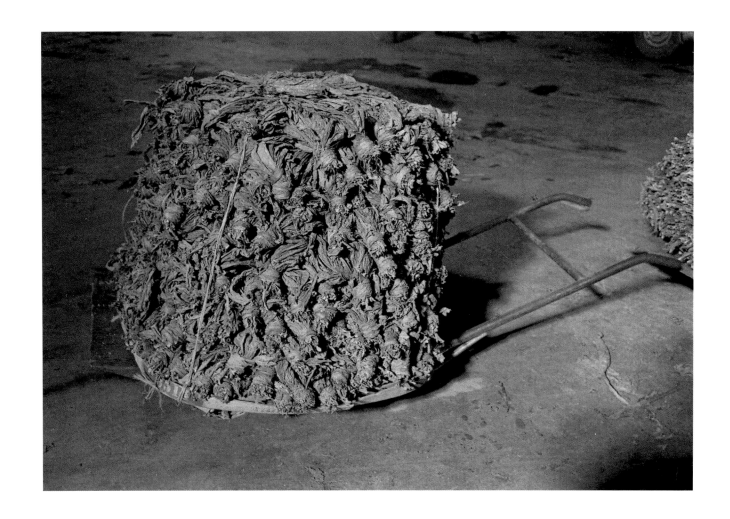

105

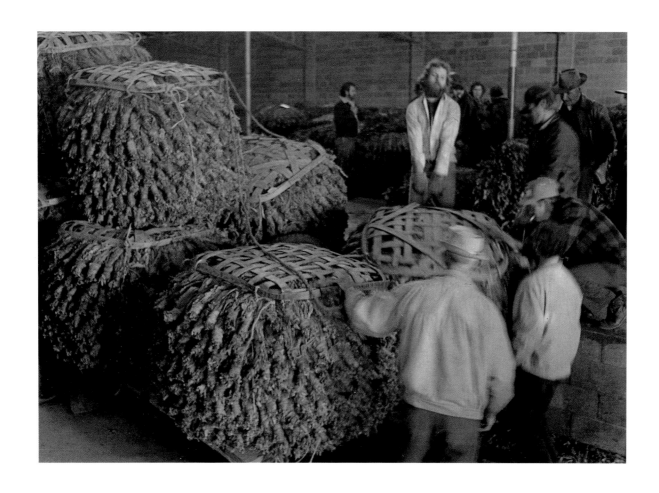

106

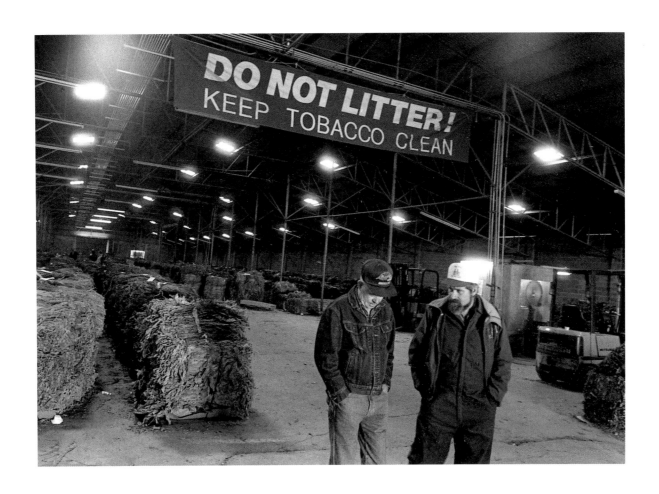

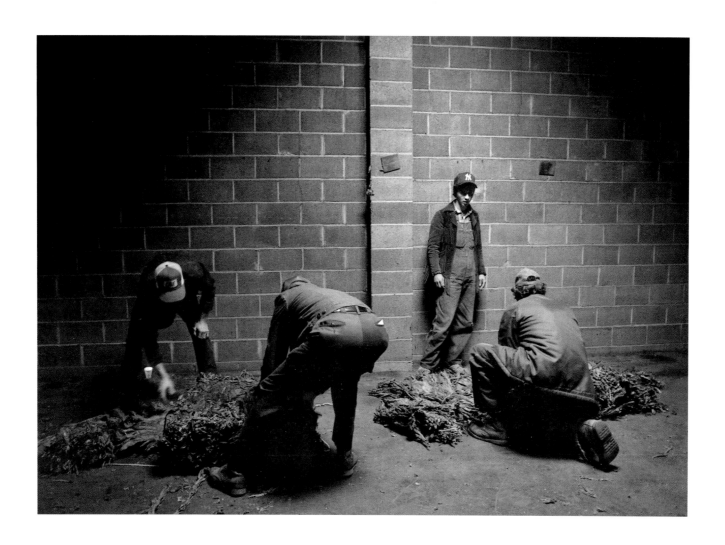

108

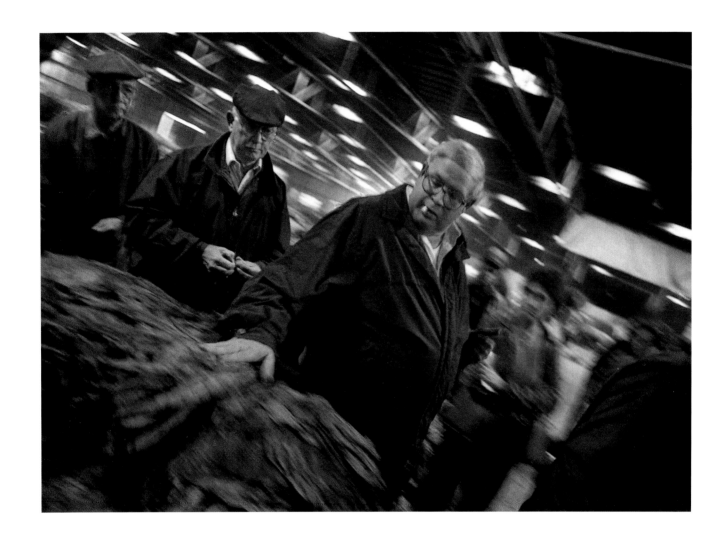

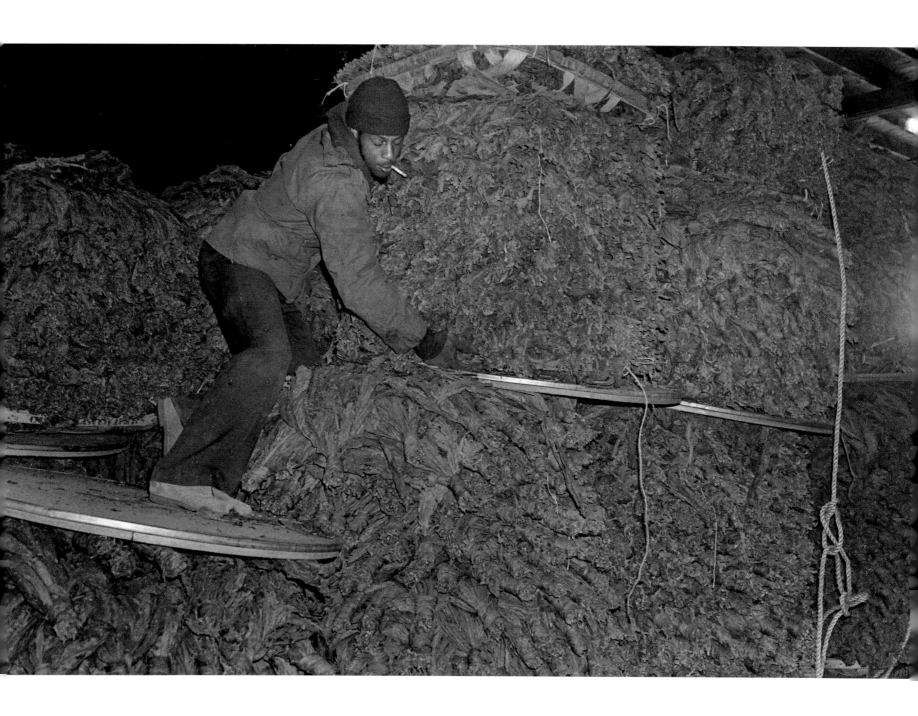

DELLIE NORTON First baccer I ever sold, I sold it at Greenville, Tennessee. Put it on a wagon. I don't think I'd ever been to Greenville before. There weren't no trucks or nothing to haul it on, and you had to take it in a wagon with horses. If it didn't bring what you wanted, didn't get the price you wanted for it, you could take it to another house. Turn the tickets on it. Sometimes it helps you to do that. I have done it. There were some years it did better, and some years it didn't. Now I took one year a bunch to Asheville, and they did me dirty there. I didn't get nothing out of it. I never took no baccer back to Asheville no more. They had this dealer, and this sheriff over at Marshall, and this Franklin fella, and who they wanted to get a good price, got it, and who they didn't want to get a good price, didn't. They used to have picks there—men there at the sale to talk big and get some a good price and others nothing.

The first time I ever went to using tobacco, how come I went to using it, I had something when I'd eat; I'd spit up my eating. Dyspepsia, old people called it. And my grandma got me to use tobacco, and it helped me. I quit spitting up what I eat. I've used it off and on ever since I was very little. I couldn't do without my snuff. I have to have it. I'd rather have it as I would eating. The first thing I want when I get done eating is my snuff, and the first thing I want of a morning when I get up is my snuff.

I've seen my mother have hundreds of twists of tobacco at one time. She chewed it, and Daddy chewed it too. They smoked it. They'd dry it and grind it up just like smoking baccer. I've seen them fix it thataway and put a little sugar in it. Then, I've seen them twist it and make big plugs of sweet tobacco. They bought something at the drugstore—what did they call it? It was black like chocolate, almost like molasses. You'd melt it and put a little of it on the twists and then press it. I've seen them press it with big hickory wood, and the baccer would taste like hickory. It was sweet and good. They'd make their own cigarettes. I've seen them roll them out of those big burley leaves, roll them big cigars. Sometimes they'd powder it up and roll it in leaves of paper.

About everybody that I knowed of uses tobacco. Most of them started young. My daughter Tildie slipped and used it. I wouldn't let her use it; I didn't want her to use it and her a going to school. And Teat, he smoked. Mary never did use it and she never did smoke till she got married, and then she went to smoking. Marthie smokes. She used to use snuff when she was little, but she quit and went to smoking. I didn't want none of them to use it because they didn't want it in the school. I didn't pay no attention to the diseases or nothing. I just didn't want them to use it cause they had to go to school.

I don't think people worried about diseases back in them days till they got to announcing it over the radio and television about smoking and chewing and dipping. Those things didn't hurt them. They claim it

gives them cancers and things now, but it didn't hurt old people for I know all kinds of old people —my grandma was ninety year old and she didn't have but one tooth out of her head when she died, and she chewed and dipped. I don't know if she ever smoked or not. I can't remember. She might have. She was really old, and she chewed baccer and dipped all her life. I don't believe it has anything to do with anyone's health or age. Not a thing. I don't know now about it, but I don't believe, years ago, there was anything to it. But it could be now because they put stuff in it a making it. They spray it with all this stuff in the fields while it's a growing. They claim they spray to keep things from eating it up. They spray for mold, and they claim it'll get ripe quicker and weigh more. You don't have to sucker it now—you can spray for them. All that stuff they spray on it now to raise it might be the cause of giving people these diseases. They didn't spray it at all years ago. But tobacco has helped this area a lot. I don't see how people could've got along without it. They did get along before it came in. They had to. Now, if you took it all away from them and not let them make it, I don't know if they could get along or not.

EIGHT Visiting

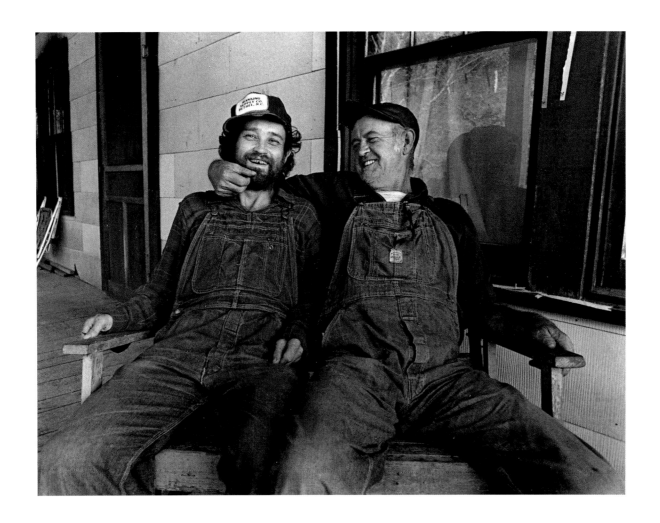

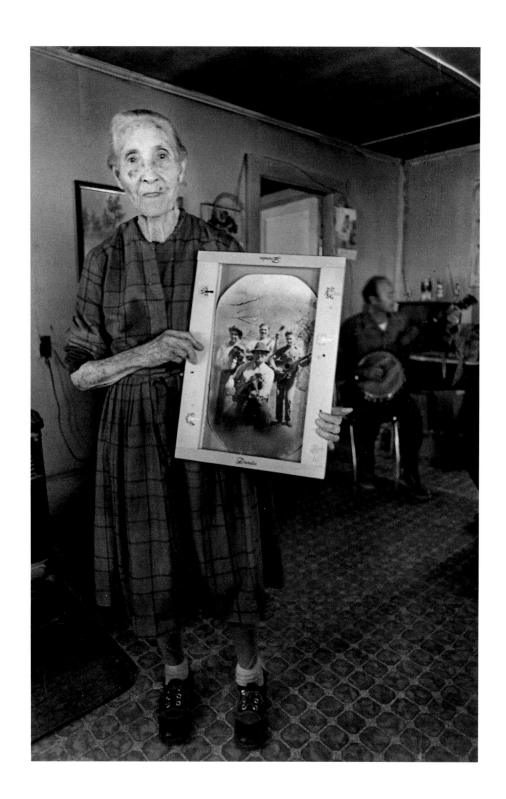

ROB AMBERG Berzilla always insisted I sit next to her when we went to visit and would take my hand in hers. She was not like her sister Dellie. Berzilla was small, frail. She would bruise if you held her too tight. Her blue eyes were light, airy, and would twinkle with mischief. Dellie's eyes were equally mischievous, but they were also fierce and capable of boring a hole straight through you. Berzilla would show me photographs; we would talk and eat something. She showed me a record album with her and her husband Lee Wallin's picture on the cover. On the album she sang "Conversation with Death."

The trips to the festivals I remember fondly: Dellie hauling jugs of her spring water to Durham and Knoxville because she couldn't drink city water; Berzilla, Dellie, and Cas Wallin wandering around a Duke University dormitory at five o'clock in the morning looking for the cafeteria. It pleased Dellie and the other singers that they could go to these new places, sing ballads they had been singing all their lives in the fields or around the house, and get fed, housed and paid to do it. They reveled in the enthusiasm with which they were greeted during their performances. And some people they met would later come to visit and become friends.

Dellie, Berzilla, and I went to see Ernie Franklin and his mother in Chapel Hill, down the road from Sodom. Berzilla knew him. They lived far off the road in an old house with wooden shingles on the roof. There was no electricity or running water in the house, and they heated it with a fireplace and cook stove. Ernie made fiddles and wooden utensils. He gave Dellie a spoon and showed her how to carve one herself. Ernie played fiddle for us while Berzilla buckdanced on the porch. Ernie's mother, Liz, seemed isolated in the remote cabin without a radio or a TV or anything to read, and she brightened at the chance to visit with Dellie and Berzilla. I made pictures. Later, I took some back to Ernie. Liz had gotten sick and moved into Asheville with Ernie's sister. He was there by himself, and it was winter. The place felt desolate, deserted to me. He thumbed through the pictures twice as we stood in the yard and announced that they were good pictures, but he didn't know what they'd be good for except fire starter.

Ernie's place in Chapel Hill was near to where Dellie's great-grandmother raised the bear cub. Dellie had told me this story one day. Her great-grandmother's husband had shot a female bear when she bothered their stores of food. The sow had a cub, and he brought it home to his wife. The story goes she had a nursing baby of her own and she nursed the baby on one breast, the bear on the other. When the bear was grown, they sold it to a circus that came through.

DELLIE INTRODUCED ME TO many people near her home and on our trips. Bonnie Chandler, Dellie's neighbor and relative, asked me to make pictures at her wedding. She was marrying a man named Jim Crow. They were both in their seventies. Jim was small, mild, and quiet. Bonnie seemed larger than she was; she was bold and outgoing. She would sit on Jim's lap, put her arms around him, and kiss him hard. I traded the pictures for home-canned green beans.

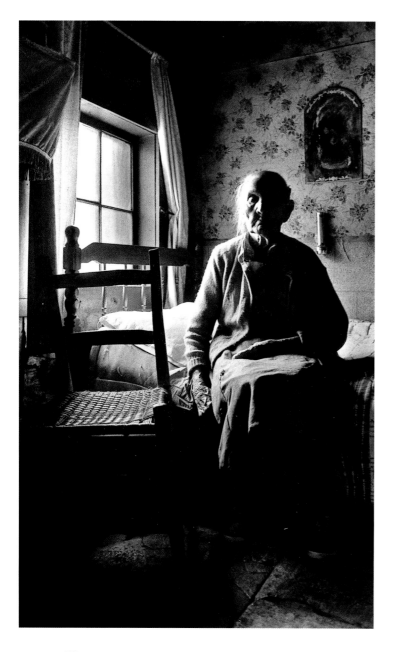

When I arrived at Dellie's house, it was a cold, rainy day but her kitchen was warm and cozy from the cook stove. We had planned to go to the Asheville Art Museum to see my pictures from Sodom; she clearly didn't want to leave. "Can't you just bring them up here and let me look at them?" "It's not the same," I insisted, "and it's the last day of the show. I'll buy us dinner in town." The gallery walls were large and white. The pictures small and far removed, evenly lit and spaced. They imposed my order on Dellie's world. Even so, she knew the people in the pictures and spoke to them. "Why there's Junior at the High Rock. Remember when he jumped out and tried to scare you? He does that to everyone he takes up there." And, "That Pet was so easy to milk and gave the best milk ever was." Farther down the wall, "Why there's the last fifty sticks of my tobacco you cut before you got sick with that cancer. Reckon that's what gave it to you?" As we walked out, past the metal dinosaur sculpture, Dellie said, "Them pictures was plain. I knew every one of them." Then, she added, "But why would a place like this want a picture of me hanging in it?"

I took Berzilla's son Doug over to Shelton Laurel to see his tax preparer. A fifteen-minute drive: over the Dickey bridge, through Guntertown, past the remains of the old Presbyterian hospital, through turns and over hills. Doug said little. The office was a trailer, sitting next to a dormant tobacco field. He wasn't inside long, and we soon started back. His mood seemed improved and he hummed an old song. When we got to Peachtree, the spot in the road where Guntertown stops and Sodom begins, he said, "Well, we're back to God's country."

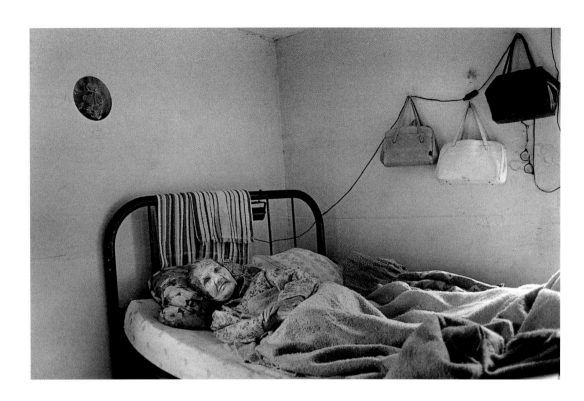

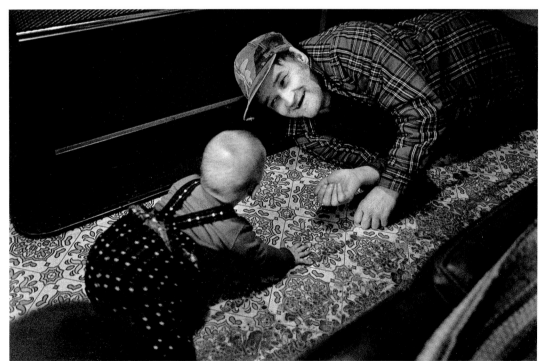

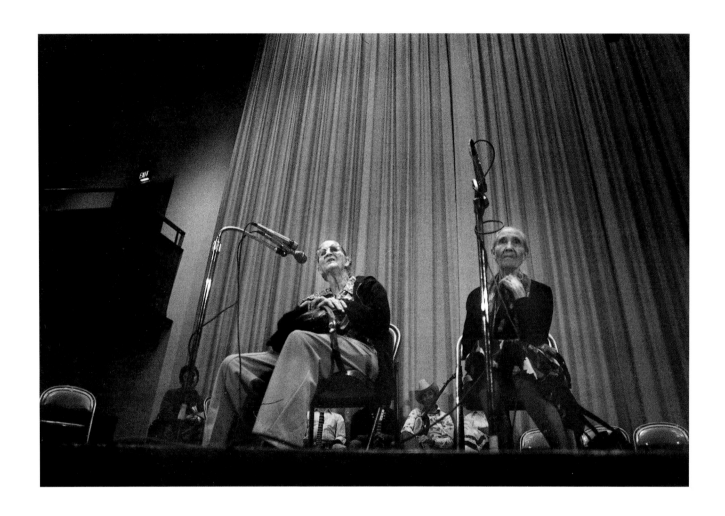

DELLIE NORTON After I got old enough to go to church I went to Sunday School every Sunday. I never did learn nothing much at school, what I learned I learnt it in Sunday school. Old man Norton, Lump Norton, he teached me out of a blue-backed speller book and a first reader. That's the only kind of books I ever went to school with. Learnt to spell, and what little I could read. Later on, I went for three months to the Presbyterians, but they didn't have no books. They had little tables you set at and little chairs, and chalk, and they put your lesson on that little table, and you had to learn out of that. Wrote it down with the chalk. I enjoyed it, but I had to walk a long way. I guess it would've been a mile from where we lived to it. I didn't go much to that school. There where my daughter Mary lives now, that was the Presbyterian Dwelling House. There was a big schoolhouse on up above there. They tore it down. You had to pay to go. The Presbyterians just had it for three months at a time, and it was a dollar and a half for three months. I went three months. They might have had it twice a year. Then I went a little to that free school. They didn't study very much for they didn't have things like they have now to study. They let you play half the time, crochet. They had a crochet day. Learn you to cook and sew and crochet, every Thursday.

Daddy, he loved to sing. He'd get up every morning while I was fixing breakfast and pick the banjo and sing. Every morning, he'd get up and build a fire and get that banjo and set in on it. He was sort of like David Holt. He loved to pick the banjo. Picked good. The old-timey way. He didn't pick that frailing like Sheila and them picks now in three-finger style.

I used to try and sing when I was little. My mama would sing and my grandma would sing; my uncle too. He lived right over from us. An old man from Shelton Laurel, he used to come to Daddy's and stay, make boards for him to cover barns with. He used to sing. Lord, he knowed all kind of songs.

Back then I could learn one as quick as I heared it, but I can't do that now. I'd learn from anyone I could hear sing. It just come to me. Of a evening, after we'd get done work, a whole gang of us would get on the porch and sing till way in the night. My brother Lloyd was a real good singer, and he was always around, lived up there with us. And lots of girls would come and stay with us. When she got big enough, Sheila used to stay at the house. We'd sing, and they'd play games and things like that after we got the work done. Young people would bunch up together and play them games. They called it Twist. Now they call it Chasing the Squirrel. That Obray Ramsey, we'd have parties, and he'd play the fiddle, and Rubin Wallin too, and they'd run Twist with the girls. They used to have all kind of different cakewalks and plays. Have corn shuckings. We'd stay up all night and shuck a big pile of corn. After we'd get it shucked, we'd play the rest of the night to pass the time. That was my main time singing, to pass the day off. Sing and dig. Sing and hoe. And then

they got that story in the paper about my singing. I didn't ever dream that I'd go to these big places like I've been to sing.

My oldest girl, Loni, she went to school up till Friday and took sick. They took her out there to the hospital, and she didn't live a hour. A ruptured appendix. She just turned thirteen. You don't know how hard it is until you have to go through it. You can lose everyone else, down to your children, and it won't hurt you as bad as it does to lose one of them. You lose one of them, and you're just all to pieces and can't ever get over it. Teat was twenty-nine when he died. Marthie was in her sixties. I don't know as it feels any different when they're older. It hurts you just as bad anyway. Of course, I didn't have many children when Loni died. I just had her and Marthie I think. That hurt me worser than anything in the world. To give her up. It's hard to do. You don't ever get over it. I just had to go through with it. I stayed busy at work, busy at something all the time. You try to forget it, but you can't forget it. Some people can give up their young-uns, and it don't seem like it hurts them so bad to me. But Lord, that was the worst thing that ever happened to me, having to give up one of my younguns.

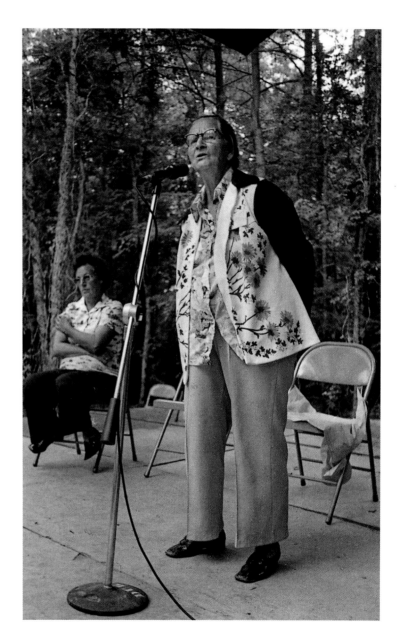

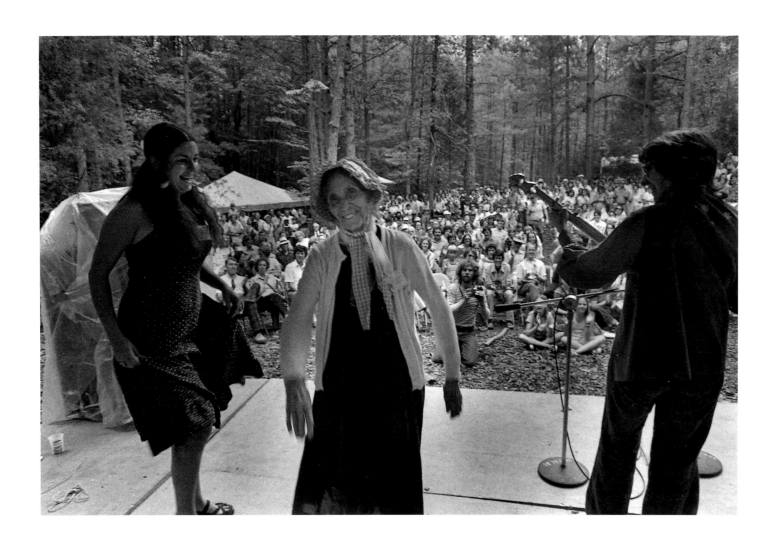

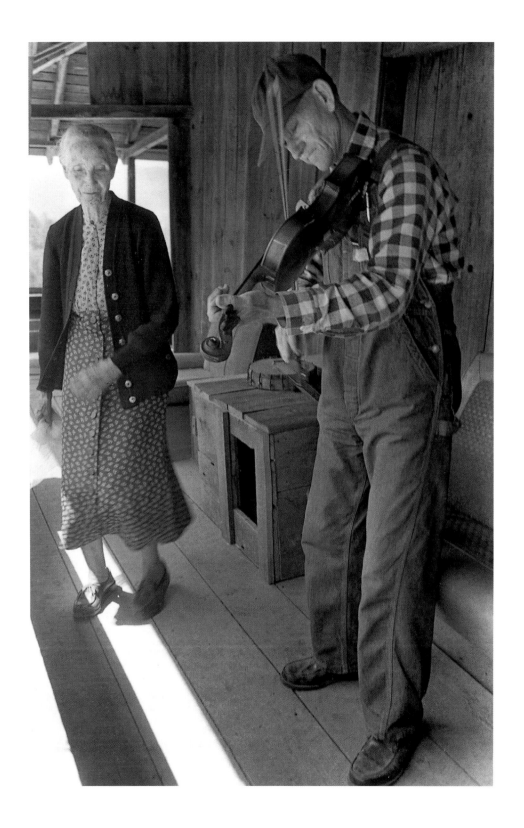

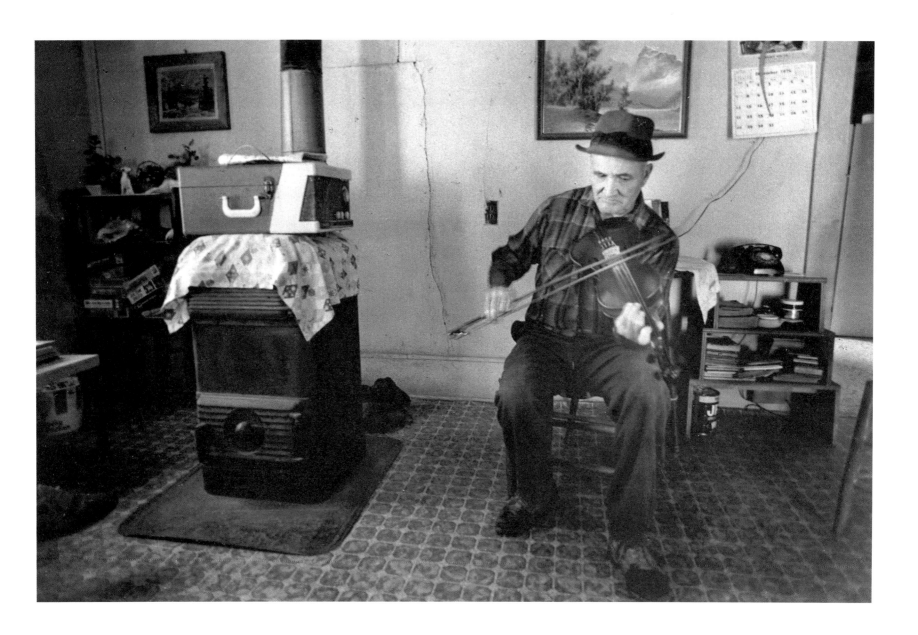

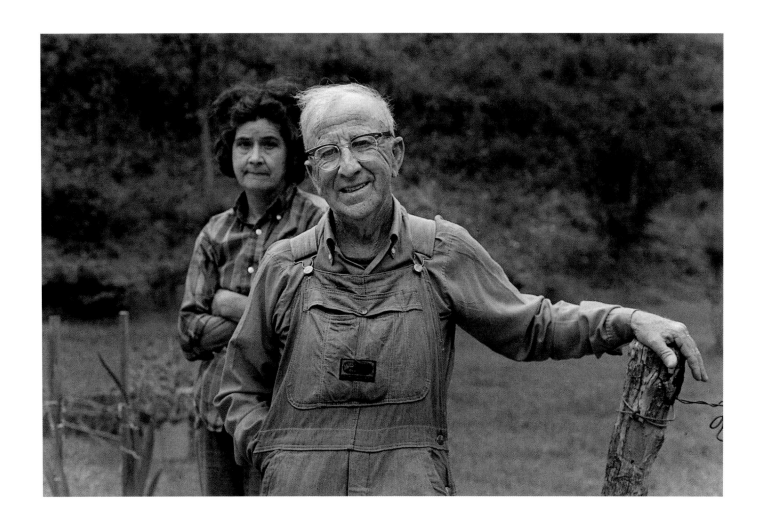

124

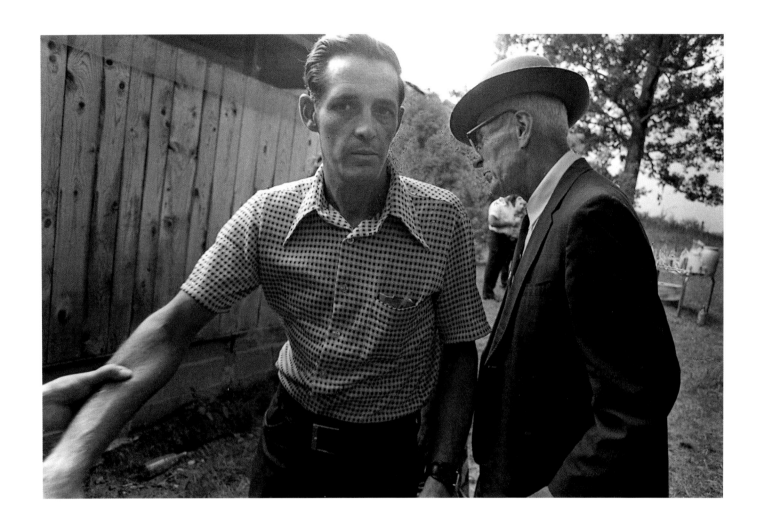

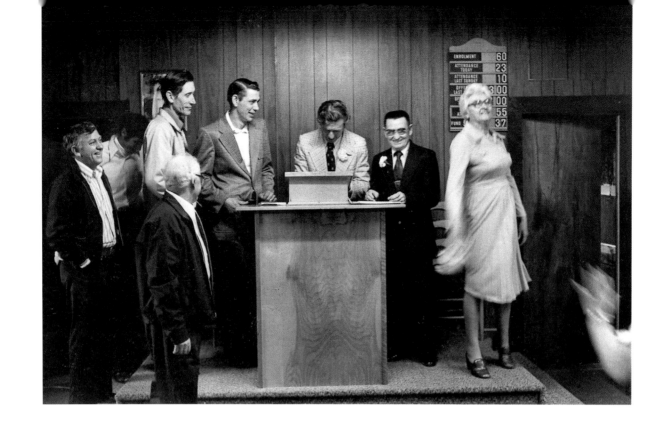

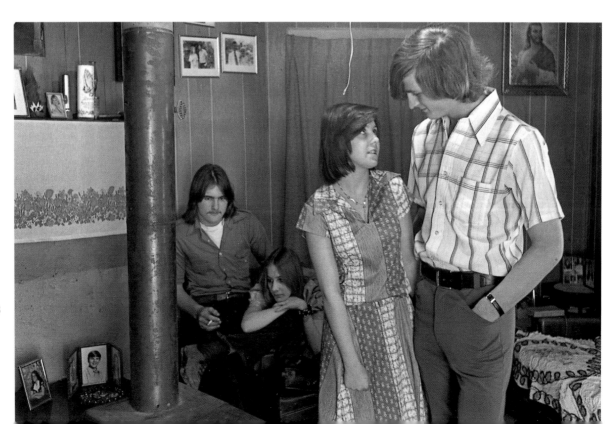

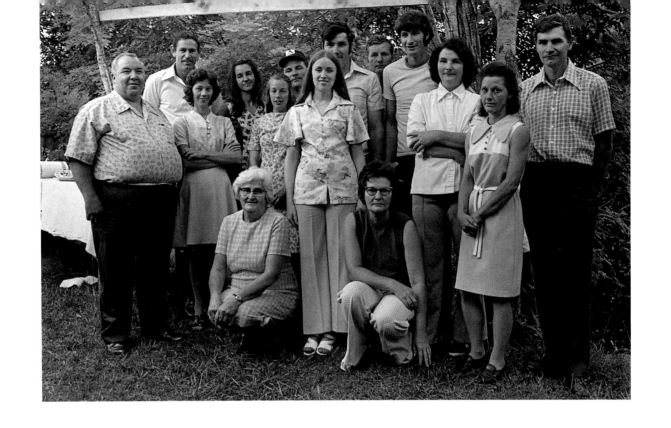

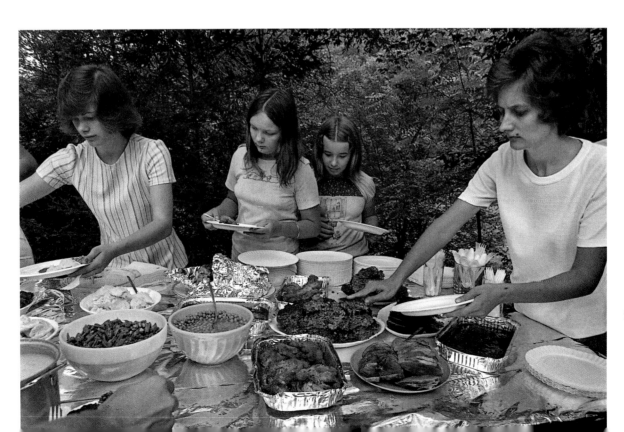

127

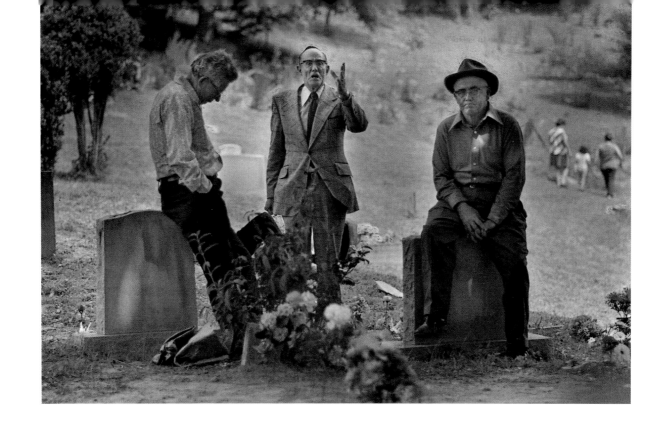

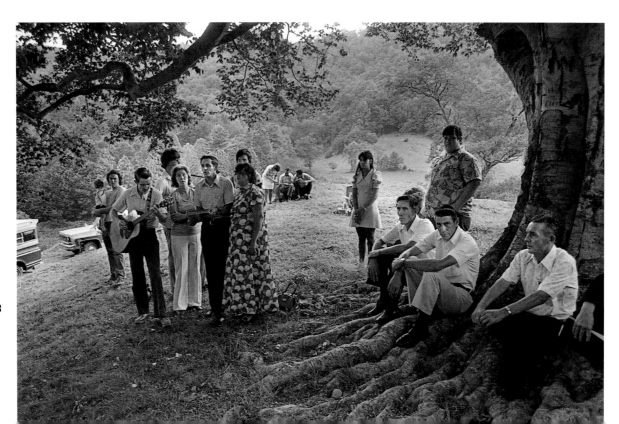

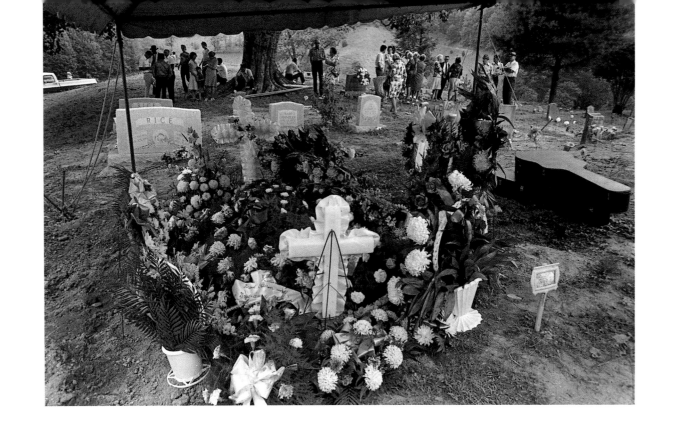

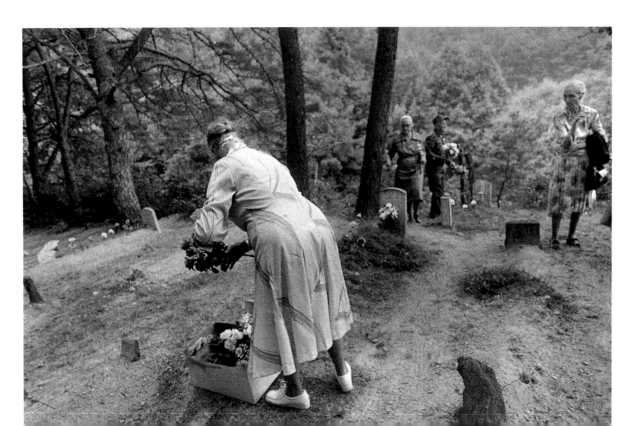

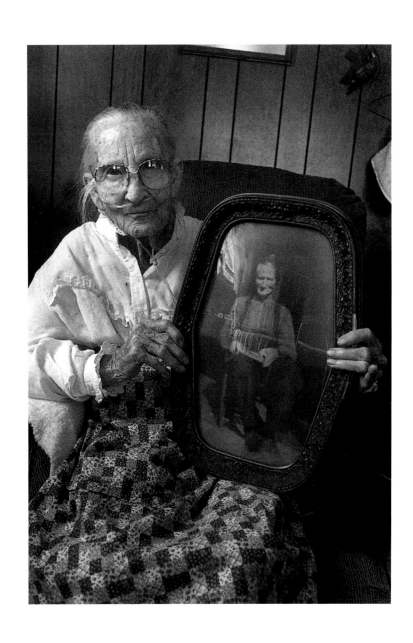

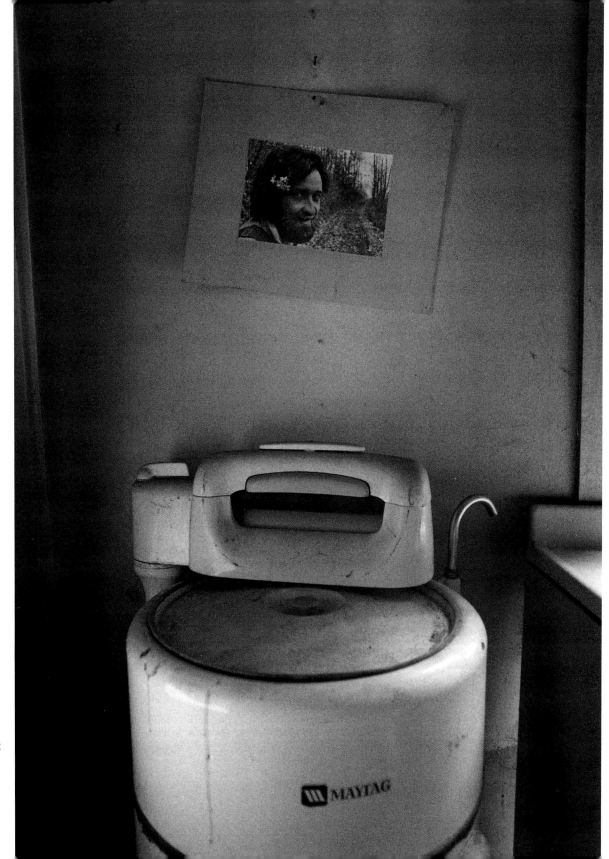

ROB AMBERG Dellie bought a house down the road from the old one. She called it the lower place. It was more convenient, and she could get out easier for her frequent trips to the doctor or the store. It had a bathroom, an electric range, and oil heat. She bought a CB radio and talked to truckers under the moniker of Granny Dell. Junior stayed at the upper place, the only home he had ever known, living on his own for the first time. He walked down to the lower place to eat, work, and hang out, and walked back at dark, or later if we played cards. But sometimes Junior would stay at the upper place for days at a time, and no one would see him. He said he cooked for himself and got along just fine.

Berzilla died. She was buried next to Lee in the family cemetery above the house. Doug said he had lost his best friend. Berzilla and Dellie hadn't spoken much in recent years. Doug had been knocked unconscious and robbed a couple of years earlier. His dog was killed in the attack. Doug was convinced one of Dellie's grandsons had done it although he never saw his attackers. Dellie was equally convinced the grandson hadn't done it, "couldn't have done it," and defended him so vigorously as to cause a breach with Berzilla and Doug.

One of Dellie's grandsons wanted the upper place not long after she moved to the lower house. The home place was willed to him. Even though Dellie had a life estate deed, he threatened to take her to court. He claimed she had cut a lot of valuable walnut timber from the place and degraded it in other ways. The grandson and his girlfriend eventually just moved in with Junior and then threw him and his belongings in the yard. Junior said he'd been threatened with a gun, and the sheriff came. Junior was forced to leave. He had no claim and wasn't an heir. He didn't know what to do or where to stay. There was no room at the lower place, with Mary living there, taking care of Dellie. He eventually made his way to his brother's place a couple of miles down the road.

Dellie had had her heart attack by then. I'd gotten a late-night call and driven into Asheville. Marthie, Tildie, and Mary were there, and a few grandchildren. Dellie was weak but alert. She gripped my hand, and it was still strong enough to hurt. I sensed she would get better. I went back to the hospital a few days later, and she was sitting up in a chair next to the bed. Her hair was combed, long and shiny. She wore a hospital gown and was barefooted, something I had never seen her do. We talked and she flirted with me, rubbing her feet on the back of my bare leg. I rubbed lotion on her feet.

In 1988, Dellie had her ninetieth birthday party at the Jesuit residence in Hot Springs. She wanted

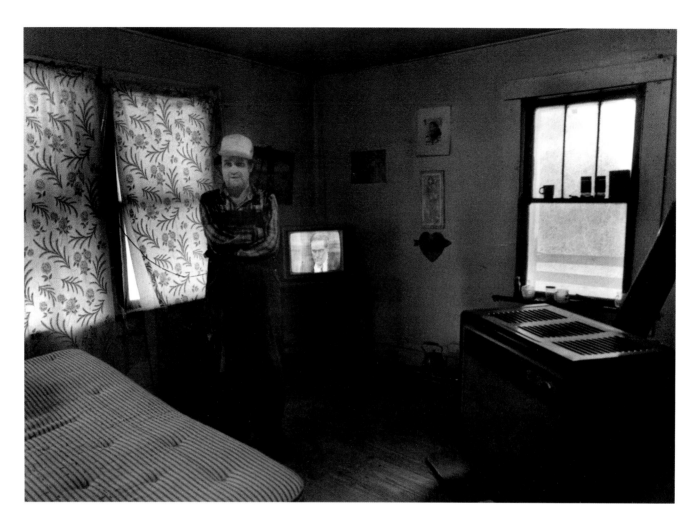

something more intimate and rowdy, but her house wasn't big enough. People came from all over the county and different parts of the country. Relatives, friends, admirers. There was music. A big cake. Some of us started the Dellie Norton Collection at Mars Hill College, and Sheila's daughter Melanie planned to organize it for class credit. Al-most five years later, two weeks short of her ninety-fifth birthday, Dellie passed. She had been saying she was ready to go, and I believed she meant it. She died of either a heart attack or a fall. Tildie was staying with her then, and she found Dellie on the floor next to her bed. Sheila called to give me the news.

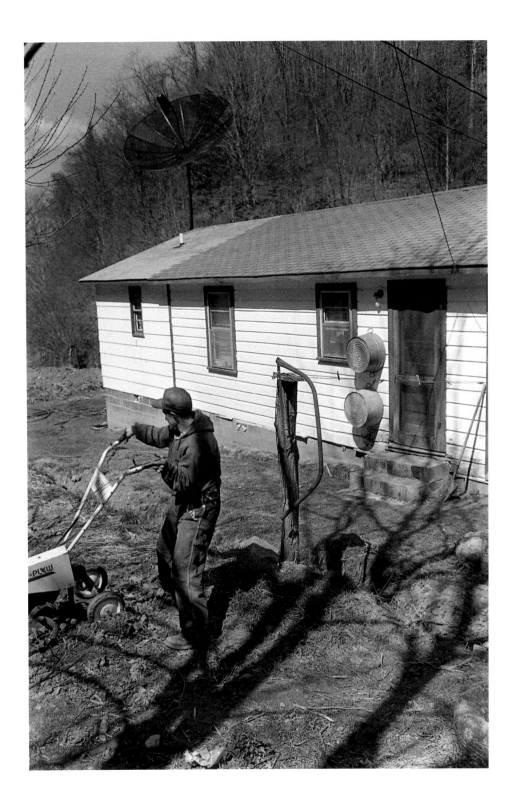

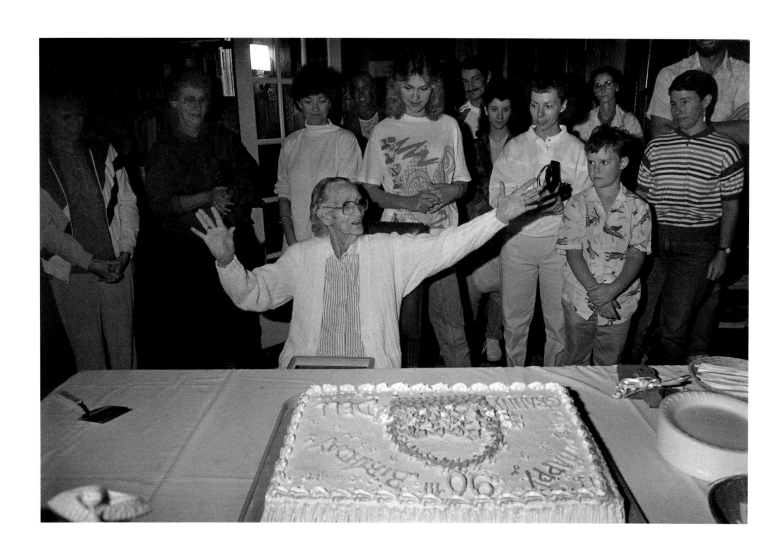

DELLIE NORTON I was very happy growing up. We didn't have much, but had plenty to eat. More to eat back then than you do now, and it was so much better. We raised all our eating. Daddy generally had two big hogs every year. Plenty of meat. He generally killed a beef every year. Have a big crib full of corn, pumpkins, kershaws. And then we made all kinds of cabbage, turnips, beans, soup beans, brush beans, and put up sixty-gallon barrels full of beans, kraut, and roasting ears, things such as that. And then you also strung them up with a needle and thread and dried them and made brush beans. You didn't shell them. You just cooked them in the hull with the bean in them. They used to be good, and I try to make me some every year. Brush beans; I string them up yet. I like them.

That bottom below the house used to be plumb full of the finest apples you ever eat, but they're about all blowed up and gone now. Winter apples, they was Ben Davis's. We took a notion to cut them out to tend the bottom. There used to be all kinds of different apples. We dried apples, peeled all day. Me and my mother, we'd do that. The next morning they'd be dry. Keep a fire on them. Winter apples were real hard and would keep all the time. We used to have an apple house. I've kept apples up in there under my basement. I went to the Sugarloaf Mountain and hauled in apples. Me and Doyle would go and haul in a truckload at a time.

We'd dry peaches and apples on a big kiln. Most anything you needed to eat, we had. We had plenty of milk and butter and kept two or three good milk cows. Chickens and eggs. We never did make no cheese. You didn't have to buy nothing unless it was a little coffee or a little flour, and you had to buy a little sugar. We had plenty of honey and molasses. We'd raise a big crop of them every year. There ain't no work going on like that to live now. It's awful to study about way back then and now.

If I could be young I'd like to go back. I loved to do that when I was young and able. Loved to work. I knowed a time you had to go to Hot Springs to get matches and salt. You'd go over and stay with some of your neighbors, go on home the next day. Just to get you some matches. If your fire went out, you had to get you this hickory bark or oak bark and keep a fire all the time. You could cover it up of the night, rake the ashes off of it, and it'd be a big bed of coals. All you had to do was lay your kindling on there. But I've seen Daddy take a flint rock and a knife and lay down cotton and start a fire. He'd put powder in the chimney, we didn't have stoves in them days, on a little rag or cotton or something and then take a hog rifle, put a cap on it, and shoot into it to start a fire when it'd go out. I've seen them put beef tallow in a bowl to make a light. Make them a wick and put it in that bowl and set it afire to make a light. Now them was hard times back then. Not many people can remember about them. But I can remember them good.

I wish I was back in them days again. I'd feel better. You didn't have all this stuff to worry about like you do now. You have to worry about paying light bills and all different kinds of things that you didn't have to worry about back then. Like getting out and going to Marshall or the bypath to get groceries. You didn't have to do stuff like that. You never got out of something to eat.

It's the young people. They don't know nothing about work or such as that. I seed my mammy set up nearly all night long and card big boxes of rolls and then spin them into thread. And then I've seed her sit up all night and weave and make carpets and make cloth to make pants. She raised sheep. We used to have sheep. She would shear them. I'd pick them burrs out with my fingers. I'd get so sore I couldn't move. She'd make us work. Now, she made a lot of money doing that.

I never did like mutton. I think them Ramseys that lived way down below us would kill sheep and eat them. I always had a weak stomach. I heard them talking, and my oldest sister's man said, "You can put that in, a big mouthful of it, and chaw it and chaw it till it'll go back to wool." And that turned me. I never did try a taste of it. I don't know if he was telling the truth or not, but that's what he said.

Now, my grandpa, he was a herb doctor. We didn't have to have these doctors like we do now and run around everywhere. He knowed what every-thing that grew in the mountains was good for. He had a big doctor book, and he studied it. Learned to doctor out of it. He knowed what to gather in to cure everything. He had good learning. I don't know where he got it at. He just picked it up himself. He'd read the Bible a lot. I don't think there was a school back then in them days when he was a youngun. He could read good. He could teach other younguns. He teached my sister to read. Mary, she used to stay with him. He'd help everybody. After he died, my daddy picked it up, a doctoring himself. He wouldn't hardly ever go to a doctor. He'd go into the mountains and gather his herbs of a summertime. Keep them all winter long and have them anytime he needed them. Sack them up where nothing could get in them.

We used to sell them. They was high, used to be. They used to have a big root house, they called it, up in Asheville, the lower end of Asheville. We'd take fifty and a hundred dollars worth at a time up there and sell it. And then they done away with that. It's been several years. I just couldn't remember when.

Now Grandpa, he charged. He could cure this, what do you call it? Some people calls it the clap, but it's a different name that these doctors use. Devil's Bite'd cure the worst cases of that ever was. It grows in the mountains. It was a root, down in the ground, and then there was another kind of root, they called it Queen of the Meadow. It'd cure

138

any kind of sore on you. He'd get it and boil it and either use tallow or lard, boil it down and make a salve out of it, and it'd cure any kind of sore. Boil the stuff down first and then mix it with the lard.

And then ginseng. It's good for high blood or shortness of breath, all kind of different things. You could make tea out of it. Grandpa always carried some in his pocket and would chew it, for high blood and heart failure. And it was good to make tea for fever and things like that. And that 'seng, you can put it in a little white whiskey, and if you've got the worst case of high blood or a headache, stomach aches, and things like that, dip you just a teaspoon full, twice a day, and it'll cure it. I know it will for I've tried it. I still use it.

Jimson weed will cure the piles. You can get it and the seeds and boil them and get hog lard and make a salve and cure people that's had to be turned over in sheets. Bleeding piles. There was a man at New River. Doctored, he said, for years and years. He had the bleeding kind. They had to turn him over in a sheet, and it'd be just as bloody as it could be. My mammy made him a pint of that, and he said he'd spent thousands of dollars, and it hadn't done him no good, and she cured him of it.

Old mullen root, you can dig it and make you a syrup out of it, and it cures that asthma. I cured one man with it that used to stay with us when he was just about dead. He'd doctored and doctored, and I told him if he'd take it, I'd make him some

syrup that'd cure it. And I went out and dug that, and he said he'd take it. And he got plumb better and picked up to where he'd go out and get wood and everything. He was an old man.

People died out that knowed about all this stuff. The young people now don't know about it, but now there's just plenty of stuff, a whole lot better than you can get from the doctors, cure you of anything you got. If you just knowed it all. The young people don't know what it'd take to get to help people. You can read the Bible, and it'll tell you how many different herbs grow in the mountains. There's a herb for every sickness, and it'll cure you.

You just had to make do back in them days. Make your own medicine or do without it. They couldn't get a doctor part of the time because there weren't no doctors to get. Part of the time you couldn't ever get up with Doc Burnett. He was the first doctor; he rode an old horse and would go everywhere a doctoring. He'd stay week in and wouldn't charge you anything. He was a good old doctor. Then there was one that lived at Walnut, Andrew McDevitt. He was a doctor. The first two doctors I ever seen. Didn't have any cars back in them days to go in, so you'd have to ride a horse if you went to Doc McDevitt. But Burnett was hard to find. He doctored all over Shelton Laurel, Spillcorn, and everywhere. He'd stay weeks at a time

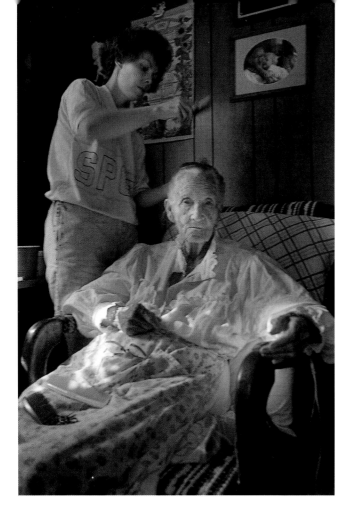

time I raised up, I'd faint. My nose bled so. Daddy, he got out and gathered this red willow. That's the best medicine for flu and fever ever was. He got out and would break it up. Get the tender limbs off and boil them and that would just cool you off if you had the highest fever ever was. He'd have you drink the water from it.

Bob Norton rode three days and nights before he found Doc Burnett and brought him in. He give me some pills. They stopped my nose from bleeding, but it had about stopped when Bob found him.

There were so many that died. All the pregnant women died. Every one of them. I knowed them all. Matthew Ramsey's wife died, and James McDevitt's wife died. James Davis's wife died. There'd be seven and eight dead at a time. Couldn't get people to strip them. They didn't take them to the funeral home back then like they do now. They had people in the community dig their graves, put their clothes on them, and bury them. Jack Ramsey used to make coffins. There was the awfulest bunch of pregnant women that died ever was. I think it was the fall of the year. My nose bled till every time I raised up, I'd faint. Nowadays, people will say they've got the flu, but they know nothing about the flu unless they had that kind.

with you. And they just had to hunt him up, ride till they found him.

It's been a long time ago. It was long before I was married. They had that bad flu through here. I don't remember what year, but I sure remember the time. I must have been about thirteen year old. I can remember it good. We lived right over there in that old big house. We all had the flu. Every

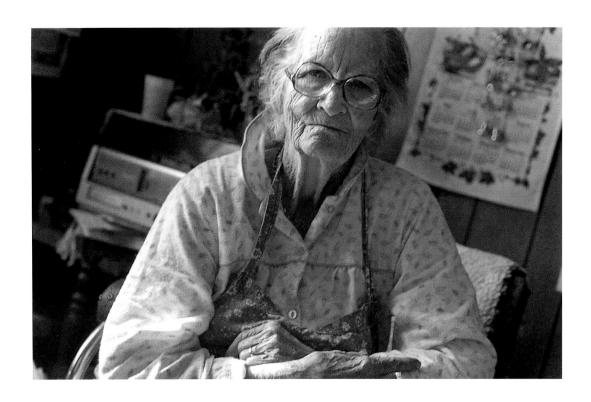

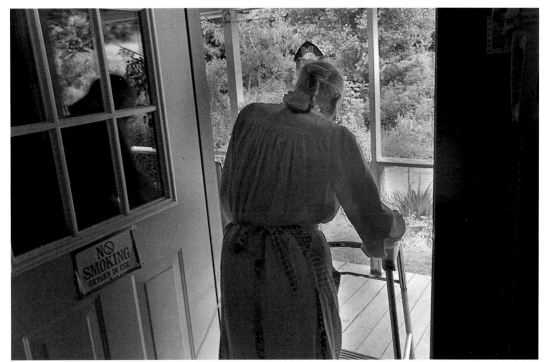

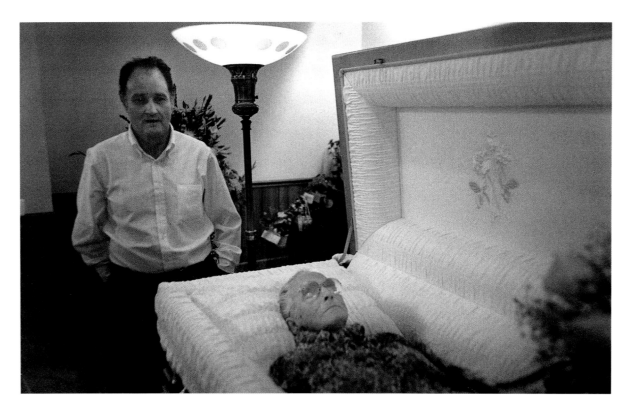

JUNIOR That was a sad funeral down there that day. Sad funeral. Sad funeral. I'm talking about my real mammy's funeral. Sad, sad, sad. Every one of my brothers and sisters was there. I saw my sisters about two years ago. That house was plumb full of people. Sad, sad. Even the preacher cried. I never seen a preacher cry before in my life.

They buried her here in Guntertown, up on a mountain, where my daddy's buried. She's right by my daddy. When I die I'm going to be right by my mother. I have some pictures of my mother when she was young. Yeah, even the preacher cried. I didn't see much of her after I came to live with Dellie. She rode off. She married again. She had one more child after my daddy died. That's all. He lives in Tennessee. She's got two dead, two little boys dead. They died when they was born. They're older than me. They're older than all of us. Twins, they were her first children. They're buried somewhere up on Lump Mountain. They died when they were born.

Then I come and stayed with Dellie up there. I was proud somebody got me. I'd have been dead. I was about dead anyway when Dellie got me, and I stayed with her and stayed with her. I'm still with her. Her husband died, and I helped her around up there. Raise baccer and corn and stuff. Garden, get the cow for her. Do them jobs for her, and I'll still be with her. When she drops off, I don't know what'll happen then.

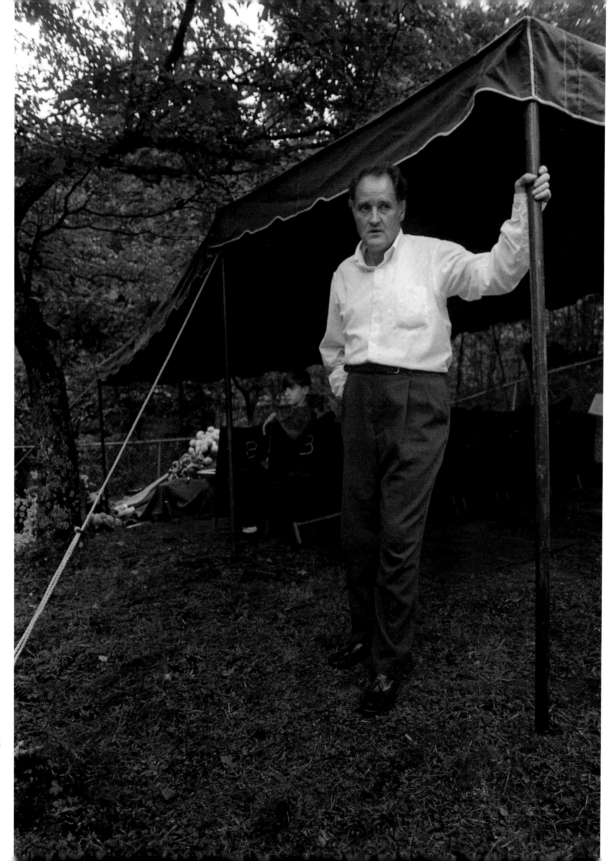

DELLIE NORTON They said they was giving them all away, you know. And I went down there to see if I could get one. I always enjoyed tending to children. That's one reason I got Junior. All my children was grown at that time. Teat was grown, and Mary and AB had got married. I just didn't want to be left alone without any younguns, and they said they was giving them all away. Well, everybody knowed it that she was giving them away after his daddy died. So, they give some in Tennessee. I think they give that oldest girl in Tennessee and the youngest one in Tennessee. Three of them was in Tennessee.

I got him at Belva. He was down there with one of his aunts. His mother had left him with one of his aunts. She had give all the rest of the children away but Junior. Their mother would've give them all away when they was sucking babies, if Junior's daddy had let her. I think they had seven—two girls and so many boys—when their daddy died.

He'd been sick a long time, not able to do nothing, and he just took a fever and died. Lived across the creek over there, back this side of White Rock. I knowed him all my life. I was kin to him. He was my aunt's boy, Junior's daddy. Me and his daddy was first cousins. His daddy was a preacher; he was a good man. After he got sick and everything, he weren't able to take care of his children. He wouldn't have ever let them take them away.

I knowed her. I knowed her long before her and Junior's daddy was married, but she was crippled up. She weren't able to do nothing, had both arms crooked. Born thataway. Now, they were more poor than most and didn't know how to do nothing or how to manage to get nothing, I guess. I'm just guessing about it. They didn't have nothing at all. I think he raised a little baccer. He tended lots of stuff. He owned the mountain up there, his daddy's place at Lumptown. Had a good place up there, till they just threw him out and he moved. Got that little place with the creek. They pretended to buy it from him, give him a cow and so much—sold the place for a cow and so much.

I don't know what would become of Junior if he was out in the world. Lord, he'd have to have help some way or another for he's hard to get along with. He'd get mad at somebody. He's easily made mad. They ain't nobody much can get along with him when he takes them, I call them, foolish spells. Nobody. Why he'll set in on me. Now, the week before last, I reckon, he set in because he put my head of lettuce down in the freezer, and a cucumber. I said, "Junior, I can't eat them now, they're froze hard as a rock." Lord, he cussed and cut the awfulest shine. He never done it. Weren't nobody else to do it. Awfulest shine over that you ever seed, and he was leaving, for me to hunt his clothes he had down here, pack them up. Well, I said, "If you have to leave, you have to leave, that's all I know." He pouted around here three or four days. He wasn't

going to do a thing. I said, "All right, suit yourself, I don't care if you do anything or not. I'll just do the best I can do. I'll do what I want to, but what I can't do, I'll let it go." He pouted around for two or three days, the lowliest person you ever seed. He takes them spells pretty often.

He'd get plenty enough money to keep him, plenty to eat and plenty to wear, if he had enough sense to take care of it. See, I get $366, I believe it is, for keeping him. That'd keep him something to eat if he knowed how to handle it, but I don't know if he'd know how to do that. I tried to tell him how to do, if I was gone, how to do with it, but I don't know if he'd do what I'd tell him to do. He couldn't sign a check. He'd have to get some of the younguns to do it for him. I don't know whether it'd come on in my name or not. It's in my name and his too. I suppose it would, and then Mary and Debby would take him out and get him something to eat if he'd let them. But I don't know whether he'd do that or not. He'd have to learn how to get by someway. I don't know how.

Junior couldn't ever get along if he ever got married. Now, there's a girl named Nanny Mae. Ross had them up in arms to marry, and I wouldn't let them marry. She was queer too, and I said, "Lord, what would them poor younguns do if they was to

marry?" Couldn't do nothing, couldn't have a home or nothing. Didn't neither one know enough to do housekeeping or how to make a living.

Course I got Junior learned how to work a little. Get wood, work in the fields, and things such as that. He's pretty good at things like that now. He didn't want to work a bit after I got him. I had to limb him a time or two. He'd just set down. "I ain't going to do a thing. I ain't going to do a thing." I just had to show him and make him do. I told him he had to work, had to learn to work, to do something. And I got him learned pretty good to help around with cows, help feed the calves and put them up, and things like that. He's as stout as a mule. Long before I sold all my cattle, I had cattle all around up there. I'd buy a hundred pounds of feed; he could just lift that up and tote it to the house. After he got big enough, sometimes I'd buy two hundred pounds and three at a time; he'd tote it. He learned to gear the horse and plow and things like that. He'd lay off ground good after he got big enough to do that. But when I first got him he didn't want to do nothing.

Junior couldn't ever learn nothing in school. I sent him nine year and he never learned nothing. He wouldn't try. He didn't like to go, I know that, said them other younguns was mean to him. I tried to learn him to have money, you know, to carry in his pocket and get his things at school. I'd give him

a dollar sometimes and put it in his pocket, and he'd come back without a cent. Just let them young-uns take it, and they said, them teachers, they couldn't do nothing with him. He'd just get up and go out, you know. Rosie, she was a teacher, said he would just set there and holler like a crow or something. "Quack, quack, quack." Worried her to death, said she'd have to hire him to behave. She hated to whoop him. She knowed he was queer, you know. They sent me word that he wasn't learning nothing, and it'd be better to keep him at home.

And you couldn't learn him nothing at home. I know, for I tried. I tried my best to learn him to read. He wouldn't try at all. He just didn't have learning in him. You could smack his jaws, and he'd turn his head off and wouldn't look at the book or nothing. He was just a queer kind of youngun. And still, he's funny. He wants his way about everything. You can't teach him much. His way, he thinks things and that's the way it goes with him, and he's easy to get mad. He gets mad at me and swears he's going to leave. I tell him to go on. You'll come back.

Junior wouldn't talk to nobody at all. I had to learn him to do that. I'd take him places with me, you know, and he'd just bow up, wouldn't speak a word. I took him up to Nepal and Ervin's to see their house. They was just a building that house

there, and he wouldn't speak a word. As I come back with him, I said, "Now, Junior, you've got to quit doing like that. I ain't going to whoop you this time, but if I ever take you with me again and you act thataway, when I get you back home, I will literally wear you out. I'm going to learn you some sense." And from that day on he'd always talk too much. Yeah, he'd talk too much. He was afeared I was going to whoop him. That's the way he was. I couldn't get him to speak a word to nobody when I first got him.

When I first got Junior, he wouldn't have weighed over ten pounds, I don't guess. They claimed he was four year old. I don't know exactly how old he was then. I went to Marshall, and they claimed he was six year old there. He was going to school, but he didn't look that old. A little, bitty thing, skinny and poor. He had big blisters all over his feet from wearing old shoes. He had a big pair of long girls' shoes on, women's shoes, when I got him, and a pair of girl's overalls, and a little old sweater. That's all he had on.

He couldn't hardly walk a step. They just drug him out to get shut of him, you know, and put him in the car. I didn't even know his name or nothing, and he couldn't hardly talk. They told me I'd have to take him and have him operated on for his back. He was all humped over. I took him to Doc

McElroy down in Marshall, and he told me all the youngun needed; he give me medicine for him, though all he needed was plenty to eat. That's what the doctor told me. Starvation. Well, probably, he's just born thataway and the starving made it worser.

Well, I had a time with him for eating too much. He got foundered when I first got him. He was starved to death, and he told me all he'd eat, his mother would set him down with an old tin bucket lid or something like that, was a few crackers or things like that.

When I first got him, he couldn't put a pair of gloves on his hands to save his life, and he couldn't tie his shoes. I tied his shoes for a year after I got him. Tried to put gloves on his hands in cold times; he couldn't put them on at all. When I first got him, if you give him money, he couldn't hold it. His hands was so crooked, he'd drop it out. They was building on that house up there, and Earl and all of them would give him nickels and dimes. They'd hit the floor. He couldn't hold them. They was crooked over, his hands, drawed up or something. They got better though, and now he can work with them good. Couldn't do nothing, used to.

There's been a lot of tough times, but he'd always calm down. He's what I guess you'd call retarded. I couldn't hardly now live without him because he helps me a lot. I can put my washing in my washing machine—the other day I had washed and I wasn't thinking about him having it hung out and dried, but he had it hung out and dried—and he done that yesterday. One day he hung it out though, and I had just put it in and washed it and hadn't rinsed it. Well, when I come back in, he had it hung out and dried, and I said, "Lord have mercy, Junior. You hadn't done that without you to catched rinsing water and rinsed it. They weren't rinsed, and you can't wear them like that." He went out and got them back in and hung them out again.

After

Sodom Laurel was first named Revere, and is still Revere on topographical maps, but I seldom hear anyone call it anything but Sodom. I asked Dellie how Sodom got its name. She said she didn't really know for sure but she had heard that years ago, when logging first came to the region, there were numerous logging camps and a lot of men away from home, with money and time on their hands. Violence and promiscuity were rampant. Dellie had heard that a preacher, upon arriving in Revere and having seen the residents firsthand, remarked, "You people are just like a bunch of Sodomites." The name stuck. Lately, partly for religious reasons and, of course, the negative connotations of the name Sodom, some community members have started using the name Revere again, and there is a Revere–Rice Cove Community Association. But also times have changed—the community is quieter than it used to be—Revere seems a more apt description of the place.

Dellie Norton received a North Carolina Folk Heritage Award from the North Carolina Arts Council in 1990, following in the footsteps of her nephew Doug Wallin, who had received one of the first awards the year before. In 1988, the Dellie Norton Collection was established at the Rural Life Museum at Mars Hill College. Dellie Norton died in September 1993. She was preceded in death by four of her five children: Malona, in 1936; Teat, in 1958; Marthie, in 1989; and Mary, in 1993.

Dellie's daughter **Tildie Payne** still lives in Madison County with her husband, Rubin. She spends her time gardening and preserving food, raising tobacco, and tending her grandson.

Junior, Simon Peter Norton, lives with his two brothers and their families. He is surrounded by nieces and nephews and their children. His disability benefits were discontinued after the nation's overhaul of the welfare system. He has a Dalmatian, tends a garden, and does odd jobs for neighbors and friends.

Most of Dellie's many grandchildren still live in the Sodom Laurel community of Madison County. They work at a variety of jobs—from electricians to schoolteachers—and are raising families of their own. Many of them sing and perform as musicians.

Berzilla Wallin, Dellie's sister, died in 1986. Her son **Doug Wallin** lived in Sodom Laurel with his brother, **Jack Wallin,** until his death at the age of 80 in March 2001. A year after he received the first North Carolina Folk Heritage Award, in 1989, Doug was awarded a National Heritage Fellowship from the National Endowment of the Arts. A compact disc of Doug and Jack's music, *Family Songs and Stories from the North Carolina Mountains,* is available from Smithsonian Folkways Recordings.

Sheila Kay Adams has gone on to national prominence as a ballad singer and storyteller. *Come Go Home with Me,* her book of stories about growing up with Dellie in Sodom Laurel, was published by the University of North Carolina Press in 1995. She has her own recording label called Granny Dell Records.

Rob Amberg lives on a hundred-acre farm in the Paw Paw community of Madison County with his wife, Leslie Stilwell, and their two children, Ben and Kate. They raise gardens and goats, heat with wood, and get their water from a spring. Rob is currently documenting the construction of the I-26 corridor as it cuts through eastern Madison County, just ten miles from Sodom Laurel.

Notes to Photographs

NOTES TO PHOTOGRAPHS

PAGE 9. Junior's bedroom, 1977

PAGE 10. Dellie fixing a meal for her pets, 1977. After breakfast, Dellie fed her many cats and dogs leftover gravy and biscuits mixed with animal food.

PAGE 11. Dellie doing laundry on the side porch, 1975. Dellie had her electric wringer washer for years and considered it a marked improvement over the washboard and kettle.

PAGE 12. Junior repairing the spring, which ran from a rock behind Dellie's house into a stone spring box, 1976. Occasionally, salamanders and crawdads, signs of water purity, would turn the flow of water away from the box. They would have to be dislodged and the water turned back to the box.

PAGE 13. Outside at Dellie's, 1977–78: the fuel oil barrel *(top, left)*, the shed and pear tree behind the house *(top, right)*, the wood shed *(bottom, left)*; Dellie taking a break from handing tobacco *(bottom, right)*

PAGE 14. Dellie and Junior, 1978

PAGE 15. Junior and the jumping cat, 1975. Dellie always tried to have among her many pets a white cat she could train to jump through her arms.

PAGE 16. Dellie's pig and calf, 1977. For most of her life Dellie had raised animals for both sale and home use, and she was still doing so the first few years I knew her.

PAGE 17. Junior and Pet, 1978. Horses were still common in the community when I first arrived and did a variety of jobs including plowing, hauling tobacco and firewood, laying off rows, and cultivating. Their manure was also a main source of fertilizer.

PAGE 18. Dellie milking her cow, 1977. Dellie milked until she moved to the lower house in 1979. She sold milk and butter for extra income, although I never saw her make butter during my time with her.

II. Planting Tobacco

PAGE 23. Junior plowing ground with Pet, Teat Holler, 1975. The first step in preparing the ground is turning the soil deeply in the early spring so it will air out and break down easily.

PAGE 24. Doug Wallin sowing his tobacco seed bed, Craine Branch, 1978. Doug's tobacco bed was six by fifty feet and had been sterilized with gas. Tobacco seed is extremely small and is mixed with a bucket of wood ash to insure even distribution. The bed is sowed in March and covered with plastic and then, later, with cloth mesh.

PAGE 26. Doyle Roberts pulling tobacco plants from a seed bed, Big Pine, 1989. Plants are pulled individually, placed in boxes, and transported to the field.

PAGE 27. Charles Massey spraying the ground with herbicides and pesticides in preparation for planting, Big Pine, 1982 *(top)*. Tobacco is highly susceptible to pests and disease, especially Blue Mold in recent years, and spraying is necessary throughout the life of the crop. McKinley Massey family and neighbors carrying tobacco plants to the field for planting, Big Pine, 1982 *(bottom)*.

PAGE 28. McKinley Massey family and neighbors planting tobacco, Big Pine, 1982 *(top)*. Because of Madison County's topography, much of the tobacco crop is planted by hand. One person walks along the row dropping plants, followed by a second person who punches a hole in the ground and sets the plant. Tilman Chandler's barn and tobacco, Ben Cove, 1975 *(bottom)*.

PAGE 29. Junior hoeing tobacco, 1976 *(top)*. Dellie's grandson Larry Norton taking a break from plowing tobacco at Dellie's place, 1975 *(bottom)*. Dellie, like her father, insisted the tobacco be plowed and hoed three times for weed control and cultivating.

PAGE 31. Dellie topping and suckering her tobacco, 1976. About midway through the crop's life, the plant produces a sucker leaf between the stalk and each main leaf. The suckers sap strength from the main leaves and must be broken off or cut out. The plant also flowers at the top; these must be cut off to allow the leaves to put on tar and weight.

III. Generations

PAGE 33. Junior in the living room, 1976. Electricity wasn't available to most Madison County communities until the 1950s, and most people didn't have televisions until the 1960s. The first satellite dishes began dotting the landscape in the late 1970s.

PAGE 34. Inez Chandler, a sister of Dellie's son-in-law Joe Chandler, holding her christening dress, 1977. Inez regularly sang in the community but was very rarely included in festivals or on record albums. Her two sons and a number of her grandchildren have continued in the family's musical tradition.

PAGE 36. Dellie's grandson Clinton Norton, Mary and AB's youngest son, holding his Robin doll, 1977

PAGE 37. Dellie's granddaughter Delline Norton, Clinton's younger sister, in Mary and AB's living room, 1977

PAGE 38. Clinton Norton waiting for the bus on the first day of school, 1977

PAGE 39. At Ramsey's store, 1977. Sitting around out front *(top)*. Donald Norton, one of Dellie's second cousins,

with his sons, Donnie and Donavan *(bottom)*. Sodom's two stores, Rube's and Ramsey's, were where people went for community news and gossip.

PAGE 40. Clinton Norton and Junior on Dellie's porch, 1977

PAGE 41. Marthie and Joe Chandler's trailer, Ben Cove, 1977. By the late 1970s, many county residents had moved trailers onto their property. A trailer was an affordable alternative to the cost of renovating the older home places.

PAGE 42. Dellie's great-granddaughter (Marthie's granddaughter) Denise Chandler in her front yard, Ben Cove, 1977

PAGE 43. Vicky Ray, her mother, Zenobia, and Dellie's great-grandson Donnie Norton, on Vicky's prom night at Madison High School, 1977

PAGE 44. Dellie's grandson Joe Ross Chandler at the door of his parents' trailer, Ben Cove, 1976

PAGE 45. Joyce Chandler, Joe Ross's wife, in the living room of Marthie and Joe's trailer, Ben Cove, 1976

PAGE 46. Ku Klux Klan rally, Wolf Laurel, 1976. The Klan never had much recruiting success in the mountains but would, on occasion, hold membership rallies. The barn where this one was held was used for cockfighting.

PAGE 47. Bobby Cantrell *(left)* and Joe Ross Chandler, Burton Cove Road, 1977. A gang of men parked at the bottom of the road one afternoon; they had a couple of cases of beer in the back of a truck and plenty of guns and ammo. They were trying to shoot the one street light in Sodom off its pole. It wasn't an unusual occurrence, and most people just stayed out of their way.

PAGE 48. Tildie talking to her daughter Glenna, Brush Creek, 1977

PAGE 51. Tildie making strawberry jam at her place on Caney Fork, 1994

PAGE 52. Joe Chandler, Dellie's son-in-law, and his son, Robert, in front of Dellie's barn, 1977. Every family owned at least one gun—for hunting, killing farm animals, keeping groundhogs under control, and protection.

PAGE 53. Joe Bullman and his cows, Lonesome Mountain, 1976 *(top)*. Cattle is a commodity easily raised in the mountains and has long been a source of cash income. Mac Davis and a friend butchering a hog in Mac's side yard, 1975 *(bottom)*. The first step is to scrape all the hair off.

PAGE 54. Charles Chandler, Inez Chandler's grandson, 1978. Charles, an accomplished musician at an early age, continues to play the fiddle in a gospel quartet.

PAGE 55. Jim Wallin, a distant relation of Berzilla Wallin, holding a royalty check for a song he wrote, 1977

PAGE 58. Clinton Norton and Dellie on her front porch, 1977

IV. Harvesting Tobacco

PAGE 61. Junior riding a sled to the field to haul in tobacco, 1976. Sleds were attached to a horse or mule and used for transporting crops, firewood, and rocks.

PAGE 62. A migrant farmworker cutting tobacco plants and spudding them on to sticks, Upper Brush Creek, 1993. Hispanic farmworkers began coming to Madison County in the mid-1980s and now do a vast majority of the tobacco labor in the county. Individual plants are cut and spudded onto sticks which are then left in the field for a few days to speed the drying process.

PAGE 64. A field of cut burley tobacco, Upper Brush Creek, 1993. After individual plants are cut and spudded on to the sticks (usually six plants per stick), the sticks are left in the field for a few days to speed the drying process.

PAGE 65. Hispanic migrant farm workers hauling sticks of tobacco, Upper Brush Creek, 1993. The sticks are loaded onto a truck or sled and taken to the barn for curing.

PAGE 66. Juanita Shelton guiding a driver with a truck load of just-harvested tobacco as he backs up to her barn, Hopewell, 1983

PAGE 67. Sixteen-year-old Angie Shelton unloading tobacco, Hopewell, 1983. The tobacco sticks, which usually hold six plants, are moved one by one into the barn.

PAGE 68. The Shelton's barn, Hopewell, 1983. Angie and Juanita Shelton unloading tobacco *(top)*. Juanita Shelton hauling tobacco in for hanging *(bottom)*.

PAGE 69. Hoy Shelton handing up a stick of tobacco plants to be hung from the tier poles for curing, Hopewell, 1983

PAGE 70. Angie Shelton and her family picking up tobacco leaves, Hopewell, 1983. Leaves are always falling to the ground while the sticks are being hung. The children usually gather, tie, and hang the stray leaves for curing.

PAGE 72. Dellie and her cow Pet in the barn with tobacco curing overhead, Burton Cove, 1977.

V. On the Porch

PAGE 73. Junior on the porch, 1977

PAGE 74. Dellie's porch, 1978

PAGE 76. Delline dancing to a fiddle tune, 1978. Musicians often gathered to play on Dellie's porch.

NOTES TO PHOTOGRAPHS

PAGE 77. Dellie stringing beans while Nancy Morris, a young musician from Florida who lived with Dellie for six months, plays guitar, 1975

PAGE 78. Mary Norton, Dellie's youngest daughter, 1977.

PAGE 79. Dellie playing a game of setback with Marthie, Junior, and Joe, 1977

PAGE xx. Dellie combing her hair, 1978

PAGE xx. Film crew working on a scene for the movie *Amazing Grace: America in Song* on Dellie's porch, 1975. The film was produced by Allen Miller and was broadcast on PBS in the late 1970s.

PAGE xx. Dellie playing banjo with her daughter Mary's husband, AB, Junior, and musician David Holt, 1978. Dellie kept a variety of instruments around the house but didn't play any of them with much proficiency.

VI. With Junior

PAGE 87. Junior in my studio, 1983. From 1983 to 1985 I had a photography studio in downtown Marshall that also briefly served as my residence.

PAGE 88. Junior at the High Rock, 1976. The long, steep walk up to the High Rock, a granite out-cropping with the two circular holes in the face, was one of my first rites of passage when I came to Dellie's. Dellie told stories about High Rock. She'd heard that years ago the native people had stored their food in the holes to protect it from animals, and that the women had put their babies in the holes to keep them safe when they collected berries at the top of the mountain.

PAGE 90. Junior, the "Hippie from Mississippi," on his way to the High Rock, 1976. When Joe Chandler saw this picture, he said "Junior looks like the 'Hippie from Mississippi'"; the title stuck.

PAGE 91. Junior at the upper house after Dellie moved, 1979

PAGE 92. Junior, 1981

PAGE 93. Junior, 1977

PAGE 94. Junior getting a shave and haircut from Mary at the lower house, 1986. Junior's grooming had more to do with the weather than any sense of style, and Mary was his barber of choice.

PAGE 97. Junior, 1979

PAGE 98. Junior hauling corn fodder to the barn, 1976. After corn has ripened and the ears hardened, the leaves, or fodder, are stripped off and fed to the horse, cow, and pig. The ears are then harvested and the kernels broken from the cob and ground into feed.

PAGE 99. Junior holding the Hippie from Mississippi picture, 1984 *(top)*. Junior taking a picture of Dellie and David Holt, holding his son Zeb, in her front yard, 1978 *(bottom)*.

VII. At the Tobacco Market

PAGE 101. Contact sheet of Junior taking down cured tobacco from the tier poles so it can be worked into "hands," 1977

PAGE 102. Junior in the barn, 1977

PAGE 104. Dellie tying the leaves into hands, 1976. Leaves are pulled from the stalks, graded, and tied into firm bundles, which are then packed into baskets in a circular fashion.

PAGE 105. Handed burley tobacco, 1981. Bundles were generally about four feet in diameter and three to five feet high and weighed anywhere from 250 to 500 pounds. The tobacco-laden baskets were moved around the warehouse on manual dollies; these days they use gas-powered forklifts.

PAGE 106. Warehouse workers unloading tobacco, Planters Warehouse, Asheville, 1981

PAGE 107. At the main entrance to Planters Warehouse, Asheville, 1994. Planters is one of the few warehouses still in operation.

PAGE 108. Spreading out wet leaves to dry at the market, Planters Warehouse, Asheville, 1988. This farmer's leaves were graded wet; in an effort to get a better price, he is trying to dry them out.

PAGE 109. K. Stark, a tobacco buyer for the Western Tobacco Company, bidding on a crop of tobacco, Planters Warehouse, Asheville, 1994

PAGE 110. Warehouse worker loading tobacco that's been purchased for shipment to a factory, 1981. Madison County farmers usually sold their crops in Asheville or Greenville, Tennessee. From there, the tobacco was shipped to factories in the North Carolina Piedmont or Virginia.

PAGE 112. Janice Rice, Dellie's grandson Larry's ex-wife, waiting for her tobacco check, Planters Warehouse, Asheville, 1994. Since tobacco was first introduced to western North Carolina (around 1915), it has been the main, sometimes only, source of cash income in the mountains. Today, tobacco is still Madison County's

primary crop, but the poundage farmers produce has dropped dramatically since the demise of the Federal tobacco program. Efforts have been made to move farmers to other crops, notably organics, ornamentals, and Christmas trees.

VIII. Visiting

PAGE 113. Junior and Joe Chandler on Dellie's porch, 1977

PAGE 114. Dellie's sister Berzilla Wallin holding a picture of the Wallin family band, Craine Branch, 1977. Craine Branch was only a mile or two from Dellie's home in the Burton Cove. The two sisters were close and visited often, walking in the early years and, later, driving when transportation was available.

PAGE 116. Liz Franklin in her home, Madison County's Chapel Hill community, 1975. Liz's son, Ernie, was a friend of Berzilla's husband, Lee, and often played music with the family.

PAGE 117. Dellie's aunt Zipporah Rice at home, Rice Cove, 1976 *(top)*. Aunt Zip was 96 when I took this photograph. She broke her leg when she was 101; after that, she negotiated her rocky front yard with a walker. She lived to be 105. Zipporah sang for Cecil Sharp when he collected ballads in Madison County and is included in his definitive volume of North American folk music. Rice Cove was about five miles from Sodom Laurel but was considered part of the Sodom community. Junior playing with my daughter, Kate, at Dellie's lower house, 1992 *(bottom)*.

PAGE 118. Dellie and Berzilla singing ballads at Marshall Elementary School on Blannahassit Island, downtown Marshall, 1978. In addition to performing at festivals around the country, they often performed close to home for schools, fish frys, and round-robins. In a round-robin, singers take turns performing songs of their own choosing.

PAGE 120. Dellie singing at the North Carolina Bicentennial Folklife Festival, Eno River State Park, Durham, North Carolina, July 1976

PAGE 121. Berzilla buck dancing on stage at the North Carolina Bicentennial Folklife Festival, Eno River State Park, Durham, North Carolina, July 1976

PAGE 122. Berzilla and fiddler Ernie Franklin, 1975

PAGE 123. Doug Wallin fiddling in his living room, Craine Branch, 1977. Doug was a skilled fiddle player and many people consider him to be the best ballad singer the community ever produced. Doug's playful delivery

and his lack of outside influences, not to mention his vast repertoire of songs, produced a quality in his music that is unmatched.

PAGE 124. Cas, Berzilla's brother-in-law, and Virgie Wallin at their home, Ben Cove, 1976.

PAGE 125. Junior's brother Willard Norton and Patterson Wilde at Bonnie Chandler's family reunion, 1977

PAGE 126. Bonnie Chandler, who's first husband was a cousin of Dellie's father, preparing to throw her bouquet during her wedding to Jim Crow, Rice Cove, 1978 *(top)*. Micky and Pattie Chandler's wedding at Bonnie's house, Rice Cove, 1978 *(bottom)*.

PAGE 127. Bonnie Chandler's family reunions, Rice Cove: Bonnie Chandler *(kneeling, left foreground)* and her children, 1976 *(top)*; food table, 1977 *(bottom)*. Many Madison County families continue to have annual homecomings.

PAGE 128. The annual Rice Cove Cemetery grave decoration: praying, 1976 *(top)*; singing, 1977 *(bottom)*. The Rice Cove Cemetery is a community cemetery not associated with any particular church. At decoration time, preachers from a number of churches are invited to participate in the ceremony. Grave decorations are usually connected to family reunions and take place during the summer months at all the county's cemeteries. The old flowers are removed, the graves raked and mounded, and new plastic flowers put on all the graves.

PAGE 129. A newly dug grave at the annual Rice Cove Cemetery grave decoration, 1977 *(top)*. Dellie placing flowers on a grave at a small cemetery on Lump Mountain, 1978.

IX. Leaving

PAGE 131. Dellie holding a photograph of her father, Mart Chandler, 1993. Family loyalty was the guiding force in Dellie's life, and her father was the primary influence on her.

PAGE 132. Dellie's wringer washer and the Hippie from Mississippi picture, 1990

PAGE 134. Junior in Dellie's old living room after she moved to the lower house, 1990

PAGE 135. Junior tilling the garden at the lower place, 1986

PAGE 136. Dellie at her ninetieth birthday party at the Jesuit residence, Hot Springs, 1988. Dellie had five children, thirteen grandchildren, and fourteen great-grandchildren at the time of her death. She also raised Junior, her husband's three children from an earlier marriage, and numerous other children who stayed with her for varying amounts of time.

NOTES TO PHOTOGRAPHS

PAGE 140. Debby Chandler, Mary and AB's oldest daughter, combing Dellie's hair after her stroke, 1991

PAGE 141. Dellie looking fierce in her living room at the lower house, 1986 *(top)*. Dellie walking out to the porch, 1993 *(bottom)*.

PAGE 143. Junior at Dellie's funeral, Marshall, 1993

PAGE 144. Junior by Dellie's funeral tent, Ben Cove, 1993

Acknowledgments

This book has been a long time in the making, and I've been thinking and talking about it for much longer than that. Consequently, there are many people to thank. I haven't remembered everyone but trust my aging memory will be forgiven.

My friends Joe Grittani and Bill Tydeman have been with Sodom Laurel Album from the beginning. They've put in years listening to my whining and procrastination. And they have read draft after draft, all the while offering solid, calming, well-thought-out advice, each pushing me forward in his own distinct way. A person couldn't have better friends.

My first photography instructor, David Lee Guss, was instrumental in helping me understand the importance of concentrating my efforts in one place over a long period of time. A weekend workshop with photographer Charles Harbutt showed me about the beauty of the moment, of instinct. Earl Dotter taught me how to print, although it's only in my dreams that I can make prints with his intensity and control. Also, Earl's understanding of the business of photography, and his willingness to share that knowledge with me, has been invaluable. For the first five years of this project, and the last two or three, John Rountree was my sounding board, and foil. His clarity of thought and his ability to communicate ideas have helped me to see.

Tom Gilmartin, former director of the Asheville Art Museum, took a risk by showing some of these photographs in 1977 when photography and folk culture were less in vogue with museums than they are now. The museum's current director, Pam Myers, also has an avid interest in photography, and she has done much to promote the medium. I deeply appreciate the Asheville Art Museum's long-term support of this work, and their efforts to bring photography to a wider audience.

Other good people have offered ideas and support over the years: Allen Tullos, Harvey Wang, Ben Porter, Paul Kwilecki, Lu Ann Jones, Charlie Thompson, John Cram, David Holt, Ralph Burns, Ken Bloom, Laura Ball, Keith Flynn, Helen Robinson, Clyde Edgerton, Bob Brunk, Barbara Amberg, Marianne Stapinski, Jim Neadstine, Chan Gordon, and Harlan Gradin. I am eternally grateful to Sheila Kay Adams, my friend and collaborator, who took me to Sodom the first time.

Institutions have been crucial to the completion of this book. Financial support has come from the John Simon Guggenheim Foundation, the National Endowment for the Arts, the Southern Arts Federation, the Appalachian Consortium, Mars Hill College, the North Carolina Arts Council, and the North Carolina Humanities Council.

My publishers, the University of North Carolina Press and the Center for Documentary Studies at Duke University, have been enthusiastic collaborators in this book. Their belief in this work has been important to me, and their staffs are a pleasure to work with: editor David Perry, and his assistant, Mark Simpson-Vos, at UNC Press; and Courtney Reid-Eaton, Bonnie Campbell, Alexa Dilworth, Cyndy Severns, Greg Britz, Dan Partridge, and Lynn McKnight, all at CDS. Tom Rankin, director of the Center for Documentary Studies, has been an inspiration—his work ethic, commitment to the "local," and selflessness are values we should all emulate.

ACKNOWLEDGMENTS

Every author should be so lucky as to work with an editor as gifted as Iris Tillman Hill. I asked her to marry me today. Early on Iris made clear her commitment to this book, and she put in countless hours taking a raw body of work and shaping it into the book you hold in your hands. Most important, from my point of view, she truly understood my ideas for the book and worked to bring those ideas into a concise, coherent, creative whole. While our collaboration hasn't always been easy, it always has been challenging, instructive, and rewarding.

Madison County is my home; it's where I'm most comfortable and feel most accepted. The mountains envelope you and hold you close. The people are accepting, open, and make you feel welcome. In Sodom Laurel, numerous people and families went out of their way for me. They acted as guides and teachers and remain my friends and neighbors. In particular, Marion and Eloise Chandler; Harlon and Debby Chandler; Clinton Norton; Tildie and Ruben Payne and their daughter, Glenna Gunter; AB Norton; Delline Cook; Allen and Lucy Norton; Dustin Ramsey; Jack Wallin; and Willard and Annie Fay Norton. Many of the people who helped me have died, among them, Dellie's daughters, Marthie Chandler and Mary Norton, and Marthie's husband, Joe Chandler, who gave me my first flock of chickens. Bonnie Chandler. Berzilla Wallin, Doug Wallin, and Evelyn Ramsey.

Dellie Norton and Junior Norton changed my life. There is no way to repay them for their gifts to me, except to say thank you.

My family, Leslie, Ben, and Kate, have provided the support, love, and structure that's allowed me to finish this work. *Sodom Laurel Album* wouldn't have happened without them.

WITH THE UNACCOMPANIED by Allen Tullos

Sodom Laurel Album

Appalachian Ballads from Madison County, North Carolina

Songs by Dellie Norton, Cas Wallin, Berzilla Wallin, Doug Wallin, Evelyn Ramsey, Edison Ramsey, and Sheila Kay Adams

Lodged in Madison County, the ballads, songs, and memories heard on this collection crisscross generations and geographies, bridge regions of dread and joy. Booming and quavering, the singers pour forth certainties and quandaries, call down judgment, walk thin ice that covers deep feeling. You'd think that in our millennial sunrise, the assembled figures here—lily-white maids, dreaming drunkards, prodigal fathers, abject bodies in cold winding sheets, naked sleeping lovers—would have worn themselves into patchy clichés and exhausted turns of phrase, having long ago met their fatal doom in some dark holler. Yet, as mortality twists and turns, human fragility remains, and so too the stubbornness to tie it in fine knots.

To what lengths mountain voices and a fiddle go to evoke the gliding years. Collected from the Norton, Wallin, Ramsey, and Chandler families of Sodom Laurel during the last quarter of the twentieth century, this music mixes Anglo-Celtic balladry, "new book" religious songs, blues ballads, broadside remnants, the skeletons of danceable tunes, the echoes of parlor melody, and Temperance tract. Expect the imagery and the haunting tones of "Conversation with Death" to break out chills, the sing-songy jingle of "Little Mohee" to break out the coconuts. This is not so much weirdness, as some have written, out where the blacktop ends, over in the minor key. No more than your breakfast cereal or cup of tea. Just the traces of folk and popular culture across a particular place's past. If you lived here you'd be home by now.

About "Little Sadie," Doug Wallin says, "Actually, I don't know whether this song is American, English, or what. I heard somebody sing it some years ago. I believe, if I'm not mistaken, it's in Sharp's book." He's right about the last, as he knows full well, while leaving something for grad students and ballad mongers to sort out. Which version came first? What are its roots and routes? As "Bad Lee Brown," "Little Sadie" nests among the "Ballads of the Negro" in G. Malcolm Laws *Native American Balladry* (1950, 1964), testifying to a racial lineage as mixed as that found in these mountains. "Little Sadie" circulates in many places almost at once: sung by Riley Puckett in Jim Crow Georgia, collected by Lomaxes at Parchman Penitentiary in Mississippi, performed by Doc Watson and Tom Ashley on a landmark Folkways album.

There are several ballads here that were already well known in the region when Cecil Sharp, Maud Karpeles, and Olive Dame Campbell included them in *English Folk Songs from the Southern Appalachians* (1917). "Pretty Saro," Dellie Norton remembers, is "about the oldest song around. I've heared Mother sing that many of a time when I was just little. That was her favorite song."

WITH THE UNACCOMPANIED

Pitched between Berzilla Wallin, born in 1893, and Shelia Kay Adams, in her mid-twenties when she recorded "Pretty Fair Miss" in 1976, each piece in this Madison County anthology comes streaming such trails of assertion and speculation as "Little Sadie" and "Pretty Saro." Ballads of love and worldly experience might be learned while drinking Dellie's homemade wine and sitting up all night with friends and relations, or while hoeing corn all day in a neighbor's field. "We camped out to tend tobacco or make molasses," remembers Cas Wallin. "We'd make us some benches and sit around singing these old songs. One of us would sing one, then another would sing one. You could hear us way off. All of us had big voices."

Characteristically, traditional ballad lyrics present a sudden shifting of imagistic scenes in which the pre-snapshot world ("His face you'll never see again") of their creation now seems a modern cinematic style. Poetic asperity bites down one minute, and jackleg word-jimmying the next. Jealous and touchy at a perceived slight. Faithful and long-suffering in anonymity. Then, surprise, as a piece of sentimental fodder rips the wary heart.

"Shady Grove," the cleaving of longed-for person and place.

The surreal desire voiced in "Dearest Dear":

I wish your breast was made of glass
your heart I might behold

the singer intent on possession

Upon it I would write my name
in letters of bright gold.

Religious singing centered around church services, revival meetings, and cemetery decoration days, or en route, when people piled into a wagon. "We used to go to singing school," recalled Dellie. "Matthew Ramsey, he was a Sunday School teacher, had singing lessons at the Low Gap Church. They'd have them probably twice a week sometimes. . . . The boys in Cas's family sang in quartets. And so did Lee [Wallin]'s and my sister's boys. . . . That Lee, he was a sight. He worked off on jobs and he get these songs and bring them in and tell tales."

A box of rain here, a handful of dust there. Sprinkle the gospel pages. In this Madison County collection we sample vintage ingredients like those that helped stir country music to life, that nurtured the Folk Revival and various Seegers, that fed the poetics of musical artists like Bob Dylan and the Grateful Dead, the permutations of Gillian Welch. Not to mention a younger generation of Appalachian-born singers. People have sung the last farewell to old-time balladry too many times to think it stops.

About the Audio Collection

Sodom Laurel Album would be incomplete without the sounds of the voices of the ballad singers from Madison County. From the early 1960s Daniel Patterson encouraged his graduate students at the University of North Carolina to go out into the field and make recordings of traditional Southern music. Patterson, who became Kenan Professor of English and Chair of the Curriculum in Folklore at UNC–Chapel Hill until his retirement in 1998, created the North Carolina Archive of Folklore and Music in the 1960s. This Archive has grown to become the Southern Folklife Collection at the University's Wilson Library. As a result, almost thirty years later, we are able to produce the compact disc that accompanies this book, and we owe our greatest and first debt of thanks to Dan Patterson.

Recordings of Cas Wallin and Cas singing with Evelyn and Edison Ramsey were made at Cas's home in 1976; the oral history with Dellie Norton was recorded at her home around the same time. These recordings were all made by Allen Tullos, then a graduate student in folklore at UNC, currently associate professor of American studies at Emory University. Tullos collected this material for a radio program about Cas Wallin that he produced. The program aired on WUNC-FM in a series of five broadcasts on North Carolina folk traditions under Patterson's direction. Tullos generously gave us permission to use his field recordings, and we thank him for sharing his work with us and for agreeing to write a brief essay about the Madison County ballad tradition.

Tracks 6, 7, 10, 11, 13, 15, 16, and 18 were mastered from recordings made during the singers' performances on the Main and Mountain Stages at the North Carolina Bicentennial Folklife Festival, Eno River State Park, Durham, North Carolina, July 3–5, 1976, by festival staff, George Holt, director. The recording of "Young Emily" sung by Dellie Norton was made during a Ballad Workshop in April 1975 at the North Carolina Folklife Festival at Duke University, also directed by Holt.

Recordings of Doug Wallin were made at his home by Wayne Martin and George Holt in 1992 and 1993. From these recordings Martin produced a record for Smithsonian Folkways, *Doug and Jack Wallin: Family Songs and Stories from the North Carolina Mountains,* issued in 1995. In selecting the final playlist Martin was not able to include many wonderful songs, and he offered us use of his outtakes. We thank him not only for loaning us the outtakes, mastered by Wes Lachot of Overdub Lane in Chapel Hill, but also for encouraging our early plans to produce a record album of the Madison County ballad singers.

All the original field recordings for *Sodom Laurel Album* are deposited in the Southern Folklife Collection at UNC's Wilson Library. The Southern Folklife Collection is a national and regional treasure, and we thank Steve Weiss, SFC's director, for his support and cooperation; Amy Davis, former library technical assistant, for help in searching the holdings for materials on Dellie Norton. We are especially grateful to Jeff Carroll, audio preservation and restoration engineer, for his technical skills, knowledge, patience, and keen ear.

—IRIS TILLMAN HILL

Audio Collection Playlist

Sodom Laurel Album

Appalachian Ballads from Madison County, North Carolina

Songs by Dellie Norton, Cas Wallin, Berzilla Wallin, Doug Wallin, Evelyn Ramsey, Edison Ramsey, and Sheila Kay Adams

1 Pretty Saro *Cas Wallin*

2 *Cas Wallin* talks about "Pretty Saro" and "Fine Sally"

3 Fine Sally *Cas Wallin*

4 *Dellie Norton* talks with Allen Tullos

5 Young Emily *Dellie Norton*

6 Black Sheep *Cas Wallin*

7 The Drunkard Song *Berzilla Wallin*

8 Pretty Peggy-O *Doug Wallin*

9 Little Sadie *Doug Wallin*

10 A Soldier Traveling from the North *Dellie Norton*

11 The Dying Boy *Dellie Norton*

12 Little Margaret *Doug Wallin*

13 Little Mohee *Dellie Norton*

14 Dearest Dear *Doug Wallin*

15 Black Is the Color *Evelyn Ramsey*

16 Pretty Fair Miss *Sheila Kay Adams*

17 Shady Grove *Doug Wallin*

18 If I Had the Wings of an Angel *Berzilla Wallin*

19 Conversation with Death *Cas Wallin*

20 Moving over Jordan *Cas Wallin with Evelyn and Edison Ramsey*

Playing time, 62:25